INDUSTRIAL SUBLIME

INDUSTRIAL SUBLIME

Modernism and the Transformation of New York's Rivers, 1900-1940

Hudson River Museum
www.hrm.org

ESE

Empire State Editions
An imprint of Fordham University Press
New York

www.fordhampress.com

I know it's unusual for an artist to want to work way up near the roof of a big hotel, in the heart of a roaring city, but I think that's just what the artist of today needs for stimulus... Today the city is something bigger, grander, more complex than ever before in history. There is a meaning in its strong warm grip we are all trying to grasp. And nothing can be gained by running away.

Georgia O'Keeffe

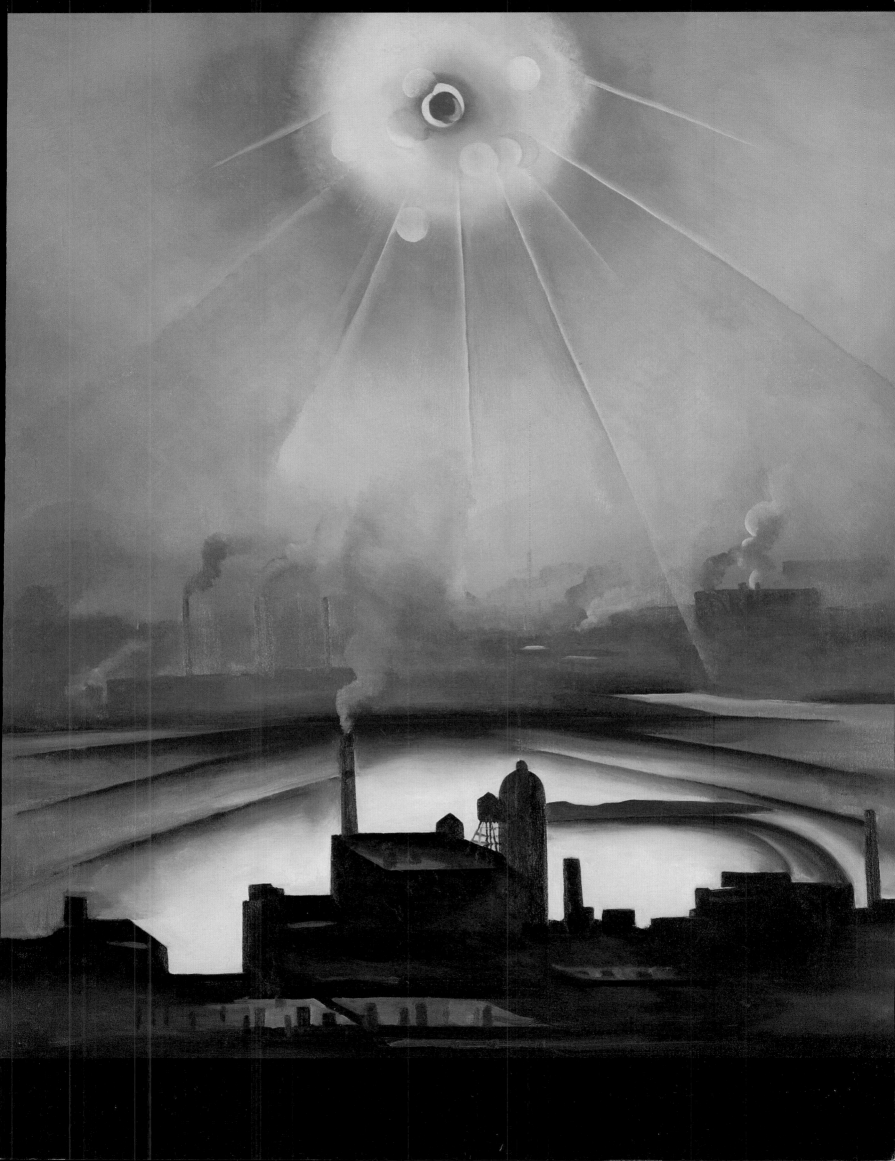

This catalogue is published in conjunction with the exhibition
Industrial Sublime: Modernism and the Transformation of New York's Rivers, 1900-1940,
organized by the Hudson River Museum.

Hudson River Museum October 12, 2013 – January 17, 2014
Norton Museum of Art March 20 – June 22, 2014

Industrial Sublime is the fifth exhibition in the Hudson River Museum series
The Visitor In the Landscape.

The exhibition and the accompanying catalogue have been made possible by a
generous grant from the Mr. and Mrs. Raymond J. Horowitz Foundation for the Arts, Inc.
The exhibition catalogue is supported, in part, by Furthermore: a program of the J.M. Kaplan Fund
and is co-published by the Hudson River Museum and Empire State Editions, an imprint of Fordham University Press.

ISBN 978-094365144-6
Library of Congress Control Number: 2013951493

Director of Publications: Linda Locke
Catalogue design: Michelle Frank
michbill@mindspring.com

Front cover George Ault. *From Brooklyn Heights,* 1925. Collection of the Newark Museum
Preceding page Georgia O'Keeffe. *East River from the Shelton* (East River No.1), c. 1927-28
Back cover John Noble. *The Building of Tidewater,* c. 1937. The Noble Maritime Collection; George Parker. *East River, N.Y.C.,* 1939. Collection of The New-York Historical Society; Everett Longley Warner. *Peck Slip, N.Y.C.,* n.d. Collection of the New-York Historical Society; Ernest Lawson. *Hoboken Waterfront,* c. 1930. Collection of the Norton Museum of Art.

Fonts Anchor Jack, Bembo, and Futura
Printed by Graphic Management Partners, Port Chester, New York

CONTENTS

VII **Preface: Creating the Industrial Sublime**

XI **Director's Foreword: Crux of Change, New York and It's Waters**
Michael Botwinick

XIV **Artists**

XV **Lenders**

XVI **Acknowledgments**

XIX **Artists Sites**

1 **Introduction: A Woman's Perspective On the Industrial Sublime**
Katherine E. Manthorne

11 **Rising From the River: New York City and the Sublime**
Bartholomew F. Bland

33 **On the Fringe: Picturing New York's Rivers, Bridges, and Docklands, 1890-1913**
Wendy Greenhouse

53 **Contested Waterfront: Environmentalism and Modernist Paintings of New York**
Ellen E. Roberts

71 **Painting Manhatta: Modernism, Urban Planning, and New York, 1920-1940**
Kirsten M. Jensen

123 **Industrial Sublime, The Paintings**
Kirsten M. Jensen
Bartholomew F. Bland

168 **Further Readings**

173 **Contributors**

174 **Index**

Kirsten M. Jensen
Bartholomew F. Bland

Creating THE INDUSTRIAL SUBLIME

Billowing smoke, booming industry, noble bridges
and an epic waterfront — American art swung on its axis.

INDUSTRIAL SUBLIME focuses on the style and sensibility of New York life during the years 1900 to 1940, and explores a new landscape painting that conveyed America's role as a global industrial power.

The Erie Canal opened in 1825 and when it did it assured the Hudson River a vital role in the evolution of a modern New York City, soon to be the nation's industrial and financial powerhouse — its "Empire City." That year also marked the beginning of what would become America's first school of painting, the Hudson River School, when Thomas Cole was "discovered" in New York by artist-colleagues John Trumbull, Asher B. Durand, and William Dunlap. A tradition of painting was set in motion that transformed American art, much as the Erie Canal was transforming the landscape.

Walt Whitman, the nation's poet and seer, saw in this transformative time a new country being birthed, and he wrote about its changing landscape:

The shapes arise!

Shapes of factories, arsenals, foundries, markets,

Shapes of the two-threaded tracks of railroads,

Shapes of the sleepers of bridges, vast

> **frameworks, girders, arches,**

Shapes of the fleets of barges, tows, lake and

> **canal craft,**

River craft,

> **Ship-yards and dry-docks**

Unlike Whitman, visual artists at first ignored New York's growing industrialization. Cole, himself, advocated the British traditions of the sublime and the beautiful in his paintings. He melded these romantic ideals into scenes he directly observed from nature and which became the beloved mainstays of American landscapes in the mid-19th century. In thousands of Hudson River School canvases we see America's countryside

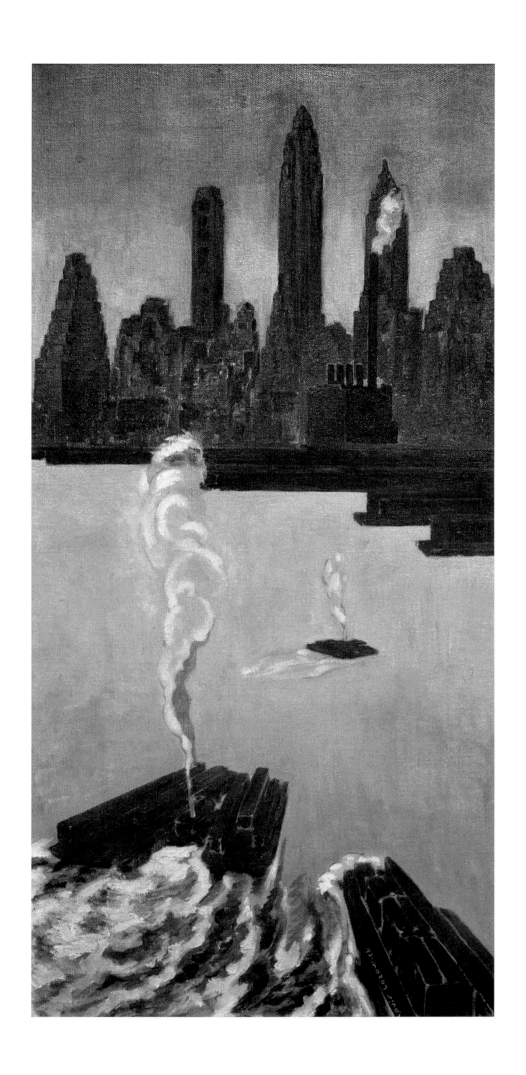

Preceding page

Cat. 63 Charles Rosen. *The Roundhouse, Kingston, New York,* 1927

Walt Whitman. *Song of the Broad-Axe,* 1856

Above

Cat. 44 Louis Lozowick (1892-1973). *Lower Manhattan,* 1932

strikingly resemble the perfection of ancient Arcadia.

From the 1820s through the turn of the 20th century, many artists clung to the pastoral image, even after the lands they painted had radically changed. For others, cities, crowds, and the raucous urban scene of a Manhattan rising in the 1940s were grist for their message. American art swung on its axis.

The movement from painting country landscapes to painting the city has been seen by scholars as a clean break, a new way of showing America. Landscape painting, though, remained the focus for American painters in the face of European Modernism. While artists continued to paint the Hudson River and its tributaries, the Harlem and East rivers, and the great harbor of New York City, they broadcasted the new energy in these scenes with drama and color in stark contrast to the pastoral paintings of a hundred years before. Artists like Robert Henri and John Sloan, and later Georgia O'Keeffe and George Ault celebrated the vibrant visage of the city. Billowing smoke, booming industry, noble bridges, and an epic waterfront now appeared on their canvases. Sights focused, they painted the glittering structures of the Machine Age.

Looking to their forebears for the romantic elements of the sublime, the artists of a spanking new 20th century combined romance and Modernism's obsession with structure and form, and so created an exciting visual vocabulary — the Industrial Sublime.

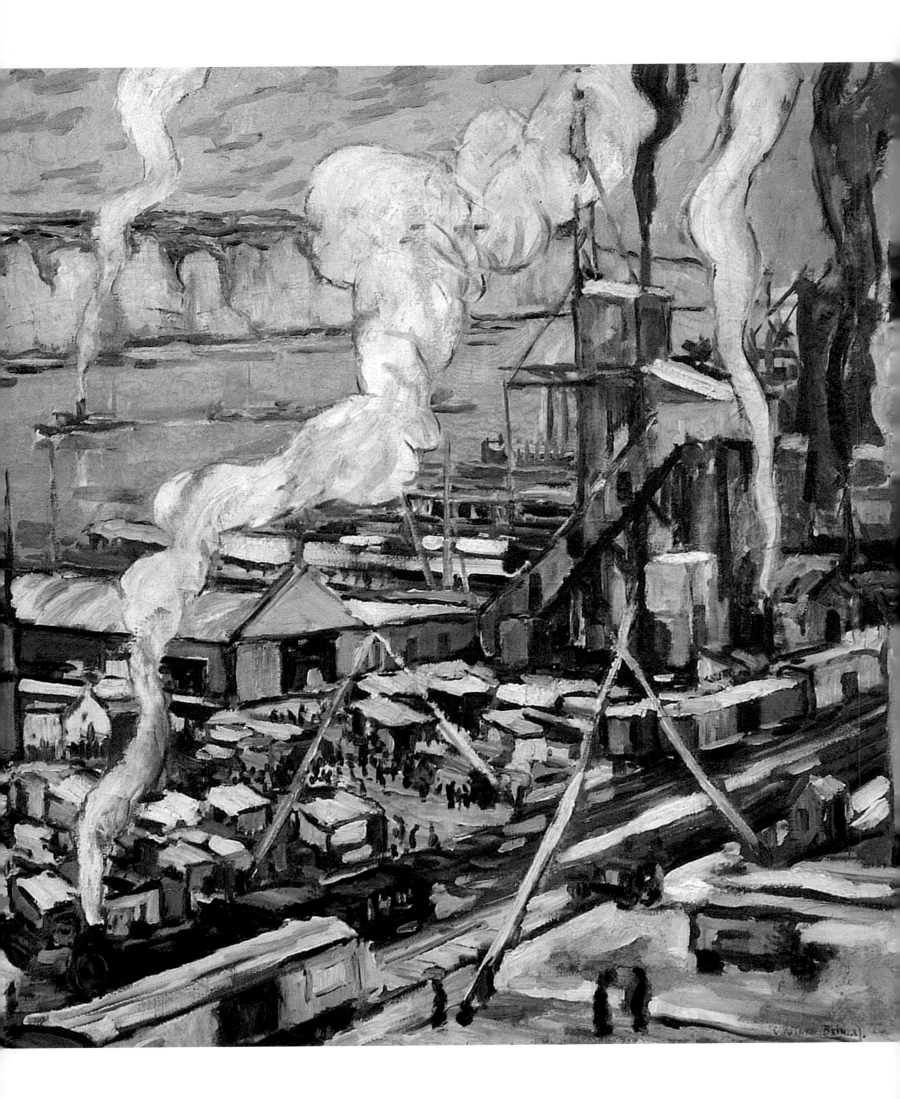

Michael Botwinick

CRUX OF *Change*, NEW YORK AND ITS WATERS

In New York's waterfront, artists find its complexity, brawny self-confidence, and its darker corners.

IN MANY WAYS, Yonkers, the home of the Hudson River Museum, is the ideal vantage point from which to consider the Industrial Sublime. From the Museum grounds you can see both the northern end of New York Harbor, south of the Washington Bridge, and the widening out of the river into the Tappan Zee. Yonkers has historically been the gatekeeper to this transition. In Dutch times it was the last of the cultivated plantations before the long reach up river to the beaver trade around Albany. When the Erie Canal opened and created a water route to the center of the country, it was the first of the commercial river ports. And then, it was the first stop on the railroad after it made its way out of the city. In the 20th century Yonkers became the city that was the transition from New York City to its suburbs. To the extent that *Industrial Sublime* spans the lower Hudson River and New York Harbor, Yonkers and the Hudson River Museum are the prospects from which we can examine the wide geographic and pictorial range of this moment in American art.

We sometimes think of the Hudson River School as the first native American painting tradition. Shaped, in part, by a magnificent and varied landscape it created a visual vocabulary that helped define our notions of pictorial beauty and informs our sense of landscape and beauty to this day. This aspect dominates early thinking about the Hudson River School, as if its artists were little more than "oil-painting William Wordsworths." More recently we have come to understand that the drama of shape and light in the Hudson Valley was for them a beginning point to tell the story of the great transformation of America from a group of states along the Atlantic Ocean to a continental-sized nation that stretched all the way west to the Pacific. We see in their landscapes the transformation of America from a picturesque antebellum and agrarian society to a postbellum nation of growth, trade, exploration, and expansion. While in their works they often put "fig leafs" on the marks industry left on the land, just as often there were peek-a-boo moments into our country's future. Hudson River School artists became the chroniclers of America's march to its Manifest Destiny.

It is no surprise that the Hudson drew artists to it again in the 20th century. They knew the geography and stylistic traditions of the Hudson River School but they showed a very different transformation. While the Industrial Revolution was working its way through the latter part of the 19th century, its greatest visual impact emerges in the first decades of the next century. The artists who painted the Hudson, Harlem and East rivers are witness to the rise of a great industrial democracy. In New York's waterfront, they find its vitality, its strength, its complexity, its diversity, its energy, its speed, its brawny self-confidence, and its darker corners. The vocabulary of modernism is suited to this task. It has an aesthetic line that captures motion and structure. It is as much at home looking at the challenges of the present as at the promise of the future. Modernism provides a rich and complex canvas.

In the essays that follow Katherine

From the 19th century to today, sugar refining remains a key industry on the Yonkers waterfront. Yonkers, New York State's fifth largest city, was the lynchpin to New York City's suburbs and the nucleus of early waterfront industry. Artists of the early 20th century were inspired by its industry and location.

Preceding page

Cat. 9 Daniel Putnam Brinley
Hudson River View (Sugar Factory at Yonkers), c. 1915

Above

Federal Sugar Refinery Co., Yonkers, c. 1920
Photographer unknown, 7 ¾ x 9 ¾ inches
Collection of the Hudson River Museum, INV.3616 B

Manthorne shows us how to use the early modern period to examine issues overlooked until recently. Kirsten Jensen gives us ways to understand the built environment from its art. Wendy Greenhouse and Ellen Roberts show how artists point us toward the enormous social and economic forces that were contesting for the landscape. Bartholomew Bland helps us navigate the transition from 19th-century visions of the sublime to its 20th-century interpretations by a rising generation of artists. We are grateful to all of the essayists for their contributions have made *Industrial Sublime* an important addition to our understanding of the ongoing narrative of American Art.

We are grateful to the Mr. and Mrs. Raymond J. Horowitz Foundation for the Arts for their continued support of the *Visitor In the Landscape* series of which this is the fifth project, and to Furthermore, a program of the J.M.Kaplan Fund, whose support has given us the chance to produce this catalogue. Bartholomew Bland and Kirsten Jensen have curated an exhibition that is rich with possibilities and endlessly rewarding to contemplate. They led a team, more specifically mentioned in the Acknowledgments, that has added significantly to our understanding of American art and America.

ARTISTS

Kurt Albrecht

Junius Allen

George Ault

Gifford Beal

Reynolds Beal

Cecil Crosley Bell

George Bellows

Oscar Bluemner

Daniel Putnam Brinley

Edward Bruce

Theodore Earl Butler

Carlton Theodore Chapman

Clarence Kerr Chatterton

James Rene Clarke

Glenn Coleman

Colin Campbell Cooper

Ralston Crawford

Francis Criss

Aaron Douglas

John Folinsbee

Inna Garsoïan

William Glackens

Robert Henri

Arnold Hoffman

Max Kuehne

Leon Kroll

Ernest Lawson

Martin Lewis

Richard Hayley Lever

Jonas Lie

Louis Lozowick

George Luks

George Macrum

John Marin

Reginald Marsh

Alfred Mira

John Noble

George Oberteuffer

Georgia O'Keeffe

Marguerite Ohman

George Parker

Van Dearing Perrine

Robert K. Ryland

Charles Rosen

Everett Shinn

John Sloan

Robert Spencer

Charles Vezin

Everett Longley Warner

Julian Alden Weir

Sidney M. Wiggins

Jan and Warren Adelson

Amistad Research Center

Arader Galleries

The Art Institute of Chicago

The Baker Museum

Boca Raton Museum of Art

Gregory and Maureen Church

Joanne and Jim Cohen

Nina and Stephen Cook

Erik Davies

Kristian Davies

Max Ember

The Flint Institute of Arts

The Fralin Museum of Art
 at the University of Virginia

John and Sally Freeman

Georgia Museum of Art,
 University of Georgia

Kristine and Marc Granetz

Hampton University Museum

Hawthorne Fine Art, LLC

High Museum of Art

Elie and Sarah Hirschfeld

Hirshhorn Museum and Sculpture Garden,
 Smithsonian Institution

Hudson River Museum

James A. Michener Art Museum

Susan Perrine King and Shawn King,
 Van Dearing Perrine Estate

Thelma and Melvin Lenkin

Martin J. Maloy

Memorial Art Gallery,
 University of Rochester

The Metropolitan Museum of Art

Munson-Williams-Proctor Arts Institute

Museum of Art, Ft Lauderdale/
 Nova Southeastern University

The National Arts Club

New Jersey State Museum

The New-York Historical Society

The Newark Museum

The Noble Maritime Collection

Norton Museum of Art

The Old Print Shop, Inc.

Pennsylvania Academy of the Fine Arts

The Phillips Collection

Private Collections

Remak Ramsay

Samuel P. Harn Museum of Art,
 University of Florida

Smithsonian American Art Museum

Staten Island Museum

Terra Foundation for American Art

Wichita Art Museum

A PROJECT OF THIS SCOPE can be accomplished only with the assistance of others. We are grateful for the generosity of the people and the institutions contributing to the success of *Industrial Sublime*. Their support and the enthusiastic participation of colleagues in museums, galleries, and private collections made this exhibition and catalogue possible.

We thank our contributors: Jan and Warren Adelson; Hubbard Toombs (Adelson Galleries, Inc.); Marie Evans (Alexandre Gallery); R.J. Marshall (AKA Design); Lee Hampton, Leiza McKenna (Amistad Research Center); Susan Charlas, Anthony Montoya (Aperture Foundation); Ruth Appleyard; W. Graham Arader III, Daniel Brunt (Arader Galleries); Judith Barter, Douglas Druick, Darrell Green, Jackie Maman, Anna Simonovic (The Art Institute of Chicago); Frank Verpoorten, Jacqueline Zorn (Artis-Naples The Baker Museum); Nicole Amoroso (Avery Galleries); Bernard Goldberg, Ken Sims (Barnard Goldberg Fine Arts, LLC.); Moira A. Fitzgerald (Beinecke Rare Book & Manuscript Library); Martin J. Hanahan, Steven Maklansky, Marisa Pascucci (Boca Raton Museum of Art); Jenna Delgado (Camden Partners); Laurel Mitchell, Anna-Sophia Zingarelli (Carnegie Institute Museum of Art); Gregory and Maureen Church; Elizabeth Saluk (The Cleveland Museum of Art); Joanne and Jim Cohen; Lorraine DeLaney, Paige Doore (Colby College Museum of Art); Nina and Stephen Cook; Jeffrey W. Cooley (The Cooley Gallery); Anna Kuehl, Lisa Strong (Corcoran Gallery of Art); Heather Campbell-Coyle, Erin Tohill Robin (Delaware Art Museum); Erik Davies; Kristian Davies; Thomas Davies; Anne Cohen DePietro (Doyle New York); Michael Dressler; Max Ember; Katherine Criss (Estate of Francis Criss); Tracee J. Glab, John B. Henry, III, Heather Jackson, Peter Ott (Flint Institute of Arts); Peter Cook, John F. Cook, Joan W. Hooker, Dianne Dubler, John B. Taylor, Michael W. Wiggins (John F. Folinsbee Art Trust); Bruce A. Boucher, Jennifer Farrell, Jean Lancaster (The Fralin Museum of Art at the University of Virginia); Mary-Kay Lombino, Anna Mecugni, PhD, James Mundy, Joann Potter (The Frances Lehman Loeb Art Center at Vassar College); John and Sally Freeman; William U. Eiland, Sarina Rousso, Christy Sinksen (Georgia Museum of Art, University of Georgia); Cody Hartley (Georgia O'Keeffe Museum); Stephen Gleissner; Howard Godel, Thomas Quick (Godel & Co. Fine Art); Kristine and Marc Granetz; Vanessa Thaxton-Ward (Hampton University Museum); Jennifer C. Krieger (Hawthorne Fine Art, LLC); David Brenneman, Paula Haymon, Stephanie Heydt, Laurie H. Kind, Michael E. Shapiro (High Museum of Art); Elie and Sarah Hirschfeld; Kerry Brougher, Annie Farrar, Melissa Front, Amy Giarmo, Mandee Nash (Hirshhorn Museum and Sculpture Garden); Jennifer M. Holl; Sara Hesdon Buehler, Bruce Katsiff, Constance Kimmerle (James A. Michener Art Museum); Susan Perrine; King and Shawn King; Richard Koshalek; Katherine Degn (Kraushaar Galleries); Thelma and Melvin Lenkin; Irvin M. Lippman; Carol Lowrey; David Major; Martin J. Maloy; Grant Holcomb, Jessica Marten, Colleen R. Piccone, Kerry Schauber, Marjorie Searl, Monica Simpson (Memorial Art Gallery of the University of Rochester); Andrew Schoelkopf, Jonathan Spies (Menconi Schoelkopf); Thomas P. Campbell, Emily Foss, George R. Goldner, Cynthia Iavarone, Peter M. Kenny, Nesta Mayo, Thayer Tolles, Sheena Wagstaff, H. Barbara Weinberg (The Metropolitan Museum of Art); Anna D. D'Ambrosio, Paul D. Schweizer, Michael Somple (Munson-Williams-Proctor Arts Institute); Diana Blanco, Rachel A. Diana, Rachel Talent Ivers, Jorge Hilker Santis, Stacy Slavichak, William R. Stanton (Museum of Art | Fort Lauderdale, Nova Southeastern University); Dianne Bernhard, Michael Gormley, Alex Rosenberg (National Arts Club); Anthony Gardner, Jenny Martin-Wicoff, Margaret M. O'Reilly (New Jersey State Museum); Amber Germano, Andrea Hagy, Mary Kate O'Hare, Mary Sue Sweeney Price (The Newark Museum); Robert M. Delap, Stephen Edidin, Linda Ferber, Eleanor Gillers, Stephen Kornhauser, Victoria Manning, Louise Mirrer, Scott Wixon (The New-York Historical Society Museum and

Library); Andrea Felder (The New York Public Library); Ciro Galeno, Jr., Erin M. Urban (The Noble Maritime Collection); Janet Maddox, Kenneth M. Newman, Robert K. Newman (The Old Print Shop, Inc.); Richard Pandich; Aaron Payne (Aaron Payne Fine Art); Lars A. Pedersen; Jennifer Johns, Anna O. Marley, Harry Philbrick, Gale Rawson, Judith Thomas (Pennsylvania Academy of Fine Arts); Giema Tsakuginow (Philadelphia Museum of Art); Susan Behrends Frank, Joseph Holbach, Dorothy Kosinski, Gretchen Martin, Eliza Rathbone (The Phillips Collection); Charles E. Greene, AnnaLee Pauls, Vicki L. Principin (Princeton University Library); Nina Sangimino (Questroyal Fine Art, LLC); Neelon Crawford (Ralston Crawford Estate); Remak Ramsay; Shannon Sweeney (Saint Louis Art Museum); Rebecca M. Nagy, Laura Nemmers, Dulce Roman, Jessica Uelsmann (The Samuel P. Harn Museum of Art); Jessica Ambler, Joe Price (Santa Barbara Museum of Art); Joanne M. Rohrig, Gene Shannon (Shannon's Fine Art Auctioneers); Elizabeth Broun, Dave DeAnna, Alison H. Fenn, Eleanor J. Harvey, Richard Sorensen, William H. Truettner (Smithsonian American Art Museum); Elizabeth Goldberg, Jonathan Greenburg, Madeline Hurst (Sotheby's); Robert Bunkin, Elizabeth Egbert, Donna Pagano (Staten Island Museum); Peter John Brownlee, Elizabeth Glassman, Cathy Ricciardelli (Terra Foundation for American Art); Carl Fleming (Terry Dowd, Inc.); Darleen Reid (USPS Corporate Communications); David Warnock, Kirk Eck, Elizabeth Koch, Patricia McDonnell, Leslie J. Servantez, Roger Turner, (Wichita Art Museum, The Roland P. Murdock Collection); Rebecca Withers; Kathleen Mylen-Coulombe (Yale University Art Gallery).

We thank our catalogue essayists: Wendy Greenhouse, Katherine Manthorne, and Ellen Roberts.

We are grateful to our partners and co-publishers at Fordham University Press: Fredric Nachbaur, Director, and his staff Will Cerbone, Loomis Mayer, Eric Newman, and Kate O'Brien-Nicholson.

Thanks to our partners at the Norton Museum of Art, where *Industrial Sublime* appears spring 2014: Hope Alswang, Aleesha Ast, Cheryl Brutvan, Maggie Edwards, Pamela S. Parry.

Thank you to the Hudson River Museum staff: We are deeply grateful to Museum Director Michael Botwinick for the support necessary to make this project a reality. Jennifer Patton, Assistant Director, Education, and her staff for creating programs complementing the exhibition; Laura Vookles, Chief Curator of Collections, for invaluable research; Takako Hara, Registrar, who worked tirelessly to secure the loans for the exhibition; Jason Weller, Senior Art Technician, who took much of the fine photography in this publication and supervised the handsome installation; Curatorial Intern Katie Flynn, who assisted with research on artists in the exhibition. We are deeply grateful to Linda Locke, Director of Publications, for her creativity, energy, and dedication producing this catalogue under tight deadlines.

Thank you to our friends, family, and colleagues: Kirsten M. Jensen is indebted to Rosemarie Haag Bletter and Andrew Hemingway, and extends her gratitude to John Cowgill, Marilynn A. Cowgill, Sherburne MacFarlan, Lars A. Pedersen, and Finn and Freja Pedersen, who, hopefully, some day will appreciate their mother's endless fascination with coal chutes, grain silos, and abandoned factories. Bartholomew F. Bland thanks Joseph Bland, Andrew Fritzer, Doreen Fritzer, Lori Fritzer, Penelope Fritzer, Stephen Fritzer, Aaron Holsberg, Katie Hustead, Benjamin Moor, Hilary Moor, Oliver Moor, Christopher Scott Sarno, Joe Weston, Blaise Woodworth, Melissa Martens Yaverbaum, and Daniel Yaverbaum.

Kirsten M. Jensen Bartholomew F. Bland

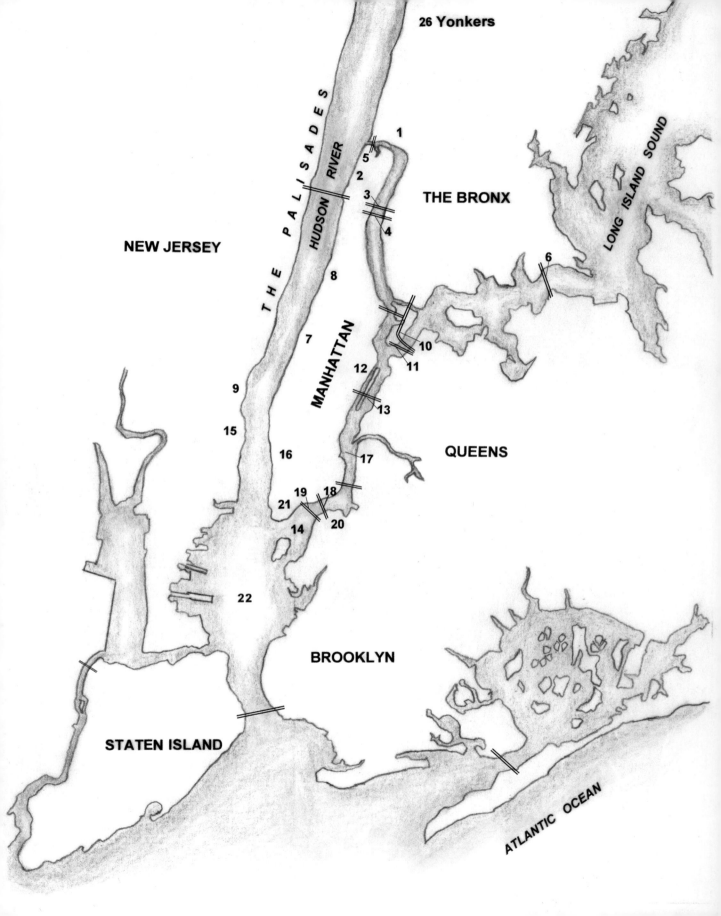

26 Yonkers

1

5

2

3

4

THE PALISADES

HUDSON RIVER

NEW JERSEY

THE BRONX

LONG ISLAND SOUND

6

8

7

MANHATTAN

10

11

12

13

9

15

16

17

QUEENS

19

21

18

14

20

22

BROOKLYN

STATEN ISLAND

ATLANTIC OCEAN

1 Harlem River
Oscar Bleumner, *Harlem River*

2 Washington Heights, New York City
Ernest Lawson, *Railroad Track*

3 Washington Bridge, Harlem River
James Rene Clarke, *Washington Bridge*

4 High Bridge
Richard Hayley Lever, *High Bridge over Harlem River*

5 Inwood, Manhattan
Aaron Douglas, *Power Plant in Harlem*

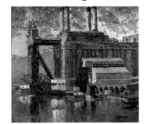

6 The Bronx-Whitestone Bridge, East River
Ralston Crawford, *Whitestone Bridge*

7 Riverside Park, New York City
George Bellows, *Winter Afternoon*

8 Riverside Drive, New York City
Richard Hayley Lever, *Riverside Drive and Seventy-second Street*

9 Weehawken Heights, New Jersey
Leon Kroll, *Terminal Yards*

10 Robert F. Kennedy Bridge, Harlem River, Bronx Kill, East River
Aaron Douglas, *Triborough Bridge*

11 Hell Gate Bridge, East River
George Oberteuffer, *View at Hellsgate Bridge*

12 Franklin D. Roosevelt Highway
Inna Garsoïan, *Eastside Drive*

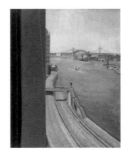

13 Ed Koch Queesborough Bridge (59th Street Bridge)
Glenn Coleman, *Queensboro Bridge, East River*

14 The East River, seen from Brooklyn
George Parker, *East River, N.Y.C.*

15 Hoboken, New Jersey
Ernest Lawson, *Hoboken Waterfront*

16 Manhattan Waterfront
Max Kuehne, *Lower Manhattan*

17 East River
Georgia O'Keeffe, *East River From the Shelton*

18 Manhattan Bridge
Marguerite Ohman, *View of the East River with the Manhattan Bridge, New York City*

19 Brooklyn Bridge
Jonas Lie, *Path of Gold*

20 Brooklyn Heights
George Ault, *From Brooklyn Heights*

21 Peck Slip, New York City
Everett Longley Warner, *Peck Slip, NYC*

22 New York Harbor
Cecil Crosley Bell, *Welcoming the Queen Mary*

ARTISTS SITES

SIGHTING THE RIVER

Cat. 8 Oscar Bluemner. *Harlem River*, 1912

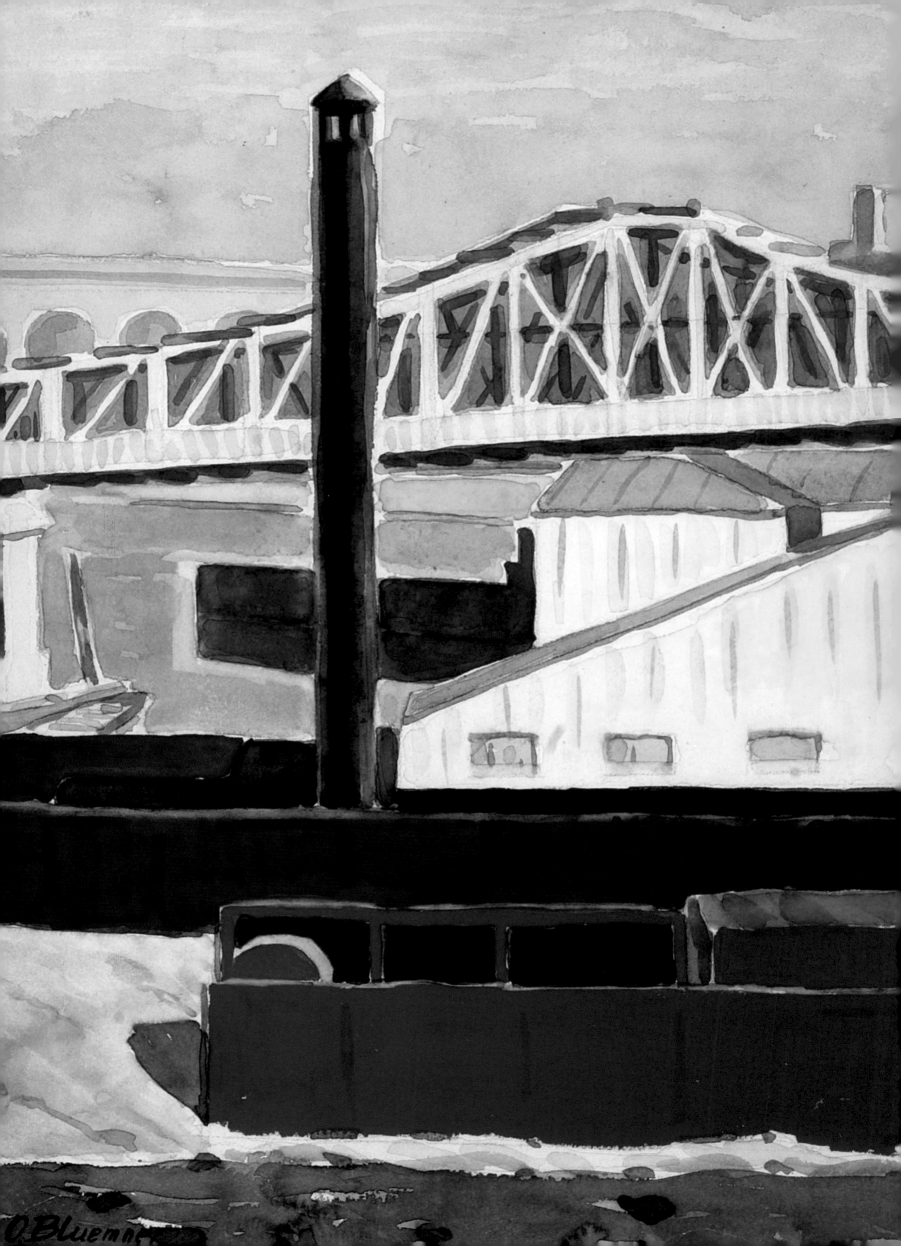

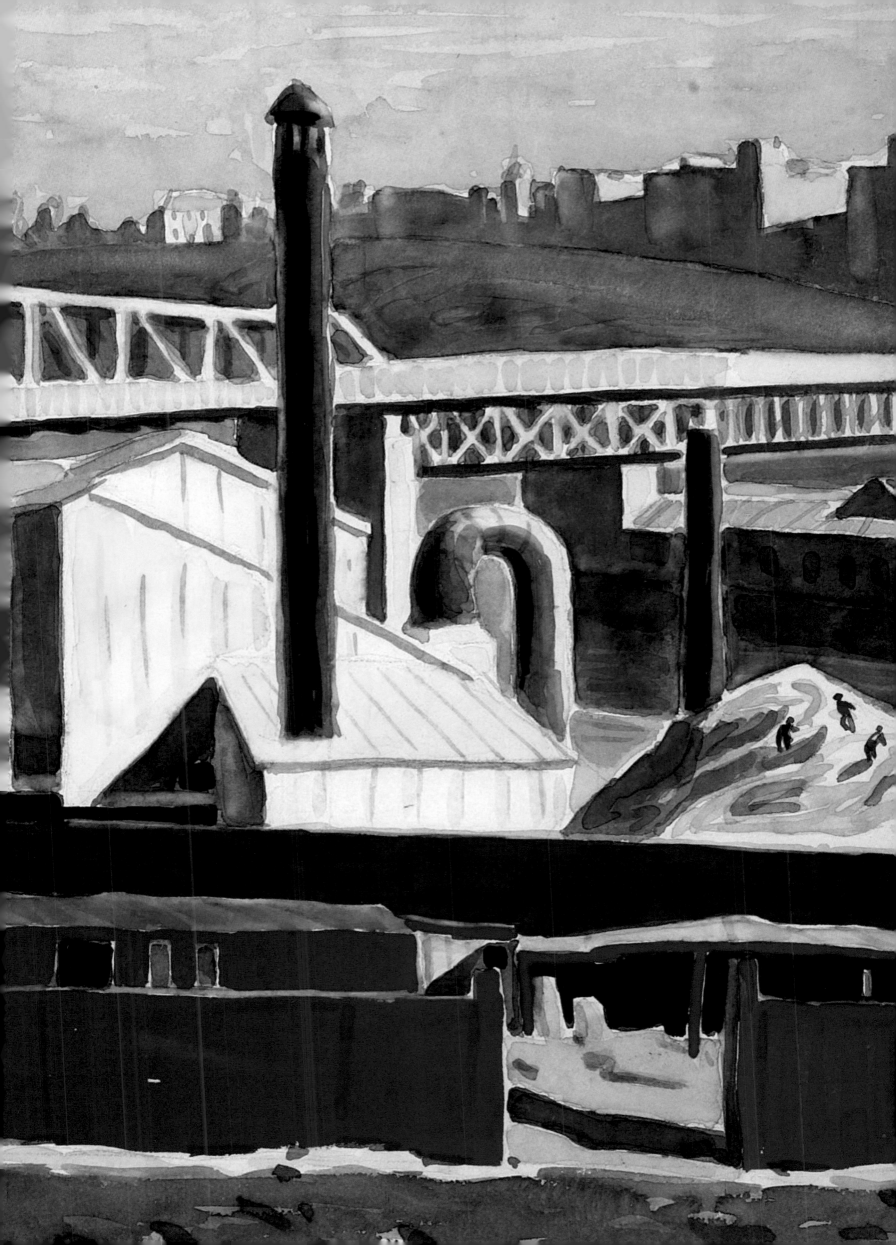

Cat. 4 Gifford Beal. *On the Hudson at Newburgh, 1918*

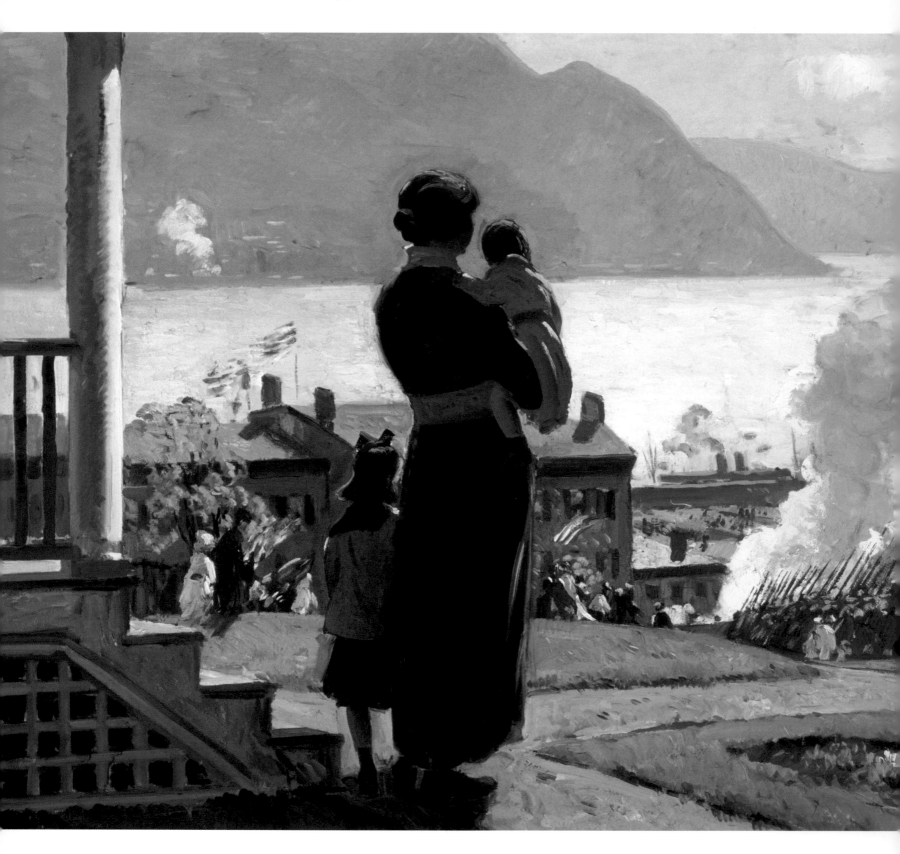

Katherine E. Manthorne

A WOMAN'S *Perspective*
ON THE INDUSTRIAL SUBLIME

Americans began to embrace the Industrial Sublime with as much
enthusiasm as they had previously nature.

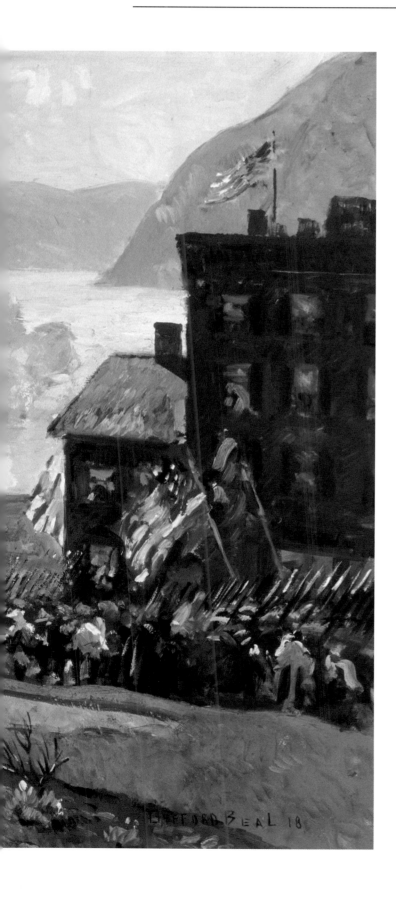

VOLCANIC ERUPTIONS, earthquakes, and thunderstorms have terrified mankind since Adam and Eve were expelled from the Garden of Eden. Impressed by such displays of power beyond themselves, human beings sought the language to express their emotions. One of the oldest essays on the subject appeared in a Greek manuscript from the 1st century A.D. titled "On the Sublime," traditionally attributed to Longinus (although probably erroneously), which declared that Nature "has implanted in our souls an unconquerable passion for all that is great and for all that more divine than ourselves."[1] For centuries the essay languished until it was printed in 1554 in Basel. By the 17th century — with translations into French and English — the concept of a search for the grand began to take hold. In *A Philosophical Enquiry* into the *Origin of our Ideas of the Sublime and the Beautiful* (1756), Edmund Burke established the sublime and the beautiful as central — and mutually exclusive — aesthetic categories intimately associated with nature.[2] Both concepts proved especially useful to gentlemen on the Grand Tour attempting to describe their experiences. It acquired further meaning in the hands of 19th-century American artists, who took up the subject of the grand and untamable, including Niagara Falls and the Grand Canyon, to inspire awe in their viewers. By the early 20th century these feelings were transferred to machines, war, and factories as the "natural sublime" gave way to the "industrial sublime," which was both a representational strategy and a philosophical orientation that accounted for fearsome, uninhabitable regions that simultaneously repulsed and excited the beholder.

The Hudson River was technologically developed early in its history and the painters who adopted it as their sacred ground had to come to terms with it. Occasionally they referenced it, but mostly they turned their backs on these intrusive elements or moved their vantage point slightly. so they could omit them from the picture. After 1900 it was no longer possible to ignore such elements. Electricity was more widely adopted for power, which permitted new facilities of unprecedented scale. Changes in production led to new aesthetics of industry. Americans began to embrace the industrial sublime with as much enthusiasm as they had previously nature. Bridges, manufacturing complexes, and factory smokestacks were celebrated as signs of progress.[3]

Many of the artworks in this publication embody these ideas including Gifford Beal's *On the Hudson at Newburgh* (1918) [Cat. 4], which offers a useful starting point for our discussion. Ostensibly the painting provides a glimpse of the then small town on the Hudson sixty miles north of New York City where the artist's family had a summer home.[5] Closer study reveals it to be programmatically constructed, a pictorial manifesto on the sublime and the beautiful as they were understood in 1918. The canvas is divided into three spatial zones, each devoted to a single aesthetic category — the beautiful in the foreground, industrial sublime in the middle ground, and natural sublime in the background, and they function individually and in dialogue with one another.

The upright figure of a woman with a baby in her arms and a young daughter by her side stands with her back to us, bathed in gentle morning light on a rise of land at the picture's threshold. The artist surveys the scene from her perspective and we with him, looking over her shoulder. From their backyard she watches a military procession, which diagonally bisects the composition and separates the domestic space from the built environment and militaristic activities of the town below. Mother and child take refuge on their well-groomed lawn with its carefully laid-out walkway and small garden. Their world is orderly, balanced, and peaceful, fulfilling Burke's definition of the beautiful. The whitewashed steps and column of the house reinforce its associations with domesticity.

She looks from this sheltered, grassy plateau upon a battalion of soldiers shouldering rifles and marching downhill to meet a waiting train that belches smoke. We can almost hear the shouts of the townspeople cheering them on, waving flags, and bidding farewell to loved ones. The street, occupied by the procession, is lined with the brick facades and tiled roofs of the town's growing industrial complex, its products transported by the railroad alongside the river, the ultimate symbol of the machine that has invaded the garden of nature. The railroad carries not only the bi-products of industry but also the soldiers who will board the waiting cars to be taken to war. Industry and technology have become the gods of the modern age. And they gave rise to another manifestation of the sublime — war.

Beal completed this large-scale canvas in 1918, just after the entry of the United States into World War I. The story it tells is one of men heading off to the battlefields of Europe, while families stay behind to maintain hearth and home until their return. On one level the painting conveys patriotic sentiment but it also reinforces the theme of the industrial sublime.

In his influential book *Critique of Judgment*, Immanuel Kant declared that war was sublime:

Even war, if waged in an orderly fashion and with observation of all civil rights, has a sublime component, and makes the way of thinking of a people who are waging it all the more sublime the more it was exposed to danger and was able to prove its courage: whereas a long peace usually leads to more mercantilism, which reinstates egotism, cowardice and effeminacy and degrades the spirit of the people.[6]

Fig. 1 Elsie Driggs (1898-1992)
Queensborough Bridge, 1927
Oil on canvas, 40 ¼ x 30 ¼ inches
Montclair Art Museum, Museum Purchase
Lang Acquisition Fund, 1969.4

Beal's stalwart woman surveys the reigning noise and confusion, harbinger of the war that rages overseas. She is filled with terror at the departure of the townsmen, likely including not only a husband but also a brother heading off to combat. The railroad engine and the ship anchored just off shore are further references to the unknown world beyond the town, rimmed by tall ugly buildings that partially block sight of the landscape.

From her vantage she can still observe Newburgh Bay, strategically located just up the river from Storm King, the North Gate of the Hudson Highlands, and considered its most magisterial vista. Beal cast this scenic emblem of the natural sublime in soft, monochromatic violet and pushed it to the background, thus relegating it to the past. The bay contrasts sharply with the humming engines of the steamship, the architectonic shapes of apartment buildings and factories that rim it, and the jagged points of bayonets mounted on rifles on the near side of the river by which the artist conveys the early 20th century present. Our female spectator, positioned securely in the realm of the beautiful, surveys a face-off between the old, natural sublime and the new industrial sublime.

Beal chose a female spectator, pointing to the relationship between gender and the sublime. Many theorists argue that women and men possess systematically different tastes or capabilities for appreciating art and other cultural practices. The most marked gender distinctions occur in our central aesthetic category of the sublime, and its opposite — beauty. Objects of beauty were described as bounded, small, and delicate, that is "feminized" traits. Objects that are sublime — drawn chiefly from uncontrolled nature — are unbounded, rough and jagged, terrifying, that is "masculinized" traits. With their supposed weaker constitutions and moral limitations, women were considered incapable of the tougher appreciation and insights that sublimity discloses. These assertions gave rise to feminist debates over whether one can discern in the history of art an alternative tradition of sublimity that counts as a "female sublime." [7] Well-known New York pictures by women artists, including Georgia O'Keeffe and Elsie Driggs (1927) [Fig. 1], support this idea.

About 1940 Marguerite Ohman created *View of the East River with the Manhattan Bridge, New York City* (1940) [Cat. 56] and *View of the East River with Queensborough Bridge, New York City* (c. 1940) [Cat. 58]. She carefully constructed the spaces, with a bridge in each picture spanning horizontally from left to right, and contrasted these man-made structures to nature: the crisscross patterns of the *Queensborough Bridge* hover above the copses of trees in Central Park, while in *Manhattan Bridge* the rectilinear smokestacks, factories, and piers frame the circular path of water currents. A second polarity is also in play: Ohman deploys the medium of watercolor traditionally associated with women's work to depict a subject defined as toughly masculine, and thereby demonstrates her ability to master

it. Like many artists working in New York City in the 1920s and 30s, she links her experience of its bridges and skyscrapers to the sublime. Her omission of human figures reinforces this dimension and leaves the viewer to confront the scene unmediated by the presence of others.

Inna Garsoian adopted a similar strategy. By the time she arrived in New York City from Russia by way of Paris in the late 1920s, she was an established painter but also practiced illustration and set design to ensure that she could earn a living. Her strong compositions, such as *Eastside Drive* (c. 1940) [Cat. 26], derive their power from emphatic geometries, stark light, and a feeling of emptiness. The paintings show a modern route to the sublime, one that conveys terror

Cat. 58 Marguerite Ohman. *View of the East River with Queensborough Bridge, New York City*, c. 1940

by presenting a modern, industrial city devoid of people. For just as volcanic and storm-filled landscapes associated with the 18th-and-19th-century natural sublime were uninhabitable, so the techno-urban landscapes of the 20th-century industrial sublime were inhospitable to human life. "Desert" places, they return us to the wilderness of the Old Testament inhabited by Adam and Eve, where we started.

The term "sublime" has undergone many changes in interpretation, scholars now positing a Post-modern Sublime[8] and a Cyber Sublime.[9] The industrial sublime was its early 20th-century reincarnation, a response to the ways in which technology made the world increasingly accessible and yet ungraspable.

1 Longinus, *On the Sublime*, ed. D. A. Russell (Oxord, Clarendon Press, 1964), 146.

2 The rise of interest in Longinus' text occurred after i was translated into French (Borlieu, 1674) and English (Smith, 739). Edmund Burke, *A Philosophical Enquiry into the Origin of our Ideas of the Sublime and the Beautiful* (4th ed., Dublin: Sarah Cotter, 1766).

3 David Nye, *American Technological Sublime* (Cambridge, MA: MIT Press, 1994).

4 The picture was recently "discovered" under the canvas of a later picture by Beal. For its history see: http://www. phillipscollection.org/collection/browse-the-collection/index. aspx?id=1998.004.0001

5 Immanuel Kant, *Critique of Judgment*, tr. J. H. Bernard (1st published 1781; London: Macmillan, 1914), p. 168.

6 "Feminist Aesthetics," *Stanford Encyclopedia of Philosophy*; accessed website on 4/27/2013: plato.standford.-du/entries/ feminist-aesthetics.

7 See, for example, Timothy H. Engström, "The Postmodern Sublime?: Philosophical Rehabilitation and Pragmat= Evasion," *boundary 2* v. 20 (Summer 1993)

8 For an instance of this see William Gardner, "The Cy er Sublime and the Virtual Mirror: Information and Media in the Works of Oshli Mamorj and Kun Satosi," *Canadian Film Studies* 18.1 (2009)

SUBLIMITY

Cat. 72 Julian Alden Weir. *The Bridge: Nocturne (Nocturne: Queensboro Bridge),* 1910

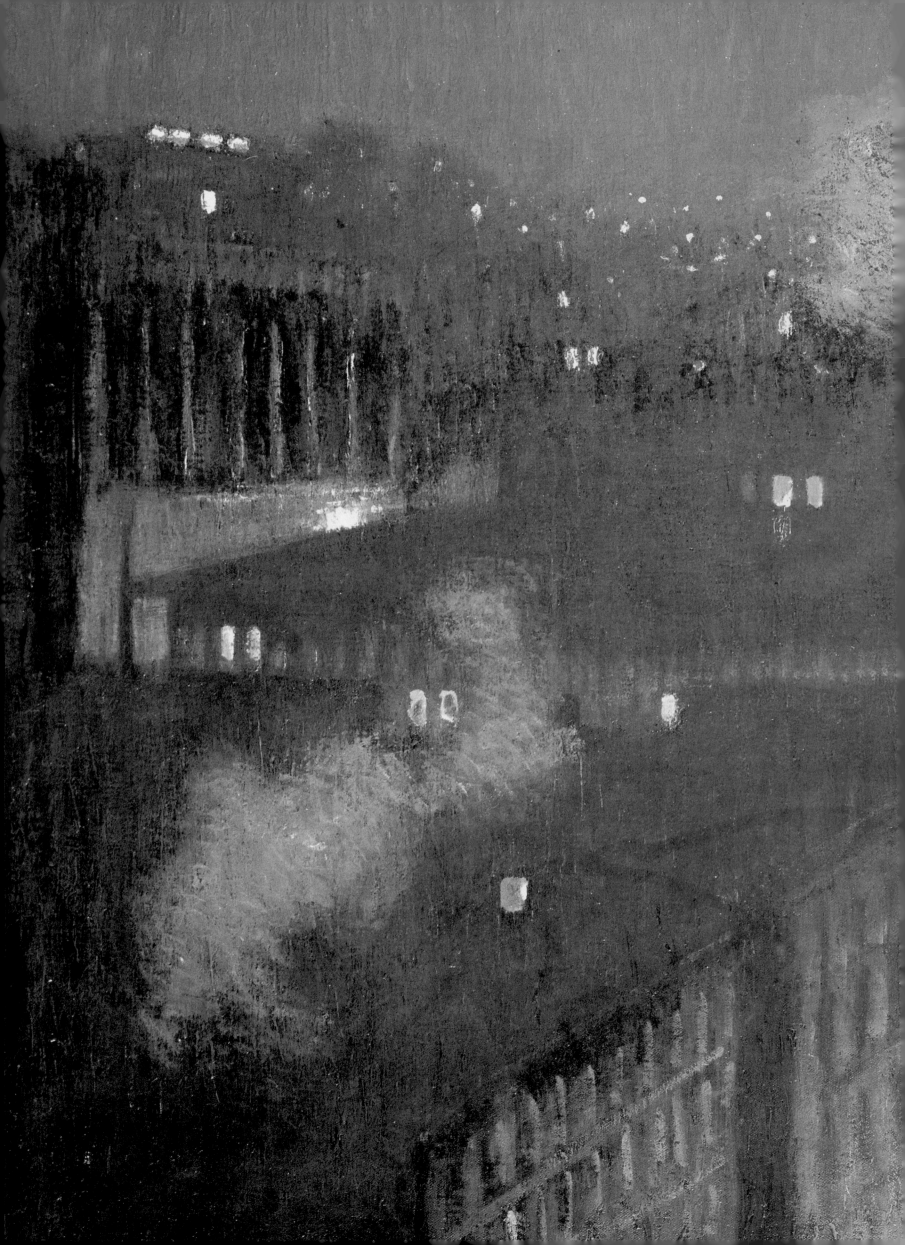

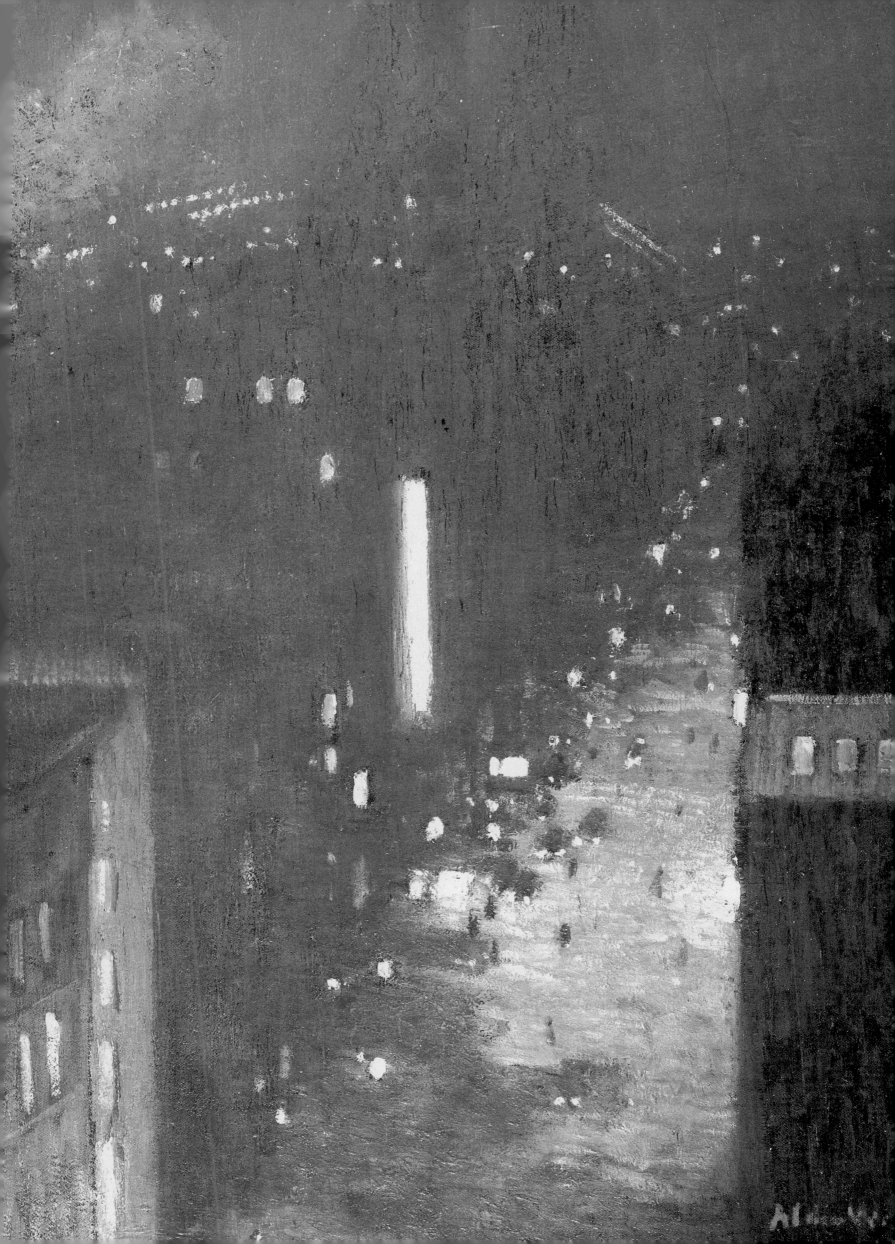

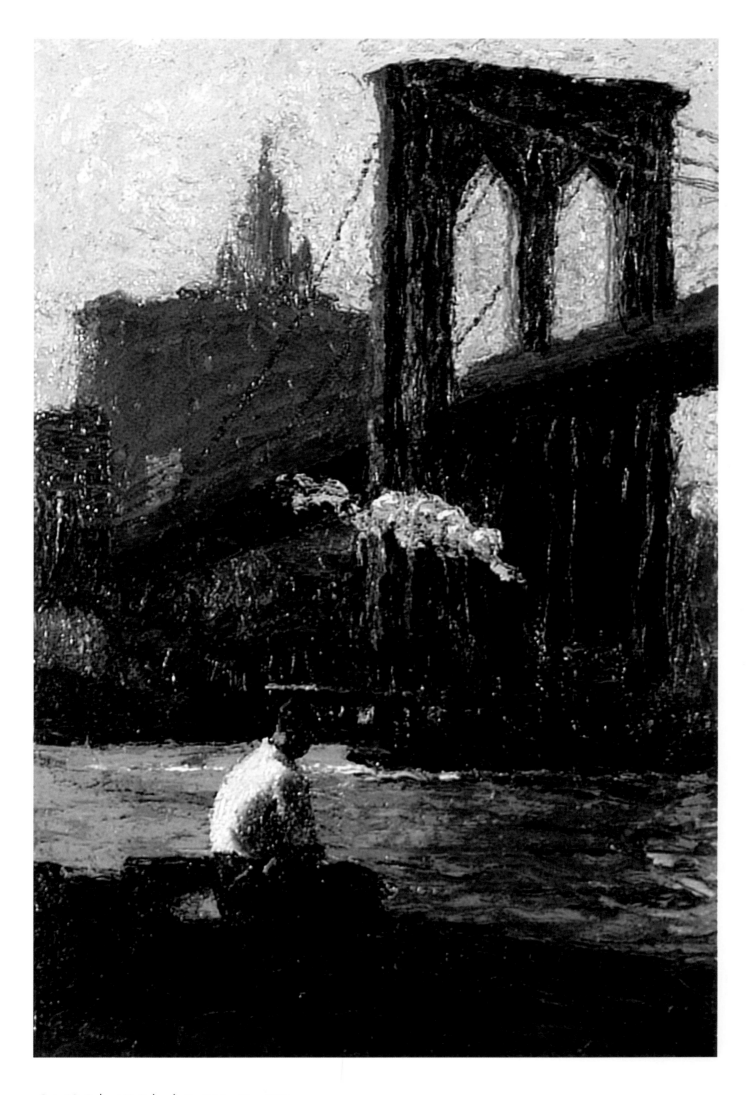

Cat. 62 Robert K. Ryland. *The Bridge Pier*, 1931

Bartholomew F. Bland

RISING FROM THE RIVER:
NEW YORK CITY AND THE *Sublime*

Industrial Sublime celebrates the American love of the new, the big, the tough, the gritty at the urban heart of New York.

A MAN SITS HUNCHED, staring out across the East River. He sees the massive form and sweeping arches of the Brooklyn Bridge. Below the bridge a boat belches smoke. Who is this man, so dwarfed by these surroundings, that we, like he does, sense both the magnificence and the oppressiveness of the modern urban landscape?

Robert K. Ryland painted *The Bridge Pier* in 1931 [Cat. 62], in the depths of the Great Depression, when the future direction of the country was uncertain. The painting is utterly of its moment but harkens back to elements favored by the Hudson River School painters of the mid-19th century. Ryland's composition gives us the grittiness of the Brooklyn waterfront and, too, a reverential point of view as the man sits low at the water's edge looking up toward the bridge's soaring gothic arches and the airy spires of the of the 40-story Manhattan Municipal Building beyond.

The contemplative elements of this urban river scene echo Thomas Cole's famous 1836 painting of the Connecticut River, in *View from Mount Holyoke, Northampton, Massachusetts, after a Thunderstorm-The Oxbow* (1836) [Fig. 2]. Both Cole and Ryland direct our attention towards the landscape. But in Cole's painting, the tiny figure facing the viewer is perched high above the river's edge and the picture brims with optimism as it offers us a "magisterial view" of all below, a view of the natural world glimmering, fresh, and unpolluted in the wake of the storm. The sublime drama of a passing storm gives way to the Arcadian ideal of perfection, signifying our nation's devlopment as a "Chosen Land".

In Ryland's painting we see the concrete results of the nation's labor, a metropolis rising from the landscape — grand but somehow sobering. The infinite possibilities of development have been hewed into reality over the course of a century, but at what cost?

Although separated by time and subject, the landscape painters of the 19th-century Hudson River School and the city-scene painters of the early 20th century are linked first, by their evolving understanding of the "sublime," which they transferred from an aesthetic celebrating the glories of nature to a celebration of the glories of an industry-bound New York City, and second, by the centrality of the Hudson River to New York's rising fortunes. The river was the common denominator for both 19th-and-20th-century artists who sought to understand what was sublime about New York. The painters of the Hudson River School, the first recognizably "American" school of art, were fascinated by natural beauty. Painters of the new urban landscape, though, were concerned with how man transformed the natural landscape into a stage for his industry.

The Hudson River, its tributaries, and New York Harbor into which they flowed, appear on the canvases of the early 20th century, sometimes as majestic and luminous, other times foggy or fetid. The rivers could be transcendently sublime sun-filled pathways leading to the Empire City or dreary portals to provide transportation — arteries to keep a city running. In many of the paintings in *Industrial Sublime*, the waters of the rivers that surround New York City advance or recede in prominence within the composition. In a few, the painter even hides the water from

our view, hinting at it merely by the arch of a bridge, man's bypass to water that was once a barrier.

What does "sublime" mean when we talk about the rivers of New York? The word has evolved in contemporary usage. Much as the way "awesome" now refers to a well-cooked hamburger or an amusing "tweet", the actual reverence for the sublime has suffered at the hands of the popular culture. In contrast to this enthusiastic, if indiscriminate, usage, the *Encyclopedia Britannica* first showed an entry for the word "sublime" in its seminal Eleventh Edition, published in 1910-1911. Compiled just before World War I, these volumes reflect a complete, though now lost, Edwardian world view imbued with a touching belief in human advancement. The *Britannica* was perhaps the last great work in the grand tradition of the Enlightenment, which espoused the reassuring idea of a single, dominant point of view before the comfort of this kind of unity was shattered by the carnage of World War I:

Sublime —

In aesthetics, a term applied to the quality of transcendent greatness, whether physical, moral, intellectual or artistic. It is specially used for a greatness with which nothing else can be compared and which is beyond all possibility of calculation or measurement. Psychologically the effect of the perception of the sublime is a feeling of awe or helplessness..." [1]

For the artists of New York, the beauty of the city met that definition of transcendent greatness.

Industrial Sublime celebrates the American love of the new, the big, the tough, the gritty at the urban heart of New York during the first forty years of the 20th century. At this time of change and growth, the city's majestic skyline rose to prominence and the burgeoning waterfront evoked fascination as well as admiration for what man had wrought.

Fig. 2 Thomas Cole (1801-1848)
View from Mount Holyoke, Northampton,
Massachusetts, after a Thunderstorm
— The Oxbow, 1836
Oil on canvas, 51 ¹²/₂ x 76 inches
Collection of The Metropolitan Museum of Art
Gift of Mrs. Russell Sage, 1908 (08.228)

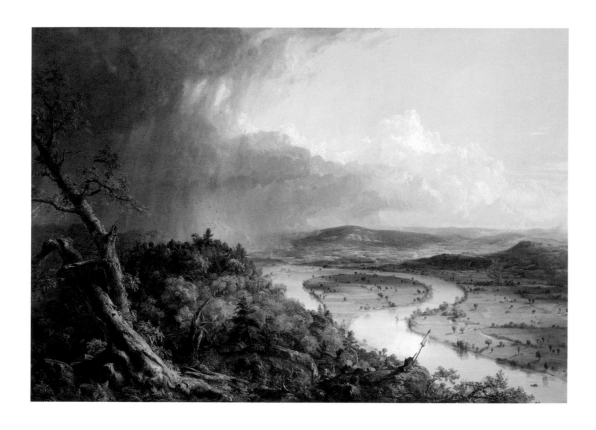

New York City, an island at the crossroads of a river and an ocean, pushed at its boundaries but its industrial development could not have happened without its waterways. The rivers, the East River, the Harlem River, and the Hudson, provided access and created a density of people on Manhattan, leading to great demand for the limited land the island offered. The skyscraper could, and did, increase space, not on land but in the air for New Yorkers and their urban pursuits. New York, at this time, was the most dramatic example of a nation of multiplying new cities as well as of established cities that were becoming bigger and bigger. In 1920 the United States census revealed that, for the first time, more people in the United States lived in cities, not the country. The modern city rising with shocking rapidity provoked awe and angst in artists searching for a specifically American voice among the cacophony of change. The novelist Sherwood Anderson voiced the fear that industrialization was homogenizing the people who lived in these changing municipalities: "The machine has caused the herding of men into towns and cities…Minds began to be standardized as were the clothes men wore."[2]

The political philosopher Edmund Burke in his 1756 treatise *A Philosophical Enquiry into the Origin of Our Ideas of the Sublime and Beautiful* strictly distinguished between the beautiful, which drew the viewer emotionally close to an object, and the sublime, which produced awe in the viewer. Burke also recognized that the terror of the sublime had to be translated through a creative medium — poetry, painting, or drama. By Burke's definition, the destruction wrought by a volcano seen in a painting might elicit a shiver of the sublime, but being physically next to spewing lava does not.[3] The popularity of disaster movies showing destruction in New York from the airplane circling the Empire State Building in *King Kong* (1933) to the snowbound New York Public Library in *The Day After Tomorrow* (2004) represents for us the awe or fear-stricken sublime experience. The emotions conjured by being consciously aware of physical safety while emotionally overwhelmed by danger may trigger a sublime

reaction, though few today might choose to describe their spine tingling reactions as sublime. It is now the prospect of rising seas and sinking cities anticipated in the not-too-distant future that provides us the shiver of dread that in the past we associated with the sublime. What distinguishes the developing "environmental sublime" from our earlier awe of the natural world is a changing perception of God's responsibility for our fate. While 19th-century mankind felt at the mercy of an all-powerful deity, in the 20th we see in the smoke and soot of industry the seeds of our own eventual destruction. We are fearful of an environment irretrievably altered by industry, just as industry inspires us to awe.

The word "sublime" appears in American books until around 1800, but it was used less and less during the 19th century when Thomas Cole and Frederic Church were embracing the idea of the sublime in the visual arts. By the first decade of the 20th century, the idea of the sublime had splintered into an array of categories, developing out of the technical and engineering marvels of the American world. Among the types of "sublimes" filling the citizenry with wonder, one scholar identified the Dynamic Sublime (railroads), the Geometric Sublime (bridges), and the Electric Sublime (nighttime illumination),[4] and each of these can be seen in *Industrial Sublime*. The experience of the sublime continued to be important to Americans during the early 20th century despite the fact that the traditional concept of a mesmerizing natural sublimity was increasingly at odds with the modern machine-oriented experience. In the 18th century Burke described the feverish confusion incurred by a vivid sublime experience, which aptly described the feelings of the first to experience motion pictures and airplanes, or inhabit 20th-century skyscrapers:

. . . the mind is hurried out of itself by a crowd of great and confused images, which affect because they are crowded and confused; separate them, and you lose much of the greatness; and join them, and you infallibly lose the clearness.[5]

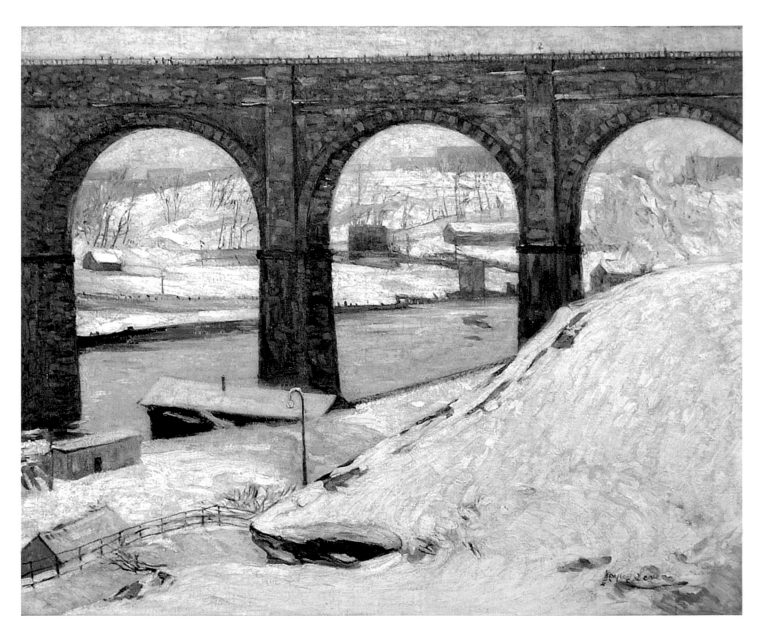

Cat. 37 Richard Hayley Lever. *High Bridge over the Harlem River,* 1913

From ancient ballads to today's smartphone screens, the idea of beauty in Western culture is seen as essentially feminine, while the sublime in its grandiosity and terribleness was overtly masculine — a symbol of patriarchy that corresponded nicely to the rise of the industrial sublime in early 20th-century American art with its muscular modernism, which could barely contain the grinding waterfront labor and thrusting, overtly phallic industrial structures in works like Martin Lewis' *Railroad Yards, Winter, Weehawken* (c. 1917) [Cat. 40]. Throughout the 19th century, the understanding of beauty and the sublime gradually converged until, by the early 20th century, American painters linked beauty to the sublime. The evolving definition of the sublime is key: the rise of the great

American cities, such as New York, produced an awe-struck feeling in many of the artists whose work is in *Industrial Sublime*. Artists translated their feelings into paintings suffused with the haunting beauty of giant buildings, girders, gears, bridges, and smokestacks glazed with smoke-filled light, just as they continually fretted over what made their work both modern and unique.

On a visit to the 1907 Winter Exhibition at the National Academy of Design, a critic for the *New York Independent* asked, "Does American art represent the ideals of the American people? Is it national? Is it modern? Is it living? Has it any connection to what we are all doing and thinking and hoping? Does it have any lesson, inspiration or influence?" These same questions puzzled

artists and viewers in the first half of the 19th century. Although the Hudson River School was belatedly recognized as the nation's first nationally significant art movement, it was the growing pains of the urban experience that now was seen as expressly American. Representing that urbanity, New York became a stand-in for the triumphal economic and cultural might of the nation. New York, tumultuously growing, filled with wildly ambitious plans, its coursing rivers swiftly moving raw goods, its harbors and neighborhoods opening wide to the people pouring in, filled the new industrial society with excitement. This display of "American-ness" made New York look so physically different from the great European capitals — the vertical thrust of the skyscraper was resisted in London, Paris, and Berlin until after World War II. A critic for *The Sun* gave stout rejoinder to the questions raised by the *New York Independent*, saying of the new painters of the New York scene, "They have a lot to put on canvas, new sights that only America can show….They make mistakes, they experiment; all art is a ceaseless experimenting. They are often raw, crude, harsh. But they deal in actualities. They paint their present environment — the only real historical school."[6]

Richard Hayley Lever's *High Bridge over the Harlem River* (1913) [Cat. 37], is not raw, crude, or harsh but depicts a massive structure in a style that could be called a quietly "beautiful sublime". Lever's *High Bridge* was painted in the same year as the famed *International Exhibition of Modern Art*, the Armory show, which was organized by the Association of American Painters at New York's 69th Regiment Armory on Lexington Avenue. Despite being surrounded by developing modernism, Lever chooses *High Bridge* as the iconic New York view and not the more recent towering structures. It is the most magnificent river architecture before the 1883 opening of the Brooklyn Bridge. Designers of technologically sophisticated constructions like the High Bridge, completed in 1848, were influenced by ideas of the Romantic Movement, attempting to demonstrate that urban growth did not need to mean the spoiling of a landscape. To them, a large man-made structure could fit comfortably into an Arcadian idyll. High Bridge was part of

the massive Croton Aqueduct project designed to bring fresh water to Manhattan, and at the time of the bridge's construction there was considerable debate over building a lower, less grandly scaled version, a bridge with smaller arches. Eventually the higher, grander, and more expensive final design was chosen to allow more shipping traffic on the Harlem River. This economic foresight also prompted the designer to sigh with relief and comment, "I cannot say…that I regret this as you know Engineers are prone to gratify a taste for the magnificent when there is a good reason for the execution of prominent works."[7]

In both form and function, *High Bridge* recalls the rounded arches of Roman aqueducts, not the graceful, pointed gothic arches seen in Ernest Lawson's *Brooklyn Bridge* (c. 1917-20) [Cat. 34]. This difference in styles reflects the 19th-century idea of picking the right style for the right purpose. Soaring bridges became the new cathedrals of the city, dominating their surroundings, while the Romanesque style, grounded and muscular, was considered the proper style for civic structures. The arches of both bridges were made from stone, and that building material and its historical references convey a sense of timelessness, such as the paintings by a long line of European artists who painted ruins of antiquity. Lever dramatizes the contrast of the modest structures surrounding the magnificent edifice of High Bridge. The snowy stillness of the scene, the silence, and the lack of visible human presence in the sparse, small buildings scattered on the landscape, convey both the sublimity of the bridge and the way the Central Bronx remained a remote, semi-rural fringe of the urban metropolis in 1913.

In his *Tugboat with Lighter* (1908) [Cat. 27], William Glackens uses the same wintry palette as Lever to convey a quiet, watery sublime but there is no grand edifice dominating the canvas to show monumentality. Instead, Glackens relies on atmospheric effects — a steel-blue sky, soft and thick with haze, which echoes the sky and clouds of Hudson River School paintings. The tugboat in the foreground, far from being majestic, appears as the "little tugboat that could," its rising wisps of smoke,

though, more a tea-kettle puff. Glackens depicts the most recognizable sublime element in the painting, the monumental Statue of Liberty as lilliputian in the distance, her torch unlit and too far away to beckon. The dockhands are in the same small scale as the statue. In a nod to his friend and fellow Ashcan painter, John Sloan, Glackens painted "Sloan" on the paddleboat moored at the left side of the composition. The previous year Sloan had completed his own evocative view of New York Harbor, *Wake of the Ferry, No. 1* (Detroit Institute of Art).

This idea of atmospheric softness inducing the kind of poetic sublime we see in *Tugboat with Lighter* is present in many other works in *Industrial Sublime*. Jonas Lie's *Afterglow* (c. 1913) [Cat. 41], another painting of New York's harbor, is a grander example of the "poetic sublime." Lie specialized in marine paintings and here he shows the growing magnificent sublime of the Downtown Manhattan skyline, rather than Glackens' more modestly picturesque view facing out towards the harbor. *Afterglow* is a stunning example of the "beautiful sublime."

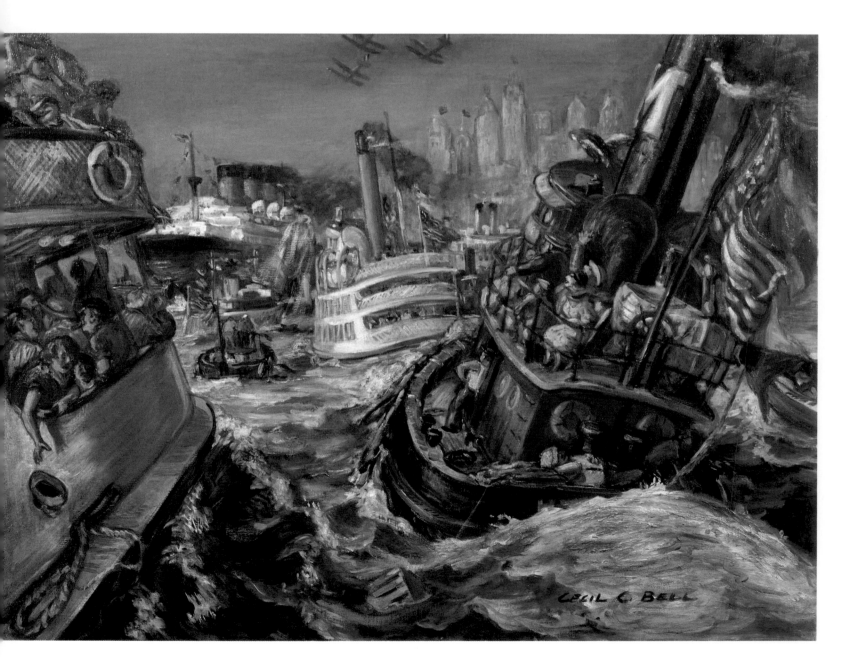

Cat. 6 Cecil Crosley Bell. *Welcoming the Queen Mary*, c.1937

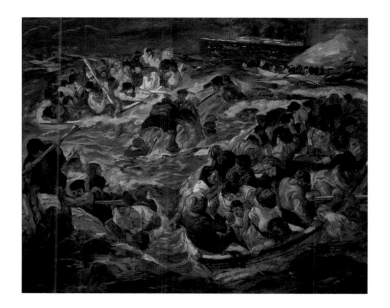

A *New York Times* critic of the period described *Afterglow* as a "primitive scheme of blue and yellow, its clear-cut patterning, its admirable accenting of windows throwing back the brilliant light, its veil of diffused steam caressing the fronts of the golden buildings, and softening their color."[8]

For New York, the early years of the 20th century seem to be a nonstop series of public spectacles and celebrations, each designed to inspire gasps, speechlessness, and the overwhelmed feeling associated with the sublime, while simultaneously trumpeting the progress of the modern world. More than any other time in American history, the years between the turn of the century and World War II embraced the advance of industrial and technological innovation. While the onset of the Great Depression tamped down the Flapper era's rosy view of progress, America was willing to embrace the new industries and the technologies that powered them — modern advances in keeping with the idea of the United States as a "young" nation, open to new ideas and new ways of living.

New York's harbor during the 40s was the scene of raucous jubilations as the great ocean liners, beloved by the public, arrived on their maiden voyages from Europe. Each new boat seemed larger and faster than the last. Cecil Bell's *Welcoming the Queen Mary* (1937) [Cat. 6], and an earlier painting by German artist Max Beckmann *The Sinking of the Titanic* (1912-13) [Fig. 3], contrast the sublimity of these great ships, one a scene of celebration, the other fated never to arrive in New York in triumph.

Bell and Beckmann each depicted one of the most famous ocean liners of his day. British ships, their construction was breathlessly covered by the press on both sides of the Atlantic. Each ship was the largest in the world at the time it launched and each artist embraced the idea of the Technological Sublime on the sea and the way inaugural voyages engaged a broad segment of the public. Beckmann's work had precedents in paintings such as the marine tragedy depicted in French painter Théodore Géricault's famed *The Raft of the Medusa* (1818-19), while Bell's follows a more triumphal pattern. Beckmann, who never saw the *Titanic,* read detailed accounts of the disaster. Living in Germany, he was perhaps far enough removed from the emotional consequences of the event to want to paint it.

The Sinking of the Titanic is a huge memorial painting of that horrific event, which shocked the world. The tragedy of the world's largest "unsinkable" ship, which struck an iceberg on its maiden voyage while racing to break speed records, seems, in retrospect, a harbinger of the end of the Progressive era. Like Icarus flying too close to the sun, the disaster came to be seen as a symbol for the hubris of man in his race for technological domination, and challenged unquestioning belief in the perfectibility of technology in the face of Nature. Beckmann focuses not on the sublime grandeur of the sinking ship but on the victims in its lifeboats, roiled by the ocean's waves and grimly determined to survive. He relegates the stricken ship to a small corner in the dark distance.

Beckmann aside, it is striking to note that the *Titanic* disaster generated little in the way of significant art among American or British painters. The Ashcan painters, certainly no strangers to scenes of urban disarray, did not engage with this tragic subject in their paintings nor with a number of other urban disasters

closer to home, such as the 1902 Park Avenue train tunnel collision. Their reluctance points to artists' inability to translate raw and current shocking events into something aesthetic that can be appreciated by the human psyche as sublime. In just the same way, contemporary art has largely failed to successfully grapple with the magnitude and terror of New York's ultimate industrial sublime event — the destruction of the World Trade Center Towers.

Cecil Bell, who studied with Ashcan artist John Sloan and adopted Sloan's style, shows a later rollicking celebration in *Welcoming the Queen Mary*, one of rolling ferries, barges and tugboats filled with people making merry. Bell, like Beckmann, pushes the ocean liner of the painting's title to the back of the canvas: the surrounding celebratory hoopla of New Yorkers in the harbor, cheering this latest technological triumph, is the painting's true subject. The churning movement in *Welcoming the Queen Mary* can also be seen in the convulsing waves of the Hudson in Ernest Lawson's *Hoboken Waterfront* (c. 1930) [Cat. 35]. In this late canvas, Lawson's style is influenced by the raucous urban scenes of artists such as Reginald Marsh. Lawson uses a bold palette, a vigorous brushstroke, flattened perspective, and an almost cartoonish sense of form.

This was a move away from his calmer, more impressionistic scenes of glistening, reflected light in earlier works like *Railroad Track* (c.1905) [Cat. 36], which showed the railroad tracks on Spuyten Duyvil Creek, filled later between 1914 and 1923 as part of Bronx development along the Harlem River.

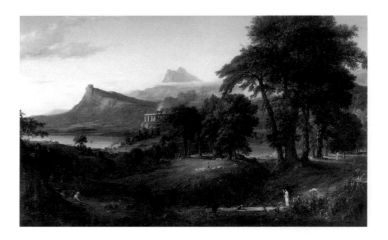

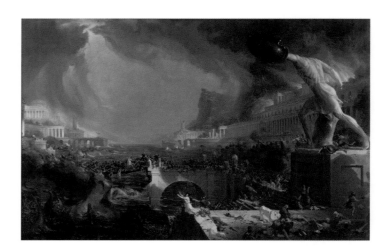

Fig. 4 Thomas Cole (1801-1848)
Expulsion from the Garden of Eden, 1827-1828
Oil on canvas, 39 ¾ x 54 ½ inches
Collection of the Museum of Fine Arts, Boston

Fig. 5
The Course of Empire: The Arcadian or Pastoral State, 1834
Oil on canvas, 39 ¼ x 63 ¼ inches
Collection of The New-York Historical Society
Gift of The New-York Gallery of the Fine Arts, 1858.2

Fig. 6
The Course of Empire: Destruction, 1836
Oil on canvas, 39 ¼ x 63 ½ inches
Collection of The New-York Historical Society
Gift of The New-York Gallery of the Fine Arts, 1858.4

Fig. 7
Samuel Coleman (1982-1920)
Storm King on the Hudson, 1866
Oil on canvas, 32 ⅛ x 59 ⅞ inches
Collection of the Smithsonian American
Art Museum, Gift of John Gellatly

In his early landscapes, Thomas Cole, "Father" of the Hudson River School, gravitated to a softly Arcadian ideal filled with romantic ruins. This vision contrasts with his later work in which he lavishes attention on sublime events such as the *Expulsion from the Garden of Eden* (1827-1828) [Fig. 4]. Cole felt more at ease with biblical or allegorical catastrophy at a safe remove, such as the destruction in *The Course of Empire* (1834-36), whereas the latest steamboat disaster was relegated to the popular press. The sharp contrast between the Arcadian and the sublime is clearly seen in two of the canvases of Cole's five-panel work. *The Course of Empire: The Arcadian or Pastoral State* (1834) [Fig. 5] is the definition of beauty, gentleness, and balance. *The Course of Empire: Destruction* (1836) [Fig. 6], with its turbulent waters, stormy skies, raging fires, pillage, and disaster is the definition of a sublime event as defined by Burke.

The differences in New York's waterfront shown by artists of the Hudson River School in the mid-19th century versus those of 20th-century painters of the urban and industrial seem sudden, shocking visual transformations, because the earlier artists threw a discreet fig leaf over development and industry. Ingrained, there was artistic resistance to highlighting the encroaching industrial development along the Hudson's shores because industry threatened the picturesque landscape. Artists who were notable exceptions to this resistance were Samuel Colman, whose post-Civil War works like *Storm King on the Hudson* (1866) [Fig. 7], anticipates the nation's growing industrial power and the centrality of the river and waterfront to this development. Both these images, painted from a low vantage, employ the stylistic conventions of Hudson River School paintings of beautiful light and magnificent scenery. They are, though, filled with a new element, billowing black smoke that portends man's growing influence over a landscape that he considers his own, not the preserve of an omnipotent deity.

Another atypical early work is Robert Weir's *The Hudson River from Hoboken* (1878) [Fig. 8], painted after he retired as Professor of Drawing at the United States Military Academy at West Point. He shows a large coal shovel loading barges that in silhouette appears a threatening guillotine.[9] The traditional sailing ships on the Hudson contrast with the rising large-scale industrial apparatus along its banks, while the crane backlit by the rising sun in the east creates a disturbingly Gothic *grand guignol*. The composition and coloration bear a strong resemblance to 18th-century British painter Joseph Wright of Derby's series of sublime paintings that show an erupting volcano, such as *Vesuvius from Posillipo* (c.1788) [Fig. 9]. One of Weir's sons, John Ferguson Weir, had created some of 19th-century American art's most vivid factory renderings in a series of works that show the interior of the West Point foundry, just a few years before his father painted *The Hudson River from Hoboken*. In works like *Forging the Shaft* (1874-77) [Fig. 10], the son created a blazing vision of cannon manufacture as an industrial Hades. Another of Robert Weir's sons, J. Alden Weir, used dramatic

Fig. 12 Claude Monet (1840-1926)
Arrival of the Normandy Train, Gare Saint-Lazare, 1877
Oil on canvas, 23 ½ x 31 ½ inches
Collection of the Art Institute of Chicago
1933.1158

Cat. 45 George Luks
Roundhouses at Highbridge, c.1909-1910

Cat. 63 Charles Rosen
The Roundhouse, Kingston, New York, 1927

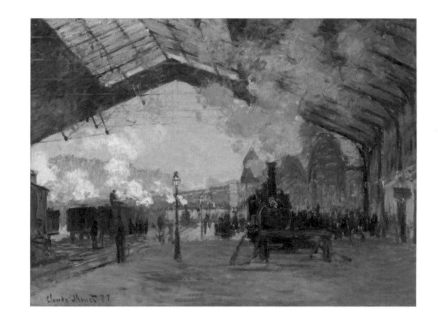

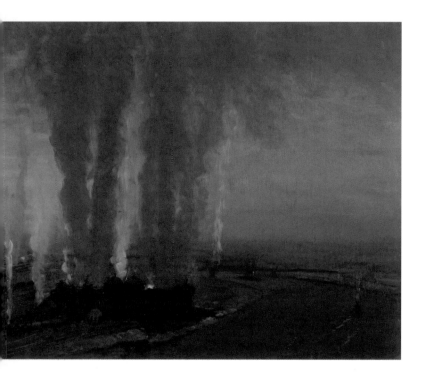

graphic, winter snow to quieting effect, composing a scene imbued with reverie. Unlike Lever, Henri makes the river itself, rather than a monumental bridge, his picture's overt subject. No massive Brooklyn Bridge in sight here. Instead, further north along the river where Manhattan's edge rises higher above the water a steep stair down to the river appears, spindly and jerry-built, a structure in danger of collapsing and hurling the figure determinedly climbing its treads down into the brown waters. Henri's steam and sailboats seem insignificant and workaday compared to the grand ships of the harbor painted by George Bellows in *Men of the Docks* (1912) [Fig. 11], which perfectly balances the mundane

activities of the dockhands with the sublimity of the ocean liner's huge hull towering over them. Henri shrouds the modest boats sailing through thick atmosphere and makes little visual distinction between river and air. In *Tugboat with Lighter*, Glackens creates the same moody effect.

Although artists had a long tradition of incorporating ships in the Hudson and in New York Harbor, their new fascination with the railroad as a symbol of the Technological Sublime along New York's rivers created another thematic link between the Hudson River School and the painters of the Industrial Sublime. A huge range of artists both in Europe and the United States recognized

trains as uniquely fitting subject matter for portraying aspects of the Technological Sublime that were recognized early by French Impressionists, who started documenting the urban growth of Paris in the 19th century. Claude Monet memorably portrayed the sublime magnificence of Paris' train station in *Arrival of the Normandy Train, Gare Saint-Lazare* (1877) [Fig. 12], a scene so lushly smoke-filled, it would have made a suitable setting for the demise of Tolstoy's doomed heroine Anna Karenina. The propulsive speed of trains added dynamism to paintings, just as they visually signified the shrinking of distance, making the world a smaller place to be mastered by man.

Among the most famous depictions of railroads in 19th-century American painting was George Inness' *The Lackawanna Valley* (c. 1856) [Fig. 13]. Commissioned by the Delaware, Lackawanna and Western Railroad, which showed the first roundhouse in Scranton, Pennsylvania, Inness infused his scene with even, golden light, a stylistic shorthand signifying benevolent progress and the approval of the heavens. For the mid-19th century, the composition was remarkable for balancing the beauty of nature with the glories of the Technological Sublime. More than fifty years later Ashcan painter George Luks in *Roundhouses at Highbridge* (c. 1909-1910) [Cat. 45], completely subsumed his trains into Walt Whitman's "long pennants of smoke" that are the definition of sublime. [12] Charles Rosen, in *The Roundhouse, Kingston* (1927) [Cat. 63], gave the roundhouses a very different form, abstracting them into graphic, linear shapes. Although the styles are radically different, all three artists use the roundhouses to conjure feelings of the sublime. In a statement for a magazine article, Luks,

himself, grappled with what the sublime should be, feeling that it might appear in different guises. Though considered eternal, he was skeptical of the place of the sublime in the modern world:

The Sublime works of Art of the ancients are so today and will be so....The sense of the beautiful is universal and so it should be....Simple beauty is sidetracked to make room for Extravagance and Rant, the boon companions of that fickle team wealth and opulence. [13]

Artists used railroad tracks as visual pathways into paintings, serving as the modern equivalent of the cow paths used for centuries in traditional landscape paintings. The rails in Lawson's *Railraod Track* (c. 1905) [Cat. 36], enable viewers to mentally place themselves along the upper reaches of the Harlem River, turning south. In Leon Kroll's *Terminal Yards* (1913) [Cat. 33], the sinuous, interlocking patterns of the tracks creates graphic patterns that give visual interest to a composition. In Arnold Hoffman's *Untitled (Weehawken)*

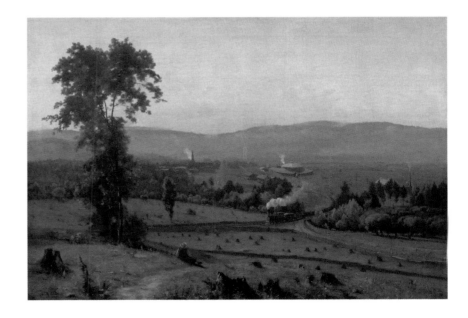

Fig. 13 George Inness (1825-1894)
The Lackawanna Valley, c. 1856
Oil on canvas, 33 ⅞ x 50 ¼ inches
Collection of the National Gallery of Art, 1945.4.1

RISING FROM THE RIVER

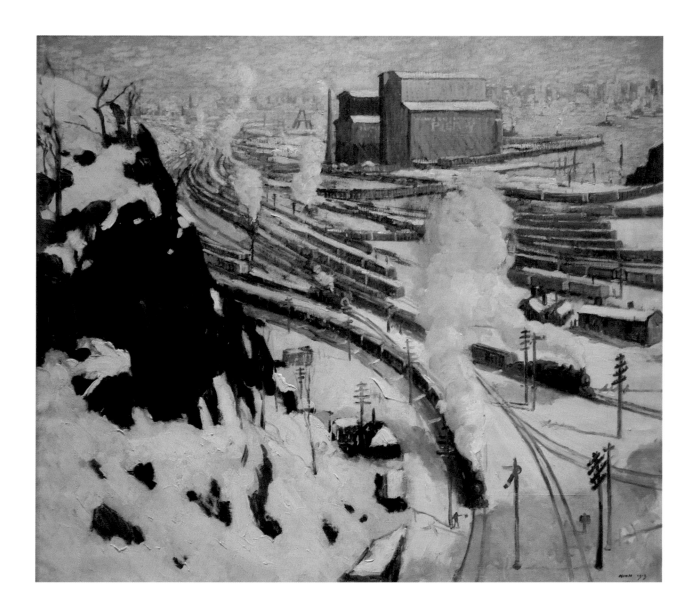

Cat. 33 Leon Kroll. *Terminal Yards*, 1913

(c. 1925) [Cat. 30], the billowing smoke from the engines became a soft, ethereal atmosphere creating contrast with the linearity of the tracks. Architects such as Warren and Wetmore created the grandest railroad stations, the "people's palaces" of the day, which were consciously made to invoke the sublime. Diagrams for Warren and Wetmore's design of Grand Central Terminal, completed in 1913, show how the architects designed the main concourse of the station to be flooded with light that appeared to flow directly from the heavens.

In *The Age of Innocence* (1920), the elder protagonist, Newland Archer, ruminates, not on the new Grand Central Terminal, but on the incredible creativity and determination of the engineers who built the underground railroad tunnels under the Hudson River in the first decade of the 20th century, the first ever non-ferry link between New Jersey and New York:

"they were of the brotherhood of visionaries who likewise predicted the building of ships that would cross the Atlantic in five days, the invention of a flying machine, lighting by electricity, telephonic communication without wires, and other Arabian Night marvels."[14] Because of Edith Wharton's place in time and her reputation, *The Age of Innocence* is thought the quintessential example of the Gilded Age literature of the 1890s. She wrote it, however, thirty years later in the post-World War I era and for an audience that lived through disorienting change in their cities, the same as that witnessed and endured by the characters in her novel.

Daniel Putnam Brinley shows how a softer, impressionistic style was used to depict sites of rail traffic and modern industry in his *Hudson River View (Sugar Factory at Yonkers)* (c.1915) [Cat. 9]. Although Brinley's

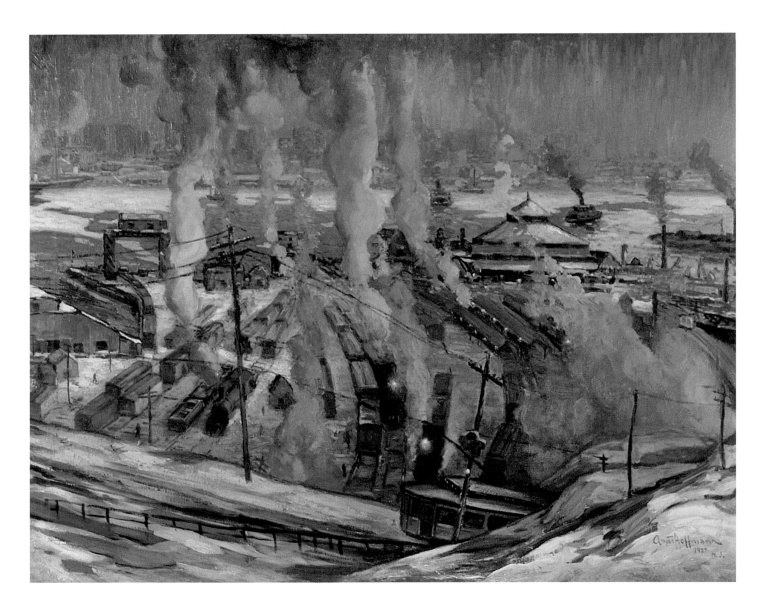

Cat. 30 Arnold Hoffman. *Untitled (Weehawken)*, c.1925

work was fairly traditional, the 1913 Armory show had made a great impact on him, and he began experimenting with a bolder color palette and geometry here. He focuses on the mechanical equipment used to load the boxcars, squeezed between the river and the railroad track, highlighting the triangular shapes of the mechanical arms, creating apexes, repeating and adding geometric interest to the busy composition. In fact the composition is chaotic, the very busyness evoking the hustle of the modern factory. This Hudson River view is not serene — the smoke eddying from the train's smokestack, the steaming boats on the river, and the factory itself, all add energy to the scene. The natural beauty of the Palisades here recedes, it is no longer and cannot be the focal point of the composition.

If the railroads hugged New York's rivers, burrowed under them, and took from the water more and more of a share in moving goods and people, the city's bridges represented the ultimate architectural statement and epitome of technology triumphing over the barriers that the rivers represented. Since its opening in 1883, the Brooklyn Bridge has inspired more painters, photographers, and writers than any other bridge in the world. Before it had even opened, the Brooklyn Bridge captivated artists and its graceful gothic arches continued to exert a formidable influence on artists from Jonas Lie in *Path of Gold* (c. 1914) [Cat. 42], and Kurt Albrecht in *Untitled (Brooklyn Bridge)* (c.1920) [Cat. 1], who painted urban scenes in traditional styles influenced by the Hudson River School, to Joseph Stella and Georgia O'Keeffe through the 1940s, who capitalized on the possibilities of modernist abstraction.

The Queensborough Bridge opened in 1909, the same year as New York's Hudson-

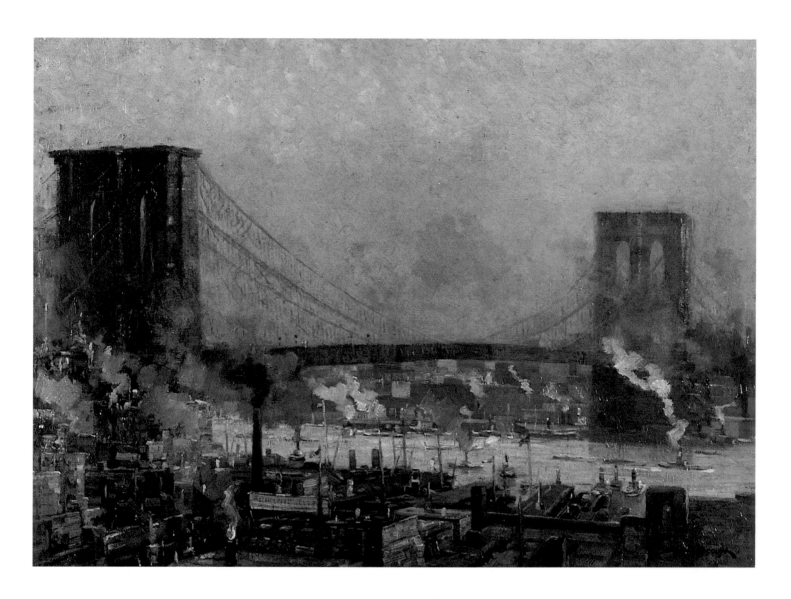

Cat. 1 Kurt Albrecht. *Untitled (Brooklyn Bridge)*, c.1920

Fulton Celebration, which commemorated the three-hundred year anniversary of Henry Hudson's arrival in New York's harbor. The bridge connected Midtown Manhattan to the borough of Queens and signaled a shift in the development of the city northward. The new bridge proved immediately popular with artists. A cantilever rather than a suspension bridge, the Queensborough was not an iconic beauty on the level of the Brooklyn Bridge, but artists such as Leon Kroll in *Queensborough Bridge* (1912) [Cat. 32], and Glenn Coleman in *Queensboro Bridge, East River* (c. 1910) [Cat. 17], were nonetheless drawn to the monumentality of its long double cantilevered span, and created highly atmospheric and monumental canvases of New York's latest landmark. The later bridges of New York did not seem to fill painters with the same wonder and romantic impulse as did the earlier East River bridges, when their technology was new and fantastical. Artists

such as George Ault painted the modernist George Washington Bridge, which opened in 1931. Paintings of grand landmarks of the New York landscape drew on the sublime impulse with a lushly romantic connection to the Hudson River School that largely drew to a close in the 1920s.

While modern industry did compel new kinds of sublime experiences, those moments have gradually become more difficult to grapple with in a post-modern, post-industrial world. In contemporary art, the sublime and its inextricable link with beauty is viewed suspiciously. Investigation of the process is frequently valued over the finished artistic product and we have become less interested in the summit of aesthetic perfection than in the arduous foothills struggling towards achievement. Likewise, it is difficult in the post-Robert Moses world to think about a time in New York when relentless development still

seemed positive and "progressive." Although the pulse of the physical development of New York City has quickened in response to widespread re-zoning during the Bloomberg administration, people continue to concern themselves with human scale, with doorways, with welcoming intimate public spaces, and to resist growth, seeing it as intrusive, dangerous, and destabilizing. Although the physical materiality of New York City and its rivers is less at the forefront of contemporary concern for today's artists, for society at large the evolving waterfront moving from industrial to a post-industrial life stands for renewal and a point of tremendous civic engagement. Hart Crane's *The Bridge*, published in 1930, is a poetic vision of sublime ecstasy met on the city's waterfront that continues to call to us today:

A tugboat, wheezing wreaths of steam,

Lunged past, with one galvanic blare

stove up the River.

I counted the echoes assembling,

one after one,

Searching, thumbing the midnight

on the piers.

The blackness somewhere gouged glass

on a sky.

And this thy harbor, O my City, I have

driven under,

Tossed from the coil of ticking towers...

Tomorrow,

And to be... Here by the River that is East[15]

1 *The Encyclopedia Britannica: A Dictionary of Arts, Sciences, Literature and General Information*, 11th ed , s.v. "sublime."

2 Sherwood Anderson. Quoted in *The Double-Edged Sword: The Technological Sublime in American Novels Between 1900 and 1940* by Zoltán Simon (Texas Christian University, Ph.D. Dissertation, 2001), 7.

3 Allan Wallach, "Thomas Cole: Landscape and the Course of American Empire" in *Thomas Cole: Landscape into History* ed. by William H. Truettner and Alan Wallach (New Haven: Yale University Press, 1994), 29.

4 David E. Nye, *American Technological Sublime* (Cambridge, MA: MIT Press, 1994).

5 Edmund Burke. Quoted in *The Essentials of Aesthetics in Music, Poetry, Painting, Sculpture and Architecture*, by George Lansing Raymond (New York: G.P. Putnam,1911)181.

6 Edward J. Wheeler, ed. *Current Literature* 44, no. 2 (April 1908):393.

7 John B. Jervis. Quoted in "Celebrating the Aqueduct: Pastoral and Urban Ideals" in *The Old Croton Aqueduct: Rural Resources Meet Urban Needs* by Laura Vookles Hardin (Yonkers, NY: The Hudson River Museum, 1992), 53.

8 David B. Dearinger, ed. "Some Old Friends Shown at Vanderbilt Gallery," qtd. in *Rave Reviews: American Art and Its Critics, 1826-1925.* (New York: National Academy of Design, 2000), 259.

9 Kenneth W. Maddox. *In Search of the Picturesque: Nineteenth Century Images of Industry Along the Hudson River Valley* (New York: Edith C. Blum Art Institute, Bard College,1983), 86.

10 Eleanor Jones Harvey, *The Civil War and American Art* (Washington, DC: Smithsonian American Art Museum, 2012).

11 Robert W. Snyder and Rebecca Zurier, 'Picturing the City" in *Metropolitan Lives: The Ashcan Artists and Their New York* (New York: National Museum of American Art, 1995),100.

12 Walt Whitman, "Song of the Exposition." (New York:1871), *Line* 204.

13 Luks, George. Quoted in "What is Art?" by J. Alden Weir, Robert Henri, Jerome Myers, Edwin H. Blashfield, E.W. Redfield and George Luks. *Arts and Decoration.* (April 1917):325.

14 Edith Wharton, *The Age of Innocence* (New York: D. Appleton and Company, 1920),323.

15 Hart Crane, *The Collected Poems of Hart Crane*, ed. by Waldo Frank (New York: Liveright Inc. Publishers, 1933), 53-54.

INDUSTRY ACCESSIBLE

Cat. 22 Aaron Douglas. *Power Plant in Harlem*, 1934, detail.

Cat. 42 Jonas Lie. *Path of Gold*, c. 1914

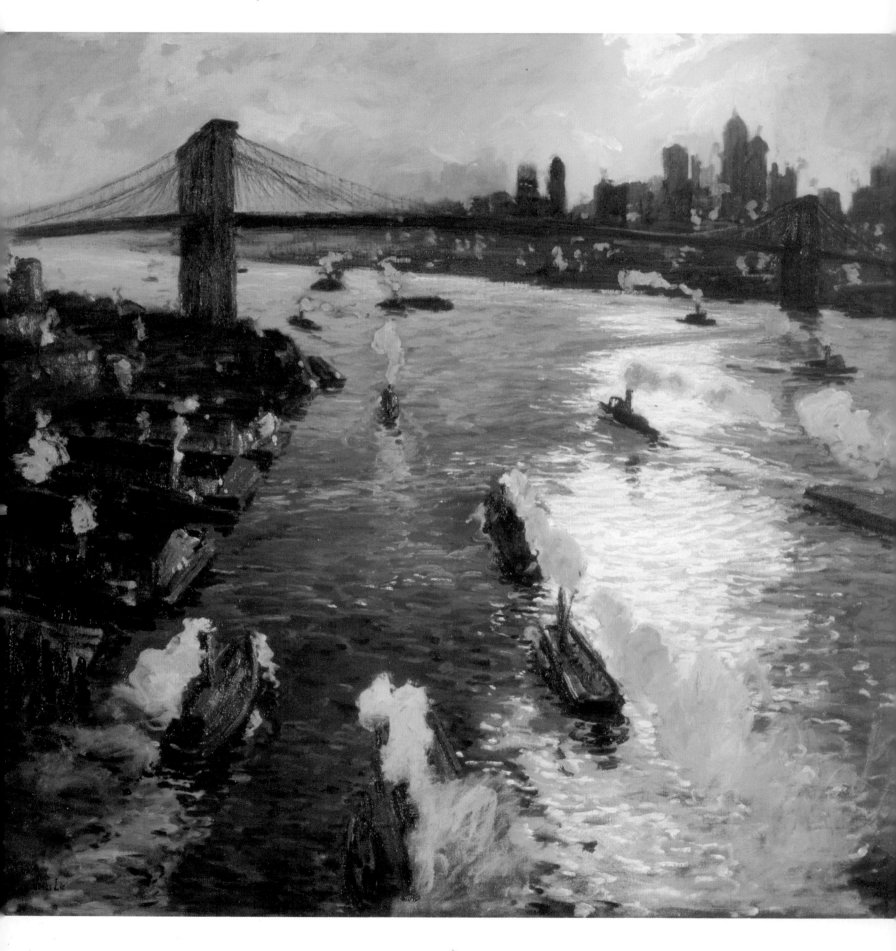

Wendy Greenhouse

ON THE FRINGE: *Picturing* NEW YORK'S WATERWAYS, BRIDGES, AND DOCKLANDS, 1890-1913

New York's industrial shoreline offered an alternative approach to characterizing the city in art and making its most alien aspects accessible.

THE CONVENTIONAL TELLING of New York's artistic interpretation in the early decades of the 20th century has often focused, not unnaturally, on the imaging of streets, buildings, and generic city dwellers.[1] According to that narrative, impressionist painters moved cautiously from genteel park settings to genteel streets, often clothing the messiness of the city in forgiving dusk, rain, or snowfall. By organizing the urban scene as a landscape subject, they held at arm's length its less palatable aspects, from the crushing mass of its buildings to its social chaos. The urban realists, in contrast, turned a spotlight on the vivid life of the city's working-class and immigrant inhabitants, complementing their audacious subject with a formal approach that flaunted its roots in such low-art fields as popular illustration, genre painting, and moving pictures. While images of Manhattan's dense interior largely uphold this familiar dialectic of relative artistic progressivism, it falters on the island's geographical fringe, where rebels and conformists alike found compelling themes and often shared subjects. The resulting images have rarely been considered as a discrete genre within the larger field of city imagery. In surveying a selection of them, this essay is concerned not so much with the distinctions between artistic "camps" as with their larger shared project of how to paint the modern city, and how to define the city as well.[2]

The first generation to paint modern New York was uncomfortable with the crushing scale of its new architecture. Everett Shinn, perhaps the most daring realist of the so-called Ashcan artists, presented the dark underside of the urban world with scathing directness in his drawings and paintings, yet even he agreed with the impressionists that to picture a skyscraper effectively, "the whole scene must be bathed in a sheen of moonlight or obscured by a swirling snowstorm."[3] New York's industrial shoreline offered an alternative approach to characterizing the city in art and making its most alien aspects accessible. Pictorially, river vistas satisfied such conventions of landscape art as open horizontality and deep spatial recession. Seen in relation to its surrounding waterways, New York appeared as the product of fortunate geography harnessed by modern engineering, its urban modernity grounded in the comforting timelessness of natural phenomena. The busy harbor, soaring bridges, and towering skyline seen from across the water particularized and celebrated New York while holding its clamorous realities — from social conflict to street congestion — at a comfortable distance. This mode of picturing the city conforms to what Wanda Corn has termed an aesthetic of accommodation, which imposed the familiar conventions of landscape art on the modern cityscape as a means of projecting urban experience as something comprehensible and controllable.[4] Yet the shoreline also presented New York at its most challenging as a spectacle of modernity. Combined with water-borne traffic, at various sites its concentration of bridges, docks, and piers, industrial installations, and railways created unmatched spectacles of raw technological and commercial might, unprecedented scale, and violent change — "manifestations of human energy which are stripped of the accident of the picturesque" and offering few precedents in artistic portrayal.[5]

New York had long been pictured in the visual context of its surrounding waterways.

Fig. 14 William Burgis
(fl. 1716-1731)
*The South Prospect of the City of
New York, in North America.*
Engraving, depicting 1717-1745;
issued August 1761 by *London
Magazine*, 8 ⁵⁄₆₄ x 21 ¹⁷⁄₆₄ inches
Princeton University Library, Graphic
Arts Collection. Department of
Rare Books and Special Collections.
Princeton University Library

Fig. 14 William Burgis
(fl. 1716-1731)
*The South Prospect of the City of
New York, in North America.*
Engraving, depicting 1717-1745;
issued August 1761 by *London
Magazine*, 8 ⁵⁄₆₄ x 21 ¹⁷⁄₆₄ inches
Princeton University Library, Graphic
Arts Collection. Department of
Rare Books and Special Collections.
Princeton University Library

Fig. 15 William Merritt Chase (1849-1916)
Harbor Scene, Brooklyn Docks
Oil on wood, 6 ³⁄₈ x 9 ⁵⁄₁₆ inches
Collection of Yale University Art Gallery
Edwin Austin Abbey Memorial Collection
1937.4000

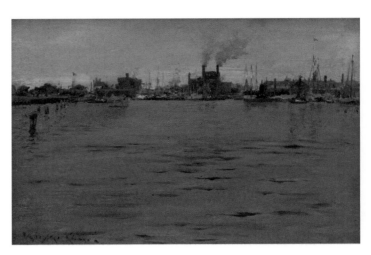

Early panoramic images of the city, such as William Burgis' *A South Prospect of New York* (1761) [Fig. 14], follow a tradition of English and continental *vedute*: celebrating commercial bounty by foregrounding waterways dense with vessels, they also maintained a convenient distance from the stink of the waterfront. New York's industrial shoreline figures as well in the origins of the now iconic association of modernity and urbanism. Around the time that William Merritt Chase began to portray urban parks, in the mid-1880s, he also painted the docklands and river in such works as *Harbor Scene, Brooklyn Docks* (n.d.) [Fig. 15].[6] Amidst calls for a distinctly national art, the city's working shoreline, by virtue of its very character as "a vulgar scene, a commonplace thing at home, a thing to look at and hold one's nose," was promoted as the "material of American landscape." [7] To paint it was a consciously modernist gesture for the time, an affirmation of the subtle instinct for discerning beauty in unlikely places that was widely regarded as the measure of a true artist.[8] Yet Chase's distant perspective on his prosaic subjects and his Whistlerian preoccupation with subtle light effects, delicate painterly brushwork, and harmonious color project an ambivalence about the industrial shoreline as a subject for art.

A powerful advocate for artistic realism, Robert Henri nonetheless forged a somewhat ambivalent relationship with its subjects. Returning to New York in 1900 from Paris, where he had painted quays and streets, he turned his attention to the cityscape with the encouragement of his New York dealer, William Macbeth.[9] Henri found affordable living quarters at the foot of East Fifty-eighth Street "with such a view of the river from both ends of the house that I shall never be in want for something magnificent and ever-changing to paint."[10] *East River Embankment* (1900) [Cat. 29], and *Cumulus Clouds* (1901-02) [Cat. 28], are among the paintings that resulted from his initial artistic engagement with New York. Their somber tones and dirty industrial subjects have been interpreted as a deliberate break with impressionism's typically sanitized color and refined settings.[11] Yet Henri's focus on the river also allowed him to look away from the city, not only geographically but in mood. Snowfall, a favorite impressionist device for softening the brutal and ugly, mutes the sense of harsh winter chill in *East River Embankment*. In *Cumulus Clouds*, broadly handled forms and sketchy scattered figures recall Whistler's intimate paintings of quaint English and continental shop fronts and pedestrians. The most notable figures, a white-bearded man paired with a little girl clad in white, lend Henri's riverfront an aura of safe domesticity at odds with the polluted industrial realities of the neighborhood, the site of coal-loading piers, slaughterhouses, and a municipal

garbage dump.[12] The painting's ultimate focus, however, is the cloudscape of pastel-tinted billows glowing with reflected sunset light. Henri renders urbanism comprehensible and reasonable by referencing both natural phenomena and artistic convention. With its glowing sky, framing elements, and waterfront theme, *Cumulus Clouds* recalls the time-honored precedent of Claude Lorrain's paintings of seaports at sunset, several examples of which Henri would have known from the Louvre's collection. He may also have been aware of a recent application of Claude's formula to a similar image of the New York riverfront, Henry Ward Ranger's tonalist *East River Idyll* (1896)[Fig. 16].That title, redolent of pleasurable respite, might easily apply as well to Henri's picture.

The younger artists Henri inspired interpreted river, harbor, and waterfront with a less contemplative spirit. For Everett Shinn and George Bellows in particular, the utilitarian character and squalid conditions of the wharves were as much an authentic expression of modern life as the human incidents to which the realists devoted their more typical works. In Bellows' *Forty-two Kids* (1907) [Fig. 17], an abandoned dock is not merely the stage for the antics of a gaggle of fun-seeking immigrant youth but also, in its condition of dangerous decay, an affirmation of their freedom from official regulation. When Bellows and other Ashcan realists shifted to the genre of landscape to paint the harbor and rivers as subjects in their own right, they necessarily disengaged somewhat from the shocking directness of their boldest images of urban poverty, brutality, and congestion, while still picturing things evidently not meant to be seen — "things which because they were commonplace and customary were supposedly beyond the pale of artistic significance," as writer Theodore Dreiser put it.[13]

Like the working-class figures populating "typical" Ashcan paintings, the utilitarian nature of industrial architecture and the constant activity on the waterways could embody the "doing," rather than "a thing done beautifully," by which Henri defined realism as an art of life.[14] Such "doing" is embodied in the vigorous brushwork

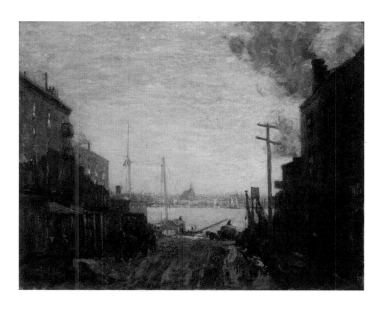

Fig. 16 Henry Ward Ranger (1858-1916)
East River Idyll, 1896
Oil on canvas, 28 x 36 inches
Collection of the Carnegie Institute Museum of Art, 00.5
Photograph © 2013 Carnegie Museum of Art, Pittsburgh

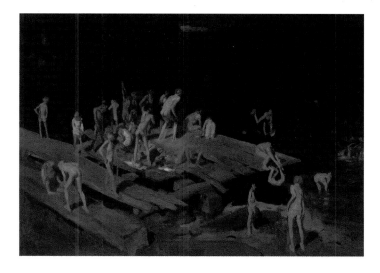

Fig. 17 George Wesley Bellows (1882-1925)
Forty-two Kids, 1907
Oil on canvas, 42 x 60 ¼ inches
Collection of Corcoran Gallery of Art, Washington, D.C.
Museum purchase, William A. Clark Fund 31.12

ON THE FRINGE

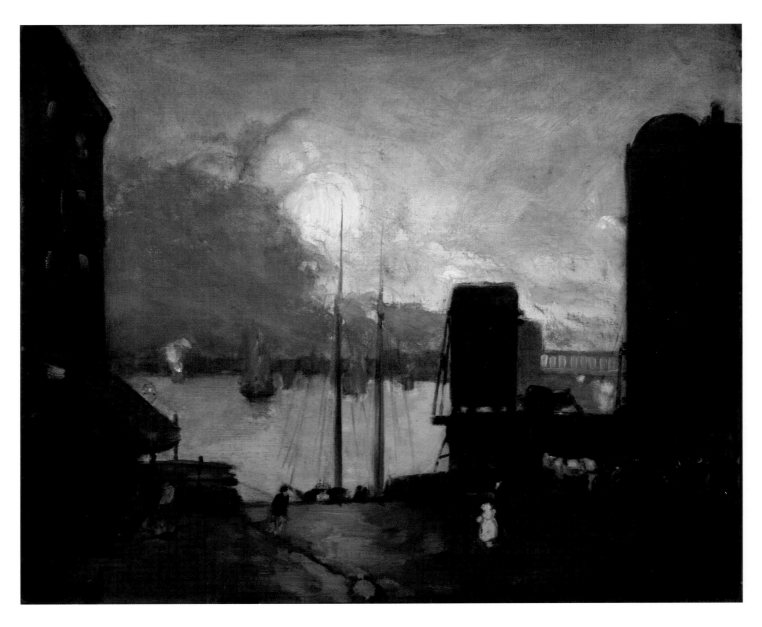

Cat. 28 Robert Henri. *Cumulus Clouds, East River*, 1901-02

of Glackens' *Tugboat with Lighter* (1908) [Cat. 27] and in the vivid activity of Everett Shinn's *Barges on the East River* (1898) [Cat. 64]. The latter is tense with the suggestion of imminent collision between the vessels crowding the view.[15] The wryly observed details of idling workers and fluttering laundry on the nearest boat, momentarily glimpsed as it begins to slip beyond the picture frame, collapse the grandeur of New York's harbor into the quotidian present of individual workaday experience. Vital in its very degradation, the waterway as pictured by Shinn embodies authenticity, much like the antiquated tenements and run-down docks in some of the urban realists' boldest images of working-class existence, such as Shin's *Cross Streets of New York* (1899) [Fig. 18].

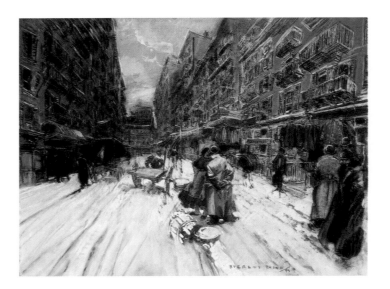

Fig. 18 Everett Shinn
Cross Streets of New York, 1899
Charcoal, watercolor, pastel, white chalk, and Chinese white on blue-gray paper, 21 5/8 x 29 1/4 inches
Collection of Corcoran Gallery of Art, Washington, D.C.
Gift of Margaret M. Hitchcock through a Museum Exchange 1975.11

Set against a typical impressionist treatment, such as Carleton Chapman's sunny, expansive *East River, NYC* (1904) [Cat. 12], Shinn's image is dark and cluttered. Its monochromatic charcoal-and-wash medium reifies the waterway's notoriously polluted water and air; appropriately, the drawing was reproduced in *Harper's Weekly* in 1902 to illustrate New York's "soft-coal nuisance."[16] The theme of industrial pollution likewise dominates George Luks's *Roundhouses at Highbridge* (c. 1909-1910) [Cat. 45], in which towering columns of smoke and steam overshadow the narrow Harlem River and the industrial shoreline of the West Bronx. Whereas Henri's *Cumulus Clouds* bears witness to the possibility that nature can be experienced even within the most densely urban environment, Luks's cloudscape blurs the distinction between the natural and the man-made, suggesting the subjugation of one to the other. *Roundhouse at Highbridge* is indebted to Whistler's urban romanticism, as scholars have noted, yet it also invokes the national landscape tradition of the panoramic vista.[17] Indeed, it subverts the celebration of the natural sublime demonstrated in such works as Frederic Edwin Church's *Cotopaxi* (1862) [Fig. 19], for here industrial effluent, rather than plumes from a volcanic eruption, blanket the sky. Similarly, *Queensboro Bridge, East River* (c. 1910) [Cat. 17], by a young Glenn Coleman, a student of Henri and Shinn, plays on the landscape convention of foreground figures inviting the viewer to share the view. Coleman's assorted city dwellers gaze not at a beautiful scene of nature but at a bleak vista of brooding sky, murky water, and industrial tanks and smokestacks, against which

Cat. 17 Glenn Coleman. *Queensboro Bridge, East River*, c. 1910

ON THE FRINGE

a northbound side-wheeler stands out like a spectral vision. The incongruous details of lines of washing at the upper left and a woman attending to her infant suggest the challenges of ordinary domestic life in the city. Above, the new Queensboro Bridge, still bearing construction scaffolding, holds the promise of suburban escape in the newly accessible residential borough of Queens.

In their somber tones, these images acknowledge the city's grimmer aspects, if also its vitality — or rather the synergy between the two. They also affirm longstanding popular perceptions of New York as a place of glaring contrast, of direst poverty, crime, and pollution as well as the wealth, fashion, and sophistication suggested in the genteel street views by such impressionist urban image makers as Childe Hassam. This dialogic construction of the city was rapidly becoming a thing of the past, however. During the 1890s, as Angela Blake notes, the reformist rhetoric of "sunlight and shadow," shifted toward a sanitized entrepreneurial construction of New York, particularly with the growth of tourism.[18] As one writer confidently announced in 1903, "the old city of lights and shadows, of heaven and hell, of vulgarly spent wealth and direst misery, is rapidly changing," giving way to a city presented, in a burgeoning promotional literature, as a showcase of modern improvements and technological solutions.[19] In the city's improving image if not in actuality, its grimmer aspects, such as the notorious waterside fringe of derelict docklands pictured by Shinn and Bellows, were rapidly being reformed out of existence, if not already banished. The dark vision that earned the urban realist painters the sobriquet of the Ashcan School was in a sense retrospective, and its practitioners had already begun to move beyond it by the time of the Eight's landmark 1908 exhibition.[20]

The momentum of the city's reformed image was partly signaled by the popularity of panoramic vistas of Manhattan from the water, in illustration and photography as well as painting. Reworking the traditional view of the port city fronted by a busy waterway, Jonas Lie's *Afterglow* (c.1913) [Cat. 41], celebrates New York as the capital of modern commerce.

According to impressionist strategies of elision and euphemism, it presents Manhattan as a dream-like vision by marrying exotic color and dramatic light to the blurring effects of weather, fading daylight, and actual atmospheric pollution. *Afterglow* hints at the inability of landscape painting to encompass the soaring modern skyline within its rationalizing frame: at the left, the narrow spire of Cass Gilbert's Woolworth Building, its construction in its final phase as the painting was completed, seemingly penetrates the canvas' top edge, as if a picture is inadequate to contain New York's boundless commercial as well as architectural dynamism. Boats, barges, and the industrial waterfront, meanwhile, are compressed into a dark, irregular line, visually a mere foundation for what one account, typifying the era's use of natural metaphor to tame the city's strange and unprecedented aspects, described as Manhattan's "Andean range of sky-scrapers."[21]

Reviewers of the National Academy of Design's 1914 spring show differed as to whether the glowing windows of the distant buildings in *Afterglow* signified reflected sunset or "offices lighting up for a few more hours' labor," but they were united in praise of the painting, which won the Academy's first Hallgarten Prize.[22] Several also noted a suggestion of irony or allegory in its romantic rendering of commercial New York as a richly tinted fairyland, for the ice-choked water that separates the viewer from the financial district "bathed in golden light" may symbolize "the hardships we must undergo before we get to the gold." From this perspective, *Afterglow* seemed a counterpart or "second lesson," according to the *New York Sun*, to the artist's recent *Path of Gold* (c. 1914) [Cat. 42].[23] In that work, the track of glaring light reflected off the East River points the way toward the commercial heart of the city, where fortunes might prove as illusory as the "path" itself. Whether New York's waterways constituted a hazardous barrier or a "highway to prosperity," crossing them was an inescapable reality, one shared by exhilarated first-time arrivals and jaded commuters alike.[24] Only from the water could New York's skyscraping skyline be thus glimpsed, with the most glamorous towers — the slender

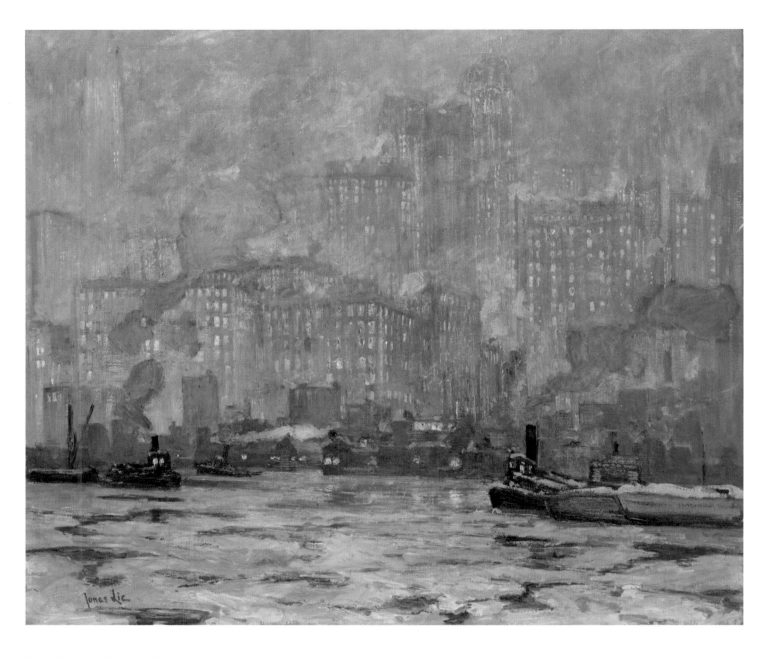

Cat. 41 Jonas Lie. *Afterglow*, c. 1913

Woolworth Building and the more bulbous Singer Building — silhouetted dramatically against the sky. With such a shoreline view, Lie centered *Afterglow* on the South Ferry Terminal, just as Alfred Stieglitz did more pointedly in his aptly titled photograph *The City of Ambition* (c. 1910) [Fig. 20].[25] Both images reference a common journey across the water to Manhattan, one that had long since come to serve as a metaphor for transformation, self-realization, and the pursuit of ambition. Such associations added a further layer of meaning to the portrayal of the city's commercial skyline from across the water.

Rivaling New York's skyscrapers as symbols of conquering technology and urban progress were the East River bridges, yet the first and the most famous of them, the Brooklyn Bridge, was nearly two decades old when painters began to see it as an acceptable subject. Irresistible to illustrators and photographers from the first, the bridge initially presented only insurmountable compositional challenges for most fine artists, who kept it at a distance. The bridge's rapid arrival as an iconic artistic subject, shortly after the turn of the century, perhaps depended not only on the balancing visual effect of Manhattan's rising skyline, as William H. Gerdts has suggested, but also on the further bridging of the East River by several equally impressive spans by 1909.[26] The completion of the Brooklyn Bridge in the early 1880s announced old New York's ambition to breach Manhattan's watery boundary and unite with (or engulf) its eastern rival Brooklyn. The new Williamsburg, Manhattan, and Queensboro bridges embodied the realization of a far vaster modern metropolis of five geographically

ON THE FRINGE

distinct but administratively united boroughs. As the historical "island city" was transformed into the modern "city of bridges," these structures increasingly symbolized New York.[27]

The bridges not only symbolized the city but the power of engineering technology to shape its character and daily life. Overwhelming physical presence was expressed in views of bridges from below, with their spans arcing overhead, a formula that appealed to artists as diverse as Edward Hopper and Ernest Lawson. In *Queensborough Bridge* (1912) [Cat. 32], by the young Leon Kroll, an intimate of the Ashcan circle, and *Bridge and Tugs* (c. 1911-1915) [Cat. 43], and an image of the Brooklyn Bridge made about the same time by Lie, a darling of the National Academy, the gargantuan bridges dwarf individual workers and the lively activity on the river. Although Lie's painting strikes a briskly celebratory note while Kroll's trudging figures hint at the brutality of life for the city's laboring poor, the images evince a shared fascination for the bridges as dominating manifestations of urbanism and as potent expressions of modern, distinctly American life. Using the more familiar convention of the vertically oriented urban street vista, Colin Campbell Cooper's *Manhattan Bridge from Henry Street* (n.d.) [Cat. 19], suggests the visually disruptive presence of the bridge's eastern pier as it terminates the view down Henry Street: the out-of-scale bridge looms over the shabby if picturesque tenements, an ethereal token of technological solutions to urban decay.

Soon to become an icon of artistic modernism, the Brooklyn Bridge was more iconic than modern in the years when the newer East River spans were completed. Its famous gothic-style, masonry-clad piers were dated in comparison with the newer bridges' bare-boned steel-frame aesthetic, which announced their more advanced suspension-bridge technology. The Brooklyn Bridge's historical character was already established when, around 1906, Everett Longley Warner began painting it as a backdrop to the quaint remnants of 18th-century architecture at the Fulton Fish Market and Ferry Terminal.[28] A painter and etcher of charming European village scenes, Warner brought a sense of nostalgia to the bridge and the buildings, survivors from successive phases of New York's past. In *Peck Slip, N.Y.C.* (n.d.) [Cat. 71], he painted them bathed together in beneficent late afternoon light, while from the lower left the shadow of the unseen taller skyline of modernity advances, forecasting the inevitable if regrettable erasure of the past. Ernest Lawson showed *Brooklyn Bridge* (c. 1917-20) [Cat. 34], under entirely different conditions, witness to a dreamy moonrise over distant Manhattan viewed through a romantic haze. Like Warner, however, Lawson envisioned it as a token of a vanishing past, companion to the quaint mansard roofs of the old Fulton Ferry Terminal in the foreground. Such romanticization was less a solution to the problem of pictorial accommodation than an acknowledgment of the Brooklyn Bridge's particular status as a historical marker of change. In Warner's and Lawson's retrospective interpretations, the bridge offers a comforting precedent for startling innovation, perhaps the

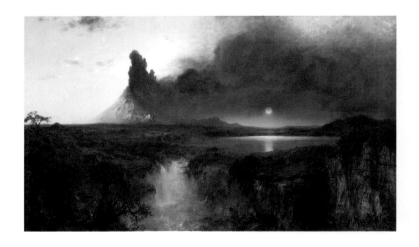

Fig. 19 Frederic Edwin Church (1826-1900)
Cotopaxi, 1862
Oil on canvas, 48 x 85 inches
Collection of Detroit Institute of Arts. Founders Society Purchase
Robert H. Tannahill Foundation Fund, Gibbs-Williams Fund,
Dexter M. Ferry, Jr., Fund, Merrill Fund, Beatrice W. Rogers Fund,
and Richard A. Manoogian Fund. 76.89

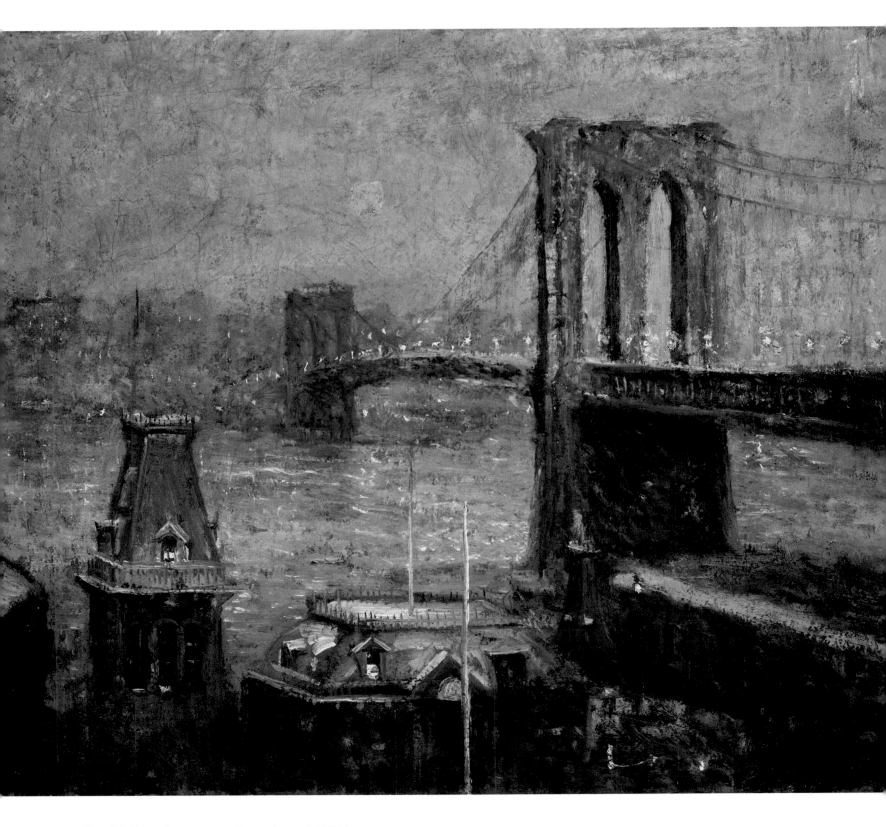

Cat. 34 Ernest Lawson. *Brooklyn Bridge*, c. 1917-20

modern city's most notable, if not disturbing, characteristic.

In contrast to the East River's layered urban history, the Hudson's comparatively open expanse presented starker contrasts of natural and man-made. At the turn of the century the degradation of the Palisades on the New Jersey shore through quarrying and other industrial activity inspired not only a conservation movement but artistic responses exalting the

setting's natural beauty. Painter Van Deering Perrine, the "Thoreau of the Palisades," ignored the industry threatening his beloved region in his romantic view upwards from the foot of the cliffs (1906) [Cat. 61]. For the urban realist John Sloan, the Hudson represented a departure from the city both artistically and personally. In the years just after he moved to New York permanently in 1904 to join his friend Henri and other members of their artistic coterie

from Philadelphia, Sloan's few scenes of New York's riverfront focused notably on the ferries by which the self-described "unacclimated Pennsylvanian" and his first wife, Dolly, began their frequent journeys back to their former hometown.[29] In 1908 and 1909, the Sloans also crossed the Hudson for respites in the comparatively bucolic environs of Coytesville on the New Jersey Palisades; there, the artist painted some of his first landscapes, including *Cliffs of the Palisades* (1908) [Cat. 65], and the larger *Hudson Sky* (1908) [Cat. 66], the first landscape painting he tried to exhibit. Both images avoid the looming skyline of Manhattan to the south; in a related painting, the view includes the city's gray urban prospect, but also the figures of two women with their backs to the skyline as they climb toward the summit of the bluffs.[30] Featuring a dramatic cloudscape that impels the gaze outward toward leafy Inwood at Manhattan's northern tip, *Hudson Sky* conveys Sloan's exhilaration at an expansive vista of a kind so rarely found in the city. His more typical paintings of urban streets, parks, backyards, and interiors often evoke a sense of overcrowding and overshadowing; rooftop settings are sites of escape from physical and psychic confinement. Sloan's Hudson River images intimate that even an artist entranced by the buoyant vitality of city life could be relieved to escape from it.

Around 1909, the Hudson drew particular attention as an urban waterway with the Hudson-Fulton Tri-centennial celebrations, substantial completion of Riverside Park, and more utilitarian shoreline improvements. In George Macrum's *The Pile Driver* (1912) [Cat. 46], which focuses on the construction of new concrete piers along the river, the rhythmically patterned surface and sun-saturated palette clearly conveys an optimism born of a faith in progress through modern engineering. In contrast, the series of Hudson River paintings Bellows executed between 1908 and 1910 offer, as Carol Troyen notes, "a carefully calibrated blending of love of nature and respect for urban progress" — a formula that proved widely saleable.[31] *Winter Afternoon* (1909) [Cat. 7], is one of several works in this series that utilize dramatic contrasts of light and dark to distinguish snow-covered ground from the river's briskly moving water. Bellows departed notably from both the aestheticizing strategies of urban impressionism and the somber tones of typical urban realist images of the East River. His broadly laid-on paint and his tactile evocation of midday glare convey a sense of winter chill and atmospheric clarity unifying the disparate elements of this urban landscape. The juxtaposition of well-dressed pedestrians with a steaming tug, riverside docks and sheds, and signs of quarrying on the far shore suggest the city's new image as a place for civilized living amidst the "doing" of business and industry. Bellows' river paintings envision the Hudson less as an industrial highway than as a redemptive natural feature relieving the density of Manhattan's gridded interior. With such landscape subjects, if not his more confrontational paintings of tenement dwellers, boxers, and packed city streets, Bellows found a lucrative compromise between urban realism and landscape convention.

Cat. 40 Martin Lewis. *Railroad Yards, Winter, Weehawken*, c. 1917

Referenced only obliquely in Bellows' painting, the Hudson's industrial aspect was fully displayed further south in the rail yards and freight and ferry terminals sprawling along its western shore. The summit of the Palisades near Weehawken commanded dramatic views of these industrial installations with Manhattan's jagged skyline as a backdrop, attracting Leon Kroll, Max Kuehne, and Martin Lewis, among other artists. Both Lewis and Kroll prominently juxtaposed the forbidding Palisades geology with the human imprint on its riverbank, using snow to accentuate the dark, rugged appearance of the ancient rock. The eccentric formations dominating Lewis' *Railroad Yards, Winter, Weehawken* (1917) [Cat. 40], stand as lonely sentinels measuring time's passage and the eclipse of the natural sublime by the industrial. In Kroll's *Terminal Yards* (1913) [Cat. 33], the cliff face frames a vertiginously sublime spectacle of industry in what the artist described as "a big sweeping design, with steam."[32] Overtopped by the elevator warehouses and the more distant cityscape, the Palisades of nature's making yield to the force of industrial development, its triumphant ascendance echoed in the composition's tipped-up perspective and the dynamic arcs of the rail lines. Exhibited in the 1913 Armory Show and purchased by the pioneering American collector Arthur Jerome Eddy, Kroll's painting won the approval of the self-described layman Theodore Roosevelt, no doubt in part for its exaltation of American industrial

ON THE FRINGE

Cat. 38 Richard Hayley Lever. *Riverside Drive and Seventy-second Street,* 1913

might.[33] While the art in the Armory Show demonstrated the importance of the figure in the radical experiments of European artists, *Terminal Yards* was among a handful of works that heralded urban and industrial subjects as defining features of the American modernism that would emerge in the following years.

Kroll's and Lewis' images sharply delineate the boundary between natural and man-made. Ernest Lawson, in contrast, found the distinctive subject of his early career at the interface between urban and rural on the banks of the Harlem River. Manhattan's natural northern boundary was also, in the early 20th century, the site of its ragged fringe of rapid urbanization in an era of intense speculative real

estate development. Collector Duncan Phillips was one of many Lawson contemporaries who marveled at the artist's ability to combine the sensual beauty of richly textured surfaces and glowing opalescent tints with the notably unpicturesque subjects that comprised what he called the "impossible familiarities of any suburban wilderness."[34] These included the starkly utilitarian highway of steel that cleaves the landscape in *Railroad Track* (c. 1905) [Cat. 36], swooping into the distance just as the unseen train would hurtle toward the city. As Ross Barrett has demonstrated, Lawson's paintings of northern Manhattan emphasize the provisional, indeterminate character of a transitional landscape: once defined by the fixed

natural boundary of the river, the character of that terrain had become temporally and spatially blurred by the haphazard progress of development — as it is visually blurred by Lawson's richly layered paint surface.[35] Northern Manhattan's awkward remaking from a leafy region of country estates to a semi-urban residential and business enclave depended, in fact, on the expansion of the rail-based mass transit so pointedly referenced here, one of several technologies by which the island's natural boundaries at the water's edge were conquered. In *Railroad Track*, the river has been rendered irrelevant, requiring not even a visible change of grade for the railroad to traverse it.

Like Bellows, Lawson allied himself with the realists in his subject matter while also pleasing cautious taste for a modernism of "sanity and sincerity."[36] By the new century's second decade, a "modern spirit" in art not only embraced the subject of the modern city's physicality but even celebrated the accidental effects and abrupt juxtapositions that characterized its fast-changing landscape, redeemed by a decorative if "virile" formal sensibility. Like Lawson's images of northern Manhattan, Hayley Lever's *Riverside Drive and Seventy-second Street* (1913) [Cat. 38], demonstrates the new artistic legitimacy of this urban geography of the unfinished and the unintentional. In 1913, the year of the Armory Show, Lever's painting was accepted by the establishment National Arts Club as his diploma presentation, a condition of membership among the club's elite artists' ranks. The transplanted Australian's homage to what he called "the land of the Brave and the Doing," is a frank depiction of the Hudson shore where Seventy-second Street's glamorous new luxury high-rise apartment buildings abutted the tracks of the New York Central Railroad in a smoke-wreathed confusion of industrial structures, shanties, docks, and muddy riverbank.[37] Revealing the influence of post-impressionism, Lever's painting is at once elegant in treatment and starkly brutal in its subject. It proved, according to a reviewer, "what good artistic use topsy-turvy [sic] New York may be put to."[38] At the riverbank Lever located an unrivaled

combination of contrasting motifs embodying the varied, potentially conflicting, facets of urban development. His painting proclaims what one observer of the new New York called "the ugliness of a new and half-built town," and orchestrates it into picturability at the border between the beautiful and the sordidly real. [39]

Within a relatively brief period at the turn of the 20th century, New York's waterways had proved richly adaptable to such "good artistic use" as a subject for modern landscape painting. The rivers, shoreline, and bridges resoundingly identified and symbolized the city even as they both represented physical escape from its confines and provided an alternative to the artistically challenging verticality of the skyscraper and the congestion of the street. By picturing New York in relation to its waterways, artists celebrated the commerce and industry that exploited them and the modern technology that conquered them, while invoking the city's history, the comforting permanence of natural phenomena, and artistic precedent. For realist painters, the working waterways with their shipping and bridges comprised a landscape of "doing," offering opportunities for a mediated, and perhaps more saleable, realism that visualized the vitality of modern life. For establishment artists, painting the industrial shoreline demonstrated a progressive spirit of "realism" safely contained within the conventions of landscape art and a decorative stylistic aesthetic. By the time more radical artists had begun to explore new formal means of capturing the experience of the modern city, the earlier generation had confronted and normalized the character of urbanism. Whether celebrating the city's toughness or its triumph, they admitted its contrasts, conflicts, and awkward juxtapositions as they pictured the often unlovely effects of industrialism and development on the material landscape. In their work, New York's shoreline emerged not as a boundary so much as a fluid interface — between natural and constructed, rural and urban, industrial and residential, degraded and triumphantly reformed, past and future.

1 See for example Wanda Corn, "The New New York," *Art in America* 61 (July-Aug. 1973): 59-65, and "The Artist's New York" in Thomas Bender and Carl E. Schorske, ed., *Budapest and New York: Studies in Metropolitan Transformation: 1870-1930* (New York: Russell Sage Foundation, 1994), chap. 11.

2 William H. Gerdts, *Impressionist New York* (New York: Abbeville Press, 1994), chap. 8, gives a focused overview of the painting of the waterfront and bridges. Elsewhere, the subject is considered in the context of individual artists, notably Bellows, and in studies of the Brooklyn Bridge. See for example Marianne Doezema, *George Bellows and Urban America* (New Haven: Yale University Press, 1992), 55-65; Carol Troyen, "Life by the River, 1908-1912" in *George Bellows* (Washington, DC: National Gallery of Art, 2012); *The Great East River Bridge 1883-1983* (Brooklyn, NY: Brooklyn Museum, distributed by Abrams, 1983); and Richard Haw, *Art of the Brooklyn Bridge: A Visual History* (New York: Routledge, 2008).

3 Shinn quoted in Corn, "The New New York," 61-62.

4 Corn, *The Great American Thing: Modern Art and National Identity, 1915-1935* (Berkeley: University of California Press, 1999), 166.

5 Bayard Boyeson, "The National Note in American Art," *Putnam's Monthly & The Reader* 4 (May 1908): 133.

6 Barbara Dayer Gallati, *William Merritt Chase: Modern American Landscapes 1886-1890* (Brooklyn: Brooklyn Museum, 1999), 78-93.

7 W. Mackay Laffan, "The Material of American Landscape," *American Art Review* 1 (Nov. 1879): 29-32.

8 See for example Mrs. Schuyler van Rensselaer, "Picturesque New York," *The Century* 45 (Dec. 1892): 168, and H. G. Dwight, "An Impressionist's New York," *Scribner's* (Nov. 1905): 544-554 .

9 Homer, *Robert Henri and His Circle* (Ithaca, NY: Cornell University Press, 1969), 108.

10 Bennard B. Perlman, *Robert Henri: His Life and Art* (New York: Dover Publications, 1991), 45.

11 Perlman, *Robert Henri*, 46.

12 Perlman, *Robert Henri*, 45.

13 Theodore Dreiser, *The "Genius"* (New York: John Lane Company, 1915), 236.

14 Henri quoted in Nancy Mowll Mathews, *Moving Pictures: American Art and Early Film, 1880-1910* (Manchester, VT: Hudson Hills Press in association with the Williams College Museum of Art, 2005), 122.

15 Mathews, *Moving Pictures*, 122

16 "The Soft-Coal Nuisance in New York," *Harper's Weekly*, September 13, 1902. See Rebecca Zurier, *Picturing the City: Urban Vision and the Ashcan Artists* (Berkeley: University of California Press, 2006), 158-159.

17 H. Barbara Weinberg, Doreen Bolger, and David Park Curry, *American Impressionism and Realism: The Painting of Modern Life, 1885-1915* (New York: Metropolitan Museum of Art, distributed by H. N. Abrams, 1994), 168.

18 Angela Blake, *How New York Became American, 1890–1924* (Baltimore: Johns Hopkins University Press, 2006), chap. 2.

19 John Brisban Walker, "The Wonders of New York 1903 and 1909: An Attempt to Forecast the Next Six Years," *The Cosmopolitan* 36 (Dec. 1903): 146.

20 Elizabeth Kennedy, "The Eight: 'Modern Art of One Kind and Another'" in Elizabeth Kennedy, ed., *The Eight and American Modernisms* (Chicago: Terra Foundation for American Art, 2009).

21 Walter Prichard Eaton, "The Harbor," *Scribner's Magazine* 49 (February 1911): 130.

22 "At the Spring Academy: Winter and Youth," *The Craftsman* 26 (April 1914): 148.

23 Quoted in David B. Dearinger, ed., *Rave Reviews: American Art and Its Critics, 1826-1925* (New York: National Academy of Design, 2000), 260. Such use of natural metaphors to describe economic phenomena was widespread in late-nineteenth-century America, as Sarah Burns notes in *Inventing the Modern Artist: Art and Culture in Gilded Age America* (New Haven and London: Yale University Press, 1996), 192-195.

24 Judy L. Larson, Donelson Hoopes, and Phyllis Peet, *American Paintings at the High Museum* (New York: Hudson Hills Press in association with the High Museum of Art, 1994), 160.

25 *The Craftsman's* reviewer described *Afterglow* as conveying "the sense of beautiful confusion that dominates South Ferry just after the sun has gone down."

26 Gerdts, *Impressionist New York*, 166; see also John C. Van Dyke, *The New New York: A Commentary on the Place and the People* (NY: Macmillan, 1909): 305-306.

27 E. Idell Zeisloft, *The New Metropolis* (New York: D. Appleton & Co., 1899), iv; John De Witt Warner, "City of Bridges," *Municipal Affairs* 3 (Dec 1899): 657.

28 See E. L. Warner, "The Story of a Prize Picture," *Carnegie Magazine* 10 (May 1937): 40-42; Gerdts, *Impressionist New York*, 170-171.

29 Sloan quoted in Zurier, *Picturing the City*, 260. On Sloan's paintings of ferries, see Grant Holcomb, *John Sloan: The Wake of the Ferry, il* (San Diego: Timken Art Gallery, 1984), and Heather Campbell Coyle and Joyce K. Schiller, "John Sloan's Urban Encounters" in Coyle and Schiller, *John Sloan's New York* (New Haven and London: Delaware Art Museum and Yale University Press, 2007), 35-36.

30 *City from the Palisades*, 1908, Santa Barbara Museum of Fine Arts.

31 Troyen in *George Bellows*, 106.

32 *Leon Kroll, A Spoken Memoir*, ed. Nancy Hale and Fred Bowers (Charlottesville: University of Virginia Press, 1983), 31.

33 Theodore Roosevelt, "A Layman's View of an Art Exhibition," *Outlook* 103 (March 29, 1913): 720.

34 Duncan Phillips, "Ernest Lawson," *American Magazine of Art* 8 (May 1917): 259.

35 Ross Barrett, "Speculations in Paint: Ernest Lawson and the Urbanization of New York," *Winterthur Portfolio* 42 (spring 2008): 1-26.

36 Catherine Beach Ely, "The Modern Tendency in Lawson, Lever and Glackens," *Art in America* 10 (Dec. 1921): 31-32.

37 Lever quoted in Carol Lowrey, *Hayley Lever and the Modern Spirit* (New York: Spanierman Gallery LLC, 2010), 18. Leon Kroll's painting *Reclaimed Land, Riverside Drive* (private collection), showing an almost identical view of the same locale and painted about the same time, suggests that Lever took few liberties with the actual scene.

38 *American Art News*, 1915, quoted in Lowrey, *A Legacy of Art: Paintings and Sculptures by Artist Life Members of the National Arts Club* (New York: National Arts Club in association with Hudson Hills Press, 2007), 139.

39 Dwight, "An Impressionist's New York," 548.

A WORLD AGO

Cat. 61 Van Dearing Perrine. *Palisades*, 1906, detail.

Cat. 57 Marguerite Ohman. *View of the Queensborough Bridge from Central Park, New York City, c. 1940*

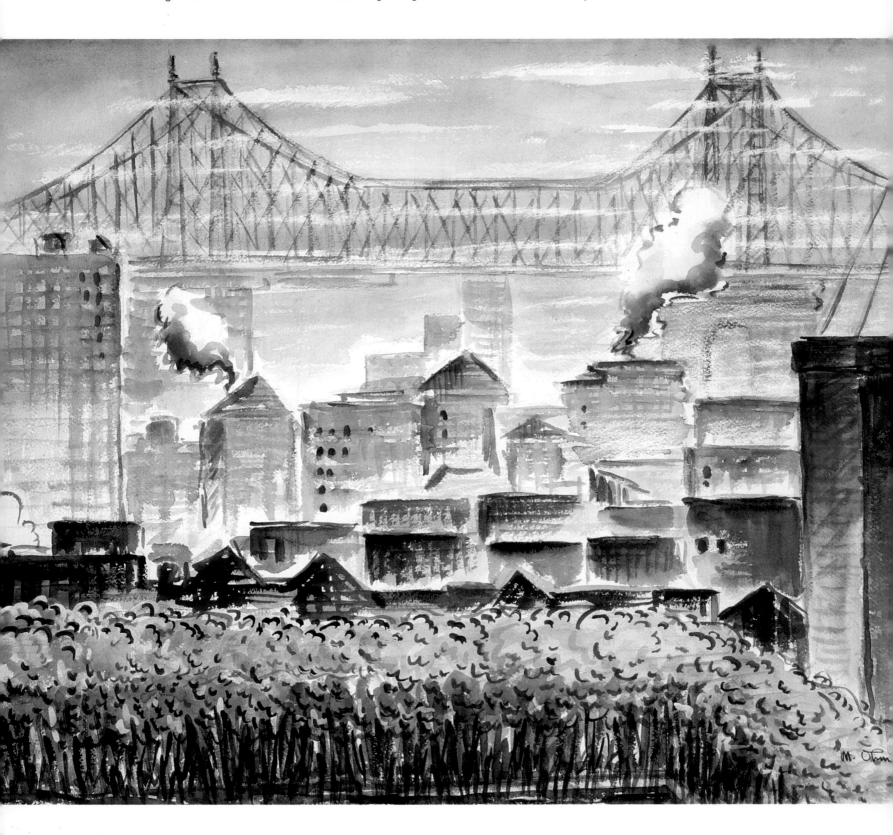

Ellen E. Roberts

CONTESTED *Waterfront:* ENVIRONMENTALISM AND MODERNIST PAINTINGS OF NEW YORK

The New York waterfront became a site where Progressive ideas clashed with industrial interests.

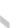

INDUSTRIALISM TRIUMPHED in the United States between 1900 and 1940 and made the country a world power. Painters created an "industrial sublime" to celebrate America's modern might in cities like New York. Yet Americans increasingly realized the negative effects of industrialization, including the toll it was taking on the natural environment. While some photographers used their art to crusade for environmental reform in this period, painters addressed these issues less overtly.[1] Nevertheless, a number of painters created works that resonated with debates about environmental conservation, especially when these issues were foremost in public thought: during the Progressive Era and the Great Depression. Although paintings of New York's rivers were dominated by industrial scenes, some artists depicted the city's waterfront parks. At this time when industry was paramount, addressing green space at all can be interpreted as an argument for its preservation. Painters of these works rejected traditional pastoral landscape modes, using innovative compositions to suggest the modern urban dweller's new relationship to nature.

American environmentalism had its roots in the early 19th-century transcendentalism of Ralph Waldo Emerson and Henry David Thoreau.[2] As the industrial revolution spread in the course of that century, the conservation of nature became a more widespread concern. From their country's beginnings, Americans had used their continent's natural wonders to define themselves in opposition to Europe's historical monuments, but by the late 19th century extensive tourism to sites such as Niagara

Falls demonstrated the increasing threat that development posed to these awe-inspiring places. Furthermore, although the North American continent's natural resources had seemed limitless to settlers from Europe who moved ever westward, by 1893, as Frederick Jackson Turner famously declared, the frontier was gone.[3] Americans began to realize that they would have to conserve the natural resources they had. To do so, they would have to control industrial development.

The impulse to conserve was part of a larger reformist spirit in the last years of the 19th century that continued through America's entry into World War I in 1917. In this Progressive Era, Americans sought to address the negative sides of modernization, and for the first time saw government regulation as a necessary curb to the excesses of big business, including the toll it was taking on nature. Environmental legislation at this time focused on the West, since that region had the most undeveloped land that could still be conserved. Nevertheless, even in industrialized cities like New York, Progressive-era ideas about the conservation of nature took hold. Indeed, in urban areas Progressives saw the preservation of nature in parks as critical for the long-term health of city dwellers.

The New York waterfront became a site where Progressive ideas clashed with industrial interests. Rivers had been key to the city's long-term commercial success, so leaders had historically been unwilling to dedicate any of the riverfront to green space; such parks would have limited their ability to send goods in and out. Thus, with the exception of the Battery at the end of Manhattan, which had been a public promenade since the 18th century, New York

parks were created in the middle of the city rather than along the edge. However, with the Progressive-era's recognition of the importance of environmental conservation, advocates for green space along New York's rivers became more vocal and engaged in lengthy debates with big business. The most contested areas were along the Hudson, which was less heavily industrialized than the East and Harlem Rivers. There, Progressive environmentalists had the most possibility of success.

A number of painters sympathetic to environmentalism depicted the Hudson River parks repeatedly in this period. One such space was the Palisades, a stretch of cliffs on the west side of the Hudson reaching from New Jersey into upstate New York.[4] By the end of the 19th century, these majestic rock formations, visible from the Upper West Side of Manhattan, were being extensively quarried for building material. New York's American Scenic and Historic Preservation Society and the New Jersey Federation of Women's Clubs began to work together for the conservation of the Palisades. In 1900 both states officially preserved the land, and in 1909 it opened as the Palisades Interstate Park.

Several painters focused on the Palisades in this era. Impressionist Van Dearing Perrine, in works such as his *Palisades* (1906) [Cat. 61], depicted the landscape as an unspoiled natural

wonder, with no hint of the vibrant city nearby. Born in Garnett, Kansas, Perrine had worked as a farmer and cowboy before he went back east to study art at New York's Cooper Institute and National Academy of Design in the 1880s. Between 1902 and 1912, Perrine lived at the base of the Palisades. His paintings depict the view from this vantage, looking up at the cliffs; this perspective collapses the pictorial space, monumentalizing the Palisades. Such views make this eastern site resemble the sublime western wilderness painted by artists like Thomas Moran in works such as *The Grand Canyon of the Yellowstone* (1872) (Fig. 21). Unlike Moran, however, Perrine allowed the viewer no imaginary access into the composition as was conventional in a landscape. In Moran's painting, the viewer's eye can enter at lower left and travel back along the Yellowstone River. Perrine, in contrast, made his composition more confrontational, holding the viewer's gaze on the awe-inspiring stretch of the Palisades' cliffs.

Contemporary critics noted the strangeness of Perrine's treatment of the Palisades. Charles M. Skinner of the *Brooklyn Eagle* called these paintings "grand, gloomy, and peculiar," writing that they were governed by "an individuality so assertive as to threaten anarchy to academic methods and smug complacency. The basal note is a joy in nature,

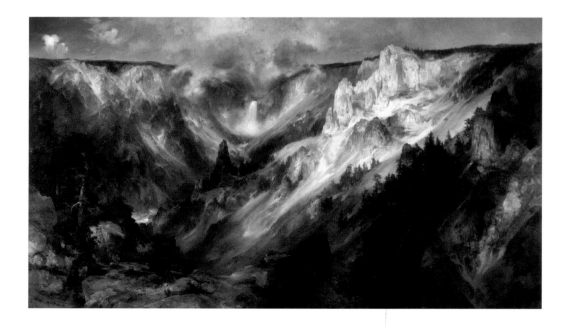

Fig. 21
Thomas Moran (1837-1926)
The Grand Canyon of the Yellowstone, 1872
Oil on canvas,
96 ½ x 168 ⅜ inches
Collection of the Smithsonian American Art Museum
Gift of George D. Pratt, 1928.7.1

Fig. 22 Van Dearing Perrine (1869-1955)
The Palisades, c. 1906
Half-tone plate engraved by R. Varley
Illustrated in *The Century Illustrated Monthly Magazine*, 72
(September 1906), p. 665

a wild, dark joy it may be, such as the savage and the gipsy feel, but sincere and temperamental."[5] Similarly, William Howe Downes, in the *Boston Transcript*, concluded:

[Perrine's] work is distinctly unconventional... Unusual directness and naturalness set it apart from ordinary work of the academic kind... The artist had evidently an uncommon capacity for getting into close and intimate contact with nature, and his impressions are characterized by much spontaneity and force.[6]

Both Skinner and Downes emphasized Perrine's intensely physical relationship to the landscape. His view of nature was consistent with Progressive-era thought. President Theodore Roosevelt, who led the nation between 1901 and 1908, helped popularize the idea of nature as a rugged, demanding place that could provide an antidote to the effeteness

of modern times. Roosevelt was a major supporter of Progressive-era conservation efforts, and had, in fact, helped preserve the Palisades when he was governor of New York. He chose another of Perrine's tough Palisades landscapes, *The Palisades* (c. 1906) [Fig. 22], to display in the White House.[7] In such paintings, Perrine presented a robust nature that could stand up to the industrial might of cities like New York. Contemporary viewers would have seen these pictures in the context of the debate over the Palisades conservation. Perrine's impressive paintings provided a visual case for the preservation of this landscape.

Like Perrine's pictures, John Sloan's *Cliffs of the Palisades* (1908) [Cat. 65], treats the cliffs from below, emphasizing their physical might. The viewer can imaginatively enter this composition only at the far left; otherwise, the steep rock face forces a contemplation of the site's grandeur. Unlike Perrine's large paintings, however, *Cliffs of the Palisades* is one of a number of small sketches Sloan made of this landscape when he was vacationing in Coytesville, New Jersey from June 16 to July 3, 1908.[8] He did produce two larger-scale, more finished views of this site: *Hudson Sky* (1908) [Cat. 66], and *City from the Palisades* (1908) [Fig. 23]. Sloan's diary indicates that he started at least one of these paintings while he was in Coytesville but continued working on them after he returned to New York. On July 26, 1908, he wrote, "I worked on my two largest Coytesville 'Hudson from Palisades' paintings the greater part of the day. Tired myself out, standing up. I have not worked at the easel for so long that it was fatiguing." He had completed the two paintings by November 2, when he showed them to his close friend painter Robert Henri, who, Sloan noted, "was most pleased with my two large ("Coytesville on the Palisades") landscapes and the small ones also interested him."[9]

In *Hudson Sky* Sloan captured an effect of clouds receding in triangular formation above the Palisades. As he later wrote of this painting: "Two or three weeks at M. Richard's 'pension,' Coytesville on the Palisade,s was a

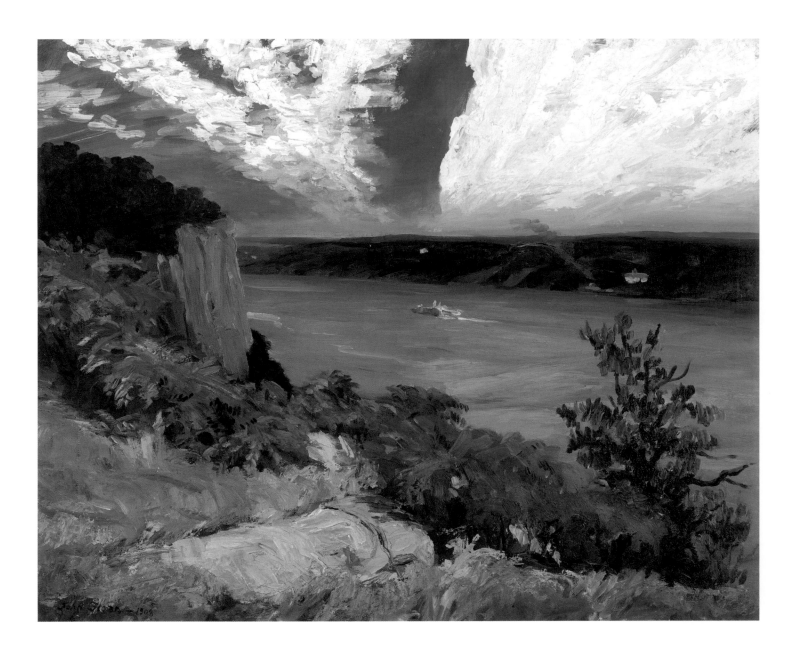

Cat. 66 John Sloan. *Hudson Sky*, 1908

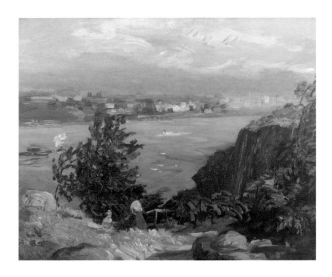

Fig. 23 John Sloan (1871-1951)
City from the Palisades, 1908
Oil on canvas. 26 ⅛ x 32 ⅛ inches
Collection of the Santa Barbara Museum of Art
Gift of Mrs. Sterling Morton to the Preston Morton Collection; 1960.82
© 2013 Delaware Art Museum/Artists Rights Society (ARS), New York

first opportunity for a continuous series of landscapes of which this may be the most important. A strangely beautiful cloud formation that hung for hours like a giant white dome overhead. The clear line of blue between the clouds ran straight across the zenith from horizon to horizon."[10] Nevertheless, while the cloud arrangement draws the viewer's eye into the far distance, the rocks and bushy undergrowth along the cliff heights stop the eye in the foreground, preventing any further imaginary travel into the composition.

The unconventional nature of this perspective becomes apparent when it is compared with more traditional pastoral landscapes, such as Jasper Francis Cropsey's *Under the Palisades* (1899) [Fig. 24]. Like his fellow Hudson River School painters, Cropsey portrayed the Palisades in the bucolic manner first used by 17th-century painters such as

Claude Lorraine, surrounding a central area of water with well-balanced contrasting compositional elements such as trees and rocks that frame the viewer's imaginative entry into the serene composition. Cropsey depicted the Palisades in the distance, so they impress but do not overawe. In Sloan's *Hudson Sky*, however, the viewer is stopped short by the jutting cliffs and abundant vegetation. Again, as in Perrine's *Palisades*, this unusual composition forces a recognition of nature's power.

Such paintings contrast with the aestheticized views of industry created in this same period. In *Hudson River View (Sugar Factory at Yonkers)* (c.1915) [Cat. 9], for example, Daniel Putman Brinley transformed the industrial landscape of Yonkers into an exquisitely balanced arrangement of color and form. His vivid factory dwarfs the Palisades visible in the background. At the same time that such artists were beautifying industry, painters like Perrine and Sloan were denying traditional landscape tropes in their views of parks, presenting nature as a rugged place that was in accord with the Progressive ideal.

Sloan adopted the same unusual compositional strategy in the other larger-scale landscape that he produced in Coytesville, *City from the Palisades*. Instead of looking toward the less settled north of *Hudson Sky*, Sloan, in this painting, faced south down the Hudson toward New York City. Again, though, the viewer's eye is halted in the foreground by the rocks and trees of the Palisades landscape. Rather than traveling over to the city, the viewer lingers in nature, just as the figures climbing the cliffs are doing. Sloan's composition emphasizes the importance of the Palisades landscape in contrast to the urban area beyond.

Fig. 24 Jasper Francis Cropsey (1823-1900)
Under the Palisades, 1899
Watercolor on paper
12 x 20 inches
Questroyal Fine Art, LLC, New York

Such paintings should not be read as overt arguments for the preservation of the Palisades. Although Sloan was a Progressive who attended lectures by anarchist Emma Goldman and joined the Socialist party in 1910, he asserted that his paintings were not political.[11] Sloan told the Socialist critic Herman Bloch, "I had no intention of working for any Socialist object in my etchings and paintings though I do think that it is the proper

Fig. 25 John Sloan (1871-1951)
The Triangle Shirtwaist Factory Fire, 1911 *In Memoriam* (alt. title)
Ink, Chinese white, and crayon on illustration board,
18 ½ x 14 ¾ inches
Collection of the Delaware Art Museum, Gift of Helen Farr Sloan, 1991
© 2013 Delaware Art Museum/Artists Rights Society (ARS), New York

party to cast votes for at this time in America." He further noted: "I had a natural outlet for propaganda in my illustrations and cartoons for political publications."[12] In drawings such as his *The Triangle Shirtwaist Factory Fire* (1911) [Fig. 25], for such left-wing magazines as *The Masses* and *The Coming Nation*, Sloan presented his liberal views in a straightforward manner. He conceived of his fine art work in painting and printmaking as separate from such explicitly political works.

Nevertheless, as scholars have argued, Sloan's liberalism is evident in his fine art. In paintings such as *Three A.M.* (1909) [Fig. 26] he depicted New York's lower classes with an unusual humanity.[13] As a Progressive, Sloan would have been in favor of the era's environmentalist initiatives, such as the preservation of the Palisades. Therefore, his paintings of the Palisades should be seen in the context of contemporary discussions about the future of this landscape. By arresting the viewer's attention in nature in these paintings, Sloan emphasized the Palisades' majesty. Whether Sloan consciously intended them to, or not, such paintings, like Perrine's, make a persuasive argument for the preservation of nature along the Hudson.

A similar claim can be made about Sloan's friend and fellow Ashcan School artist George Bellows, who painted a series of landscapes from Riverside Park along the Hudson in Manhattan between 1908 and 1912. Most of these, including both *North River* (1908) [Fig. 27] and *Winter Afternoon* (1909) [Cat. 7], show the Palisades across the river in the background. As with Sloan, Bellows' paintings should not be read as overt political statements. Bellows was also involved with Progressive politics in New York, attending Emma Goldman's lectures, teaching art classes at the anarchist Ferrer School, and producing politically-charged illustrations for left-leaning publications such as *The Masses*. Yet, like Sloan, Bellows conceived of his paintings as separate from this political world, asserting, "As a painter I am not a preacher; I am not trying to uplift or teach. I am merely trying to do the best work of which I am capable."[14] Scholars Marianne Doezema and Carol Troyen have persuasively argued that Bellows' Hudson River paintings helped him promote his career, marketing his art as modern, but still safe.[15] These paintings were more critically palatable and saleable than his contemporary views of New York tenements, such as *Cliff Dwellers* (1913) [Fig 28], which presented the crowded yet vibrant reality of the modern city in unavoidable terms. Nonetheless, just as such sympathetic treatment of New York's lower classes cannot but be read in political terms, Bellows' paintings of

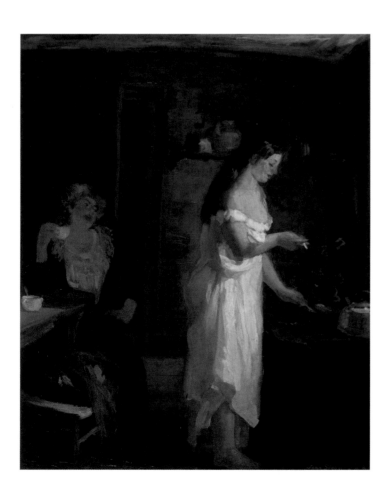

Fig. 26 John Sloan (1871-1951)
Three A.M., 1909
Oil on canvas, 32 ⅛ x 26 ¼ inches
Collection of the Philadelphia Museum of Art
Gift of Mrs. Cyrus McCormick, 1946
© 2013 Delaware Art Museum/Artists Rights Society (ARS), New York

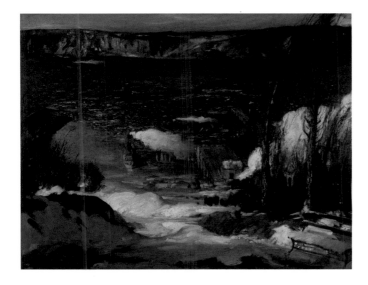

Fig. 27 George Bellows (1882-1925)
North River, 1908
Oil on canvas, 32 ⅞ x 43 inches
Courtesy of the Pennsylvania Academy of the Fine Arts, Philadelphia
Joseph E. Temple Fund. 1909.2

Riverside Park should be understood in the context of Progressive-era environmentalism. Like his depictions of the inner city, Bellows' views of parks promoted his Progressive ideals.

In the years when Bellows was painting Riverside Park, it was a highly contested space.[16] The park had been established in 1867 for practical reasons: it enabled the city to avoid grading the steep area between the newly settled Upper West Side of Manhattan and the Hudson. Upper West Side residents also saw the proposed green space as a buffer between their neighborhood and the unsavory commercial activity along the river. The first section of Riverside Park, designed

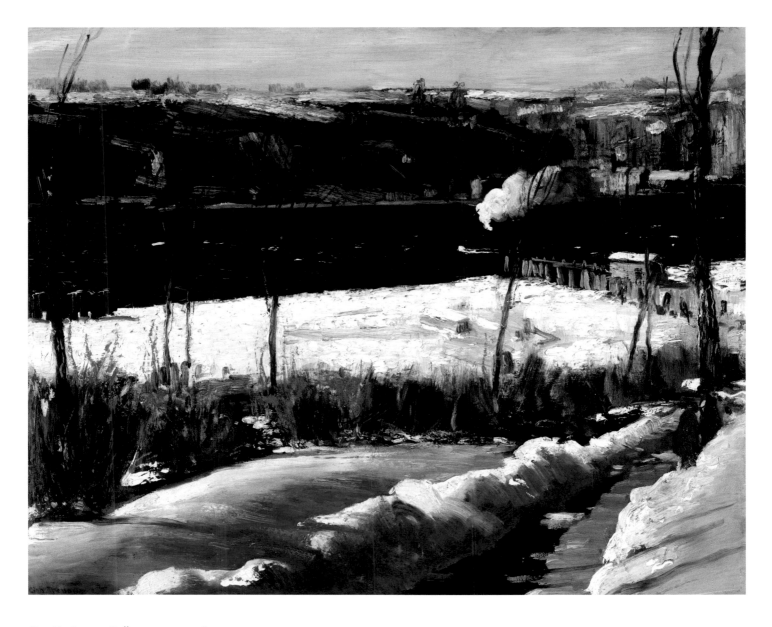

Cat. 7 George Bellows. *Winter Afternoon,* January 1909

CONTESTED WATERFRONT

by master landscape architect Frederick Law Olmsted, opened in 1880. However, debates over the park's future continued through the Progressive era, as advocates for green space faced off against the industrial interests representing shipping and the railroad that extended through the park. Indeed, just as Bellows was painting Riverside Park, new fill in the Hudson expanded the land to the west of the railroad tracks. Environmentalists and industrialists disagreed about whether the new land should be used for park or commercial space.[17] In this era of the City Beautiful Movement, architects advocated using grandly formal elements to bring harmony and unity to the modern city. Designers such as A. Van Buren Magonigle proposed plans for the newly expanded Riverside Park that would enhance the public space with monumental statuary, staircases, and gardens, hiding the unsightly garbage dumps and railroad tracks along the Manhattan shore. Progressives pointed out the benefits for public health and recreation that such green space would afford. Jens Jensen, a City Beautiful designer from Chicago, described how Riverside Park could fulfill the Progressive ideal, writing:

From the standpoint of art, [Riverside Park] is a masterpiece, a living out-of-doors art exhibit. . . . It is the most precious piece of park land the foreground to one of the greatest views of this country; it affords to the citizens packed away in tenement dwellings something of an outlook into the world, something of a vision that broadens their horizon and imprints upon their souls some of the grandeur of our country. . . . It is in our parks the city dweller finds himself; and since it rests with him alone to make city life healthier, more beautiful and more worth while, then the greater the artistic expression from which he receives inspiration, the greater its value to mankind.[18]

Bellows' pictures of Riverside Park capture this Progressive vision of green space in the city. As Perrine and Sloan did, Bellows created unusual compositions to prevent his viewer from reading his paintings as conventional landscapes. Although many of them offer the viewer a way to imaginatively enter the space — such as the path extending into the composition from the lower edge of *Winter Afternoon* — most of these works are dominated by a series of horizontal bands moving up the composition.

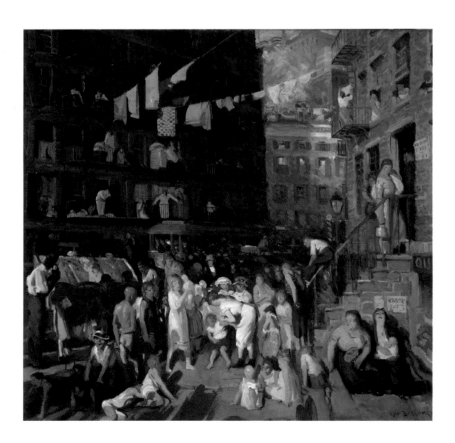

Fig. 28 George Bellows (1882-1925)
Cliff Dwellers, 1913
Oil on canvas, 40 ³⁄₁₆ x 42 ¹⁄₁₆ inches
Collection of the Los Angeles County Museum of Art
Los Angeles County Fund 16.4
Digital Image © 2013 Museum Associates/ LACMA
Licensed by Art Resource, NY

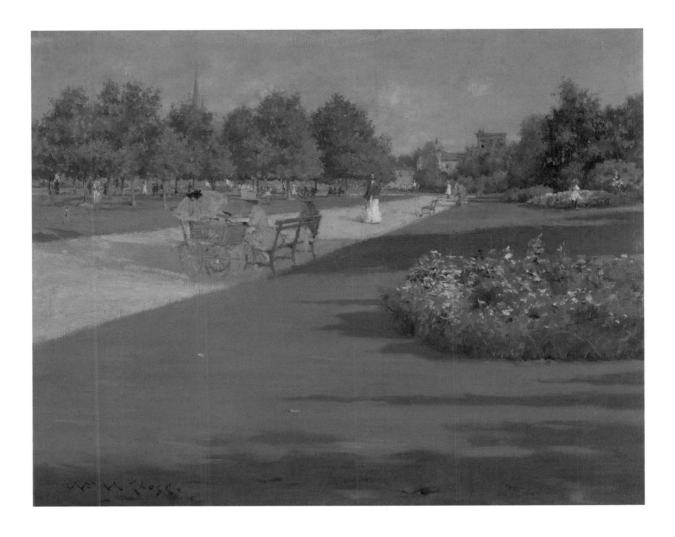

Fig. 29 William Merritt Chase (1849-1916)
Tompkins Park, Brooklyn, 1887. Oil on canvas, 17 ⅜ x 22 ⅜ inches
Collection of the Colby College Museum of Art 1963.040
Photography: Peter Siegel

With few elements receding into space, it is difficult to read the strips as three-dimensional. The viewer must stop in order to decipher the space.

Bellows' innovative compositions become more apparent when they are contrasted with American Impressionist paintings of parks, such as William Merritt Chase's *Tompkins Park, Brooklyn* (1887) [Fig. 29]. In such works, Chase aestheticized the landscape, enhancing the beauty of the scene by arranging the composition in the most harmonious way possible. Elements such as the path on the left and flower bed on the right balance each other on the picture plane and simultaneously lead the eye easily back into space. In contrast, Bellows' *Riverside Park* is not a graceful design but a space difficult to understand, forcing the viewer to study it. Rather than Chase's elegant nature, Bellows presented a rough, physically demanding landscape that reflects Progressive-era views. Critics described Bellows' river paintings in Progressive terms —

one noted that in Bellows' *The Palisades* (1909, oil on canvas, Terra Foundation for American Art), he "slams on his color most indecorously with splendid effect. . . . He shoots with both barrels of his gun but he bags his game."[19]

Bellows' *Riverside Park* paintings also differ from impressionist views because he included the industrialization that punctuated the urban landscape. While contemporary tourist views of the park such as Chase's *Tompkins Park, Brooklyn* often eliminated mechanized elements such as the railroad, docks, and tugboats, Bellows included such signs of industry in all these works. His paintings thus present the Progressive ideal of an urban park. Although contemporary environmentalists such as John Muir, who co-founded the Sierra Club in 1892, argued for the cessation of development so that nature could be preserved for its own sake, they were in the minority. Progressive-era environmentalism was instead dominated by figures such as Gifford Pinchot,

CONTESTED WATERFRONT

first head of the United States Forest Service, who argued that nature should be sustainably conserved for long-term human use.

The Progressive vision of balance between conservation and industrial development is what Bellows presented in his Riverside Park pictures: in these paintings, people advance technologically and enjoy nature simultaneously. The art critic Sadakichi Hartmann had described Riverside Park in these Progressive terms in 1900:

A picture genuinely American in spirit is afforded by Riverside Park. Old towering trees stretch their branches toward the Hudson. Almost touching their trunks the trains on the railroad rush by. On the water, heavily loaded canal boats pass on slowly, and now and then a white river steamboat glides by majestically, while the clouds change the chiaroscuro effects at every gust of wind.[20]

Like Hartmann in his paintings of Riverside Park, Bellows presented a vision of natural and industrial elements existing in harmony in the modern city.

For the viewer in Bellows' time, his paintings would have had immediate resonances of both the controversies over the future of Riverside Park and the preservation of the Palisades, marked by the opening of the Palisades Interstate Park at just this time. Such pictures caused viewers to compare the two parks — the Palisades, which had been safely conserved, and Riverside, still threatened by commercial interests. The contrast was emphasized by a contemporary event: the Hudson-Fulton celebration in September 1909.[21] The occasion commemorated both the three-hundredth anniversary of Henry Hudson's first voyage up the Hudson River and the one-hundredth anniversary of Robert Fulton's first steamboat ride up the Hudson. The Palisades Interstate Park was officially opened at the festivities, and Riverside Park was promoted as the perfect place to witness the celebration. Bellows attended the festival,

painting its naval demonstrations in *Warships* (1909, repainted 1918, oil on canvas, Hirshhorn Museum and Sculpture Garden). The Hudson-Fulton celebration's recognition of both industrial progress and conserved nature made it an ideal Progressive event. In his paintings of the Hudson River, Bellows similarly presented urban green space coexisting peacefully with commercial interests, asserting that a robust nature with its positive effects available to all, could thrive in the modern industrial city.

The Progressive era waned after America's entry into World War I in 1917. In the Roaring Twenties a laissez-faire American government allowed corporations to grow without regard for environmental costs. Technological advances made mechanized conveniences such as the automobile more affordable, and Americans embraced them wholeheartedly, ignoring their environmental impact. Modernist artists such as George Ault [Cat. 3], and Georgia O'Keeffe [Cat. 55], celebrated the grandeur of the industrialized New York waterfront, without addressing the city dweller's shrinking connection to nature.

The 1930s saw the pendulum swing back to some extent as President Franklin Delano Roosevelt worked to preserve the natural landscape throughout the United States with New Deal programs such as the Civilian Conservation Corps. Nevertheless, in this time of the Great Depression, economic concerns were paramount and the environmental costs of development seemed less important in the wake of so much immediate human hardship. In New York, artists suggested the perilous position of urban green space in such an atmosphere. In his 1936 painting *Triborough Bridge* (1936) [Cat. 23], Aaron Douglas depicted a cheerless-looking public park sandwiched between industrial structures. The leafless trees seem especially spindly in contrast to the industrial masses surrounding them.

The Triborough Bridge was just being completed when Douglas painted this work — in fact, he included a sign announcing its construction in the right middle ground. The monumental bridge allowed cars easy access between Manhattan, Queens, and the Bronx over Randall's Island in the East River.

The structure was one of many endeavors spearheaded by the influential Robert Moses, who served in a number of civic positions in New York, including parks commissioner, president of the State Parks Council, and head of the Triborough Bridge and Tunnel Authority.[22] A controversial figure, Moses transformed New York through a number of large-scale road projects, which he could fund through New Deal programs such as the Works Progress Administration. Most were linked to the development of parks, including the small area Douglas depicted in his painting that was created during the building of East Side Drive, now the Franklin Delano Roosevelt Highway. Immediately after its construction, the writer of *The WPA Guide to New York City* wrote optimistically about this area:

A radical change in the character of the district's river front was brought about by the construction of the East River Drive approach to the Triborough Bridge. The Drive borders the river from Ninety-second to 125th Streets, its clean wide sweep of roadway and adjoining landscaped mall replacing the dumps, tenements, and shanties that had made an ugly stretch along the water front. Benches placed beneath trees on both sides of the Drive make it useful and attractive to residents of the neighborhood as well as motorists.[23]

Douglas' view of this new space is less positive. By framing the view of the park with the structure and shadow of the 2nd Avenue elevated train and painting the Harlem River Lift approach to the Triborough looming in the near distance, Douglas gives the viewer a discomforting sense of being hemmed in by the modern city. Indeed, his painting presages the new bleakness of the public parks standing in the shadows of Moses' massive highways.

An even more claustrophobic depiction of nature in the industrial city appears in Marguerite Ohman's watercolor, *View of the Queensborough Bridge from Central Park, New York City* (c. 1940) [Cat. 57]. Built in 1909, the Queensborough Bridge extended across the East River from Manhattan to Queens at Fifty-ninth Street. Ohman's watercolor appears to have been painted from the southeast corner of Central Park, but she manipulated the perspective, working from a bird's-eye view that transforms the city into a densely packed array of buildings. She also depicted the bridge not perpendicular to the picture plane, as it would appear from the park, but parallel. As a result of this ninety-degree shift, the structure looms over all, blocking any recession into space and trapping the viewer in this industrial environment. Central Park is sandwiched up against the picture plane, nearly strangled by the modern city.

Like Perrine, Sloan, and Bellows, Douglas and Ohman used inventive compositional arrangements to unsettle their viewers, denying them the pastoral view of nature provided by conventional landscapes. Yet the nature that emerges in these 1930s paintings is not the rugged, physically demanding place of the Progressive era, but green space under siege. The Progressive ideal of a balance between rugged nature and industry in urban areas no longer seemed possible.

Environmentalists in New York between 1900 and 1940 frequently fought losing battles against industrial development. Their minority status is paralleled by the few painters who addressed these concerns along New York's waterfront. Yet environmental activism at this time did establish the importance of the city dweller's access to nature for health and quality of life, as well as suggesting precedents for government control of industrial development. In the late 20th century, when the failures of early 20th-century urban planners such as Robert Moses became apparent, and New York's commercial might no longer relied on manufacturing, environmentalists began to build on such beginnings to successfully promote green space in New York. In the early 21st century, urban planners have returned to the vision of Progressives like George Bellows a century ago: of nature and modernity in balance on the New York waterfront.

1 For the role that photographers played in environmental reform in this period, see Finis Dunaway, *Natural Visions: The Power of Images in American Environmental Reform* (Chicago: University of Chicago Press, 2005).

2 On American environmentalism, see Benjamin Kline, *First Along the River: A Brief History of the U.S. Environmental Movement*, 4th ed. (Lanham, Md.: Rowman and Littlefield, 2011); and Hal K. Rothman, *Saving the Planet: The American Response to the Environment in the Twentieth Century* (Chicago: Ivan R. Dee, 2000).

3 Frederick Jackson Turner, "The Significance of the Frontier in American History," in Frederick Jackson Turner, *The Frontier in American History* (1920; New York, N.Y.: Henry Holt and Company, 1958), pp. 1-38.

4 On the History of the Palisades Preservation, see Robert O. Binnewies, *Palisades: 100,000 Acres in 100 Years* (New York: Fordham University Press and Palisades Interstate Park Commission, 2001).

5 Charles M. Skinner, quoted in Edward Jewitt Wheeler and Frank Crane, eds., "A Painter of the Palisades," *Current Literature*, 41 (October 1906), pp. 408–409.

6 William Howe Downes, quoted in Edward Jewitt Wheeler and Frank Crane, eds., "A Painter of the Palisades," *Current Literature*, 41 (October 1906), p. 408.

7 Edward Jewitt Wheeler and Frank Crane, eds., "A Painter of the Palisades," *Current Literature*, 41 (October 1906), p. 408.

8 For Sloan's sketches of the Palisades, see Rowland Elzea, *John Sloan's Oil Paintings: A Catalogue Raisonné*, pt. 1 (Newark, Del.: University of Delaware Press, 1991), pp. 85-92.

9 Bruce St. John, ed., *John Sloan's New York Scene* (New York: Harper and Row, 1965), pp. 233, 258.

10 John Sloan, *Gist of Art* (New York: American Artists Group, 1939), p. 219.

11 On the Progressive politics of Ashcan School artists including John Sloan and George Bellows, see Robert W. Snyder, "City in Transition," in Rebecca Zurier, Robert W. Snyder, and Virginia M. Mecklenburg, *Metropolitan Lives: The Ashcan Artists and Their New York*, exh. cat. (National Museum of American Art, Smithsonian Institution, 1995), pp. 42-44.

12 John Sloan, diary, May 5, 1909, published in Bruce St. John, ed., *John Sloan's New York Scene* (New York: Harper and Row, 1965), p. 310.

13 Robert Snyder, "City in Transition," in Rebecca Zurier, Robert W. Snyder, and Virginia M. Mecklenburg, *Metropolitan Lives: The Ashcan Artists and Their New York*, exh. cat. (National Museum of American Art, Smithsonian Institution, 1995), p. 45. On Sloan's city scenes, see also Joyce K. Schiller and Heather Campbell Cooper, "John Sloan's Urban Encounters," in Heather Campbell Cooper and Joyce K. Schiller, *John Sloan's New York*, exh. cat. (Delaware Art Museum, Wilmington, Del., 2007), pp. 22-81.

14 "Honor George Bellows, Artist Who Blasts Traditions," *New York Herald*, September 29, 1912, magazine section, p. 9.

15 See Marianne Doezema, *George Bellows and Urban America* (New Haven, Conn.: Yale University Press, 1992), p. 55; and Carol Troyen, "Life by the River, 1908-1912," in Charles Brock, ed., *George Bellows*, exh. cat. (National Gallery of Art, Washington, 2012), pp. 105-113.

16 On the history of Riverside Park, see Ann L. Buttenwieser, *Manhattan Water-Bound: Manhattan's Waterfront from the Seventeenth Century to the Present*, 2nd ed. (Syracuse, N.Y.: Syracuse University Press, 1999), pp. 109-150.

17 A plan for Riverside Park that appeased both commercial and park interests was finally conceived in 1916, after years of negotiations. A period of public comment was supposed to follow, but it was interrupted by America's entry into World War I in 1917. As a result of this and other major interruptions, a unified plan for Riverside Park was not finally executed until 1937, after forty-one years of debate and thirty-six unimplemented proposals for this space.

18 Jens Jensen, "Report to the Women's League for the Protection of Riverside Park on the Proposed Plan for Changes in the New York Central Railroad Along the Hudson," Chicago, November 26, 1916, 10, Women's League for the Protection of Riverside Park Papers, file "1916," Manuscript Collection, New-York Historical Society

19 Unidentified clipping, George Wesley Bellows Papers, box 9, folder 5, Amherst College Archives and Special Collections, Amherst College Library.

20 Sadakichi Hartmann, "A Plea for the Picturesqueness of New York," *Camera Notes*, 4 (October 1900), p. 94.

21 On this festival, see Kathleen Eagen Johnson, *The Hudson-Fulton Celebration: New York's River Festival of 1909 and the Making of a Metropolis* (New York: Historic Hudson Valley and Fordham University Press, 2009).

22 On Robert Moses, see Gina Pollara, "Transforming the Edge: Overview of Selected Plans and Projects," in Kevin Bone, *The New York Waterfront: Evolution and Building Culture of the Port and Harbor*, rev. ed. (New York: The Monacelli Press, 2004), pp. 176–189.

23 William H. Whyte, ed., *The WPA Guide to New York City* (1939; New York: Random House, 1982), p. 270.

CONTESTED WATERFRONT

CITY OF BRIDGES

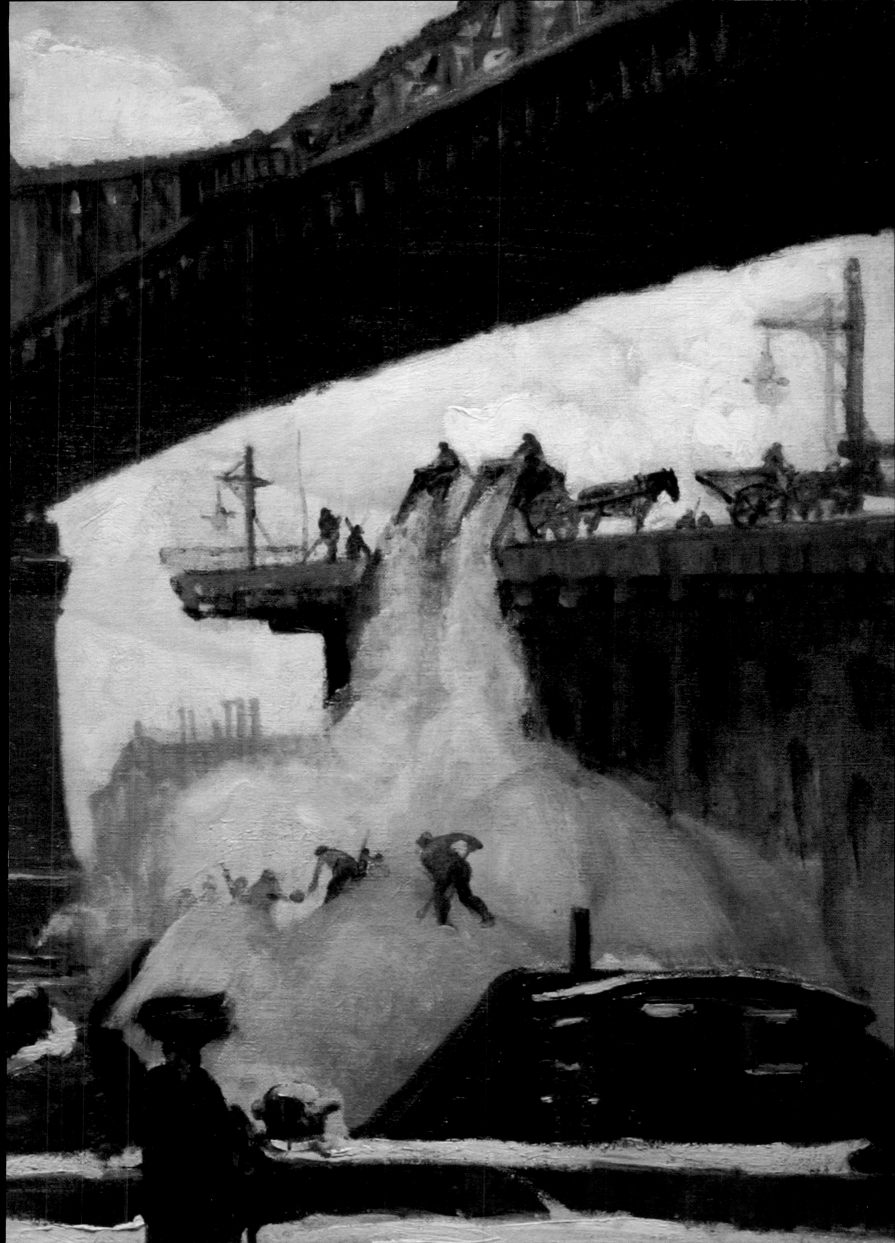

Cat. 20 Ralston Crawford. *Whitestone Bridge, c. 1939-1940*

Kirsten M. Jensen

PAINTING MANHATTA: MODERNISM, URBAN PLANNING, AND *New York,* 1920-1940

If monumental skyscrapers had characterized the 1920s,
then the titans of the 1930s were bridges.

OF ENORMOUS SIZE, New York City is visually stunning. Its buildings rise majestically — mythically, even — from the glittering waters of its harbor and seem to scrape the sky. Massive bridges soar above the city's rivers. Lights blink like beacons from tall windows and shimmer on the surface of the water. The city derives its aesthetic power from the juxtaposition of grand, natural vistas — expanses of water, landmasses fringing thirteen-mile long Manhattan Island, and bright, clear skies with the machines of modern commerce and travel — bridges, skyscrapers, cranes, ocean liners, and tugs.

"There never was quite such a mountain barrier made by human hands and stretched along the eastern sky at sunset," John C. Van Dyke remarked in his 1909 book *The New New York.* "Even in the full light of noonday, with dark shadows flung down the great walls and high lights leaping from cornice to gilded dome, or at dusk when each house of many thousand electric lights has its windows illuminated, there is still a grandeur of mass, of light, of color, that is most imposing."[1] Van Dyke's declaration not only encapsulates the city's aesthetic qualities, but also transposes onto the urban landscape the aesthetics of the natural sublime, creating a new and distinct iconography for the modern era.

John Marin's vibrant and pulsating view of the skyline from the water, *Lower Manhattan from the River, No. 1* (1921) [Cat. 48], underscores Van Dyke's point, capturing the energy and excitement of the modern metropolis as well as the awe inspired by its busy waterways, its soaring skyscrapers, and the deep caverns in between. Marin's skyscrapers are slender and magnificent, and rise like mountainous stalagmites to the sky to meet a setting sun that bathes them all in a warm and benevolent glow.

In the decades between the First and Second World Wars, New York became even greater as a symbol of modernity, progress, and success. America rose to global prominence in the aftermath of World War I. These were decades of massive urbanization and expansion in the city, spurred in the 1920s by postwar prosperity and in the 1930s by New Deal government financing. It was then that many of the world's tallest and most modern skyscrapers were erected. New bridges — each a feat of engineering and technological innovation — were built to span its waters, just as an artery of roadways was constructed to link New York to its suburbs. All this activity created a dynamic urban environment that transformed the city into an organic whole, one that symbolized a new metropolitan way of life. As the city's infrastructure developed during the interwar years, cultural reaction to rapid industrialization and its broad impact on urban life changed too. How artists explored and expressed the urban landscape similarly changed over time, representing new responses to the city's urbanization, emerging modernist aesthetics, and New York's larger role in America's collective imagination and national identity.

Painted in 1921, Marin's *Lower Manhattan* is a perfect point of departure for a discussion of these new ways of conceptualizing the city in the second quarter of the 20th century. In its response to new developments in technology and urbanization, as well as its Cubo-Futurist style, *Lower Manhattan* embodies early modernist visions of New York in the

pre-World War I era.[2] By the 1920s, however, artists were beginning to search for a new language to define the modern metropolis, and increasingly eschewed the expressively fragmented and dynamic urban vision. Marin conveys a more rational and austere visual idiom, inspired, in part, by the adoption of a new "straight aesthetic" in photography, practiced by artists and photographers in the circle of Alfred Stieglitz, and promoted by his seminal magazine *Camera Work*. The technique "celebrated photographic qualities previously considered appropriate for utilitarian images," using cropped and oblique views, and paid

"rigorous attention to the interplay of buildings' shadows and forms."[3] The resulting images of the city transformed straightforward photographs of the urban environment into detached, highly conceptualized expressions of modernist abstraction[4] (1917) [Fig. 30].

The same year Marin completed *Lower Manhattan* two photographers associated with the Stieglitz circle, Charles Sheeler and Paul Strand, released *Manhatta*, a nine-minute film that employed straight photography techniques to cinematically explore the city's urban landscape. While the film lacks an overt plot, it illustrates a typical day in the city from

Cat. 48 John Marin. *Lower Manhattan from the River, No. 1,* 1921

seen recomposing itself abstractly."[6] It is also a document of an emerging aesthetic and cultural tendency to celebrate industrial imagery and its products. It shows the widespread belief in their potential to transform society into an efficient and mechanized environment — a tendency that gave rise to the characterization of the era as the Machine Age. It was a time when President Calvin Coolidge famously declared, "The man who builds a factory builds a temple. The man who works there worships there."[7] From the idealization of the machine and the urban grid there developed a new aesthetic, now called Precisionism. Sheeler was its leading proponent, making some of the earliest Precisionist images from those used in *Manhatta* (1920) [Fig. 32]. A blend of realism and abstraction, Precisionist imagery emphasizes bold geometric shapes, linearity, flattened picture planes, hard-edged forms, and depopulated architectural subjects, all rendered in a muted palette and executed in a mechanical

the arrival of commuters on the ferry to the setting of the sun over New York's dramatic skyline. Interspersed throughout the views of the city are phrases selected from a number of Walt Whitman's poems celebrating New York — *Crossing Brooklyn Ferry, A Broadway Pageant*, and *Mannahatta*.[5] Although thus grounded in the literary past, *Manhatta* is a thoroughly modern expression of the city, one less concerned with the actual view than with de-contextualizing the city's architectural environment to accentuate its abstract qualities. In often lyrical passages Strand's and Sheeler's camera explores the geometric patterns created by the steel cable trusses of Brooklyn Bridge, the grid created by massive I-beams as a new skyscraper takes shape, or the stark contrasts in light and shadow as the sun struggles to reach the deepest recesses of urban canyons (1922) [Fig. 31].

If Marin's landscape represented an emotional response to the cadence of modern life, *Manhatta's* vision of the cityscape is detached and austere. It is a "geometer's New York of sharpened edges and extreme angles, a city which, in the process of rebuilding, can be

Manhattan—"The Proud and Passionate City"
Two American Artists Interpret the Spirit of Modern New York Photographically in Terms of Line and Mass

Fig. 31 Film stills from *Manhatta*, reproduced from "Manhattan — The Proud and Passionate City," *Vanity Fair*, April 1922
Photography: Beinecke Rare Book & Manuscript Library, Yale University

PAINTING MANHATTA

Fig. 32 Charles Sheeler (1883-1965)
Church Street El, 1920
Oil on canvas, 16 ⅛ x 19 ⅟₁₆ inches
Collection of the Cleveland Museum of Art
Mr. and Mrs. William Marlatt Fund
1977.43

manner. The style captured perfectly the formal qualities of the city and its sleek new bridge and skyscraper architecture that offered artists a "ready-made subject with which to explore the abstract arrangement of flat, simplified shapes," without compromising recognizability.[8] The Precisionist idiom became the signature means by which to express the modern metropolis of the 1920s, either in exaltation of its urban landscape or as an evocation of its dehumanizing qualities. While artists like Sheeler tended to focus on the interior of the city,[9] others chose to explore the places at its edges where water and architecture intersected, contrasting the natural and the man-made to create dynamic and visual documents of the constantly changing urban environment.

George Ault's *From Brooklyn Heights* (c. 1925-28) [Cat. 3], is one such view of the city, a vertical frieze-like slice of Lower New York with the Singer Building at its apex, the docks and warehouses lining the shores of Brooklyn at its bottom and the East River in between. A portrait of New York, it gives you a sense of the range of the city's industrial scenery. Ault painted his picture from his studio and so presented a perspective similar in subject to John Folinsbee's *The Harbor* (1917) [Cat. 24], (also painted from the artist's window), but is dramatically different in its effect. Folinsbee wanted to convey movement and the dramatic and prismatic quality of the city's light but Ault gives us the drama of timelessness. His New

York is cool, remote, and highly controlled, an environment in which everything — skyscrapers, water, ships — is flattened and simplified to the most basic geometric forms, smoothly rendered with machine-like precision; even the wharves on the Brooklyn shoreline are clean and crisp, depopulated and devoid of any trace of industrial detritus. With the exception of the curling smoke and mist, all transitory aspects are stripped away to enhance the subject's essential forms. Bare, anonymous, and universal, *From Brooklyn Heights* is a masterpiece of Precisionist urban vision.

Ault's view of New York can be seen, on one hand, as a celebration of the industrial power of the metropolis — its economic enterprise and commercial triumph embodied in its towering skyline and active waters — but perhaps it is also an ambivalent response to the impact of industrial development and the increased mechanization of urban life. Not so much an actual portrait of the metropolis, it is "an image of its motive-power — indeed a city of terrific mental activity. Calculations added to calculations with an iron logic, permeating the whole surroundings, river and sky with the irresistible energy of multiplication and addition."[10] It is a serene landscape but its beauty is cold and brittle. Vitality drains down the composition — from austere gray skyscrapers to Brooklyn's red wharves encased in a sheath of bluish-black — increasing in intensity the farther one progresses away from the city. Color does little to animate it, even the sun is absent and dwarfed by the skyline hidden in thick smog. The East River's waters are a sickly yellow, its pointy waves rigidly rising and falling in regular abstracted patterns. Stripped of its natural character, the river is merely a cog in the larger urban machine, a platform that links the city with its industrial edges, mere manifestations of the artist's "iron logic." The only element of the painting that moves is the curling smoke, which, of course, is man-made. Reduced to a "realm of shapes that denote functional things...utterly detached from use,"[11] Ault's vision of the river and city is jarringly immobile despite our knowledge of the pulsing energy animating urban life in the modern age.

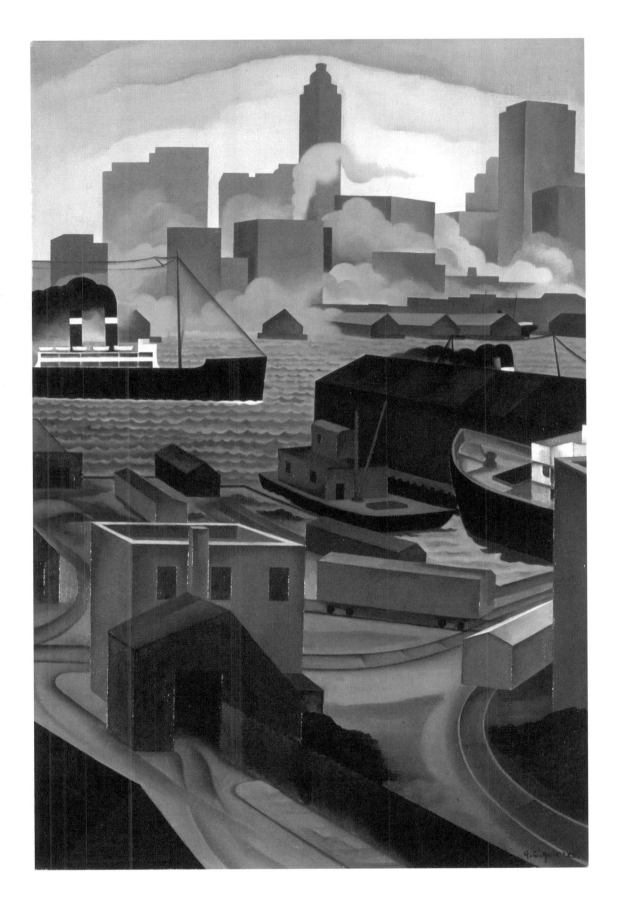

Ault's sublime vision of New York is equally mesmerizing and terrifying in its machine-like indifference. Its ambivalence — hostility even [12] — toward the mechanization of modern life underscores concerns voiced by contemporary critics like Paul Rosenfeld and Waldo Frank that America was becoming a nation of "cities not so much of men and women as of buildings. The imperious structures that loom over us seem to blot us out…we have lavished our forces altogether on the immensities about us, turned our genius into steel and stone, and to these abdicated it." [13] These concerns, voiced early in the Machine Age, only increased as the decade progressed and the city expanded, the old was demolished to make way for the new, and people on the streets became anonymous faces in the crowd

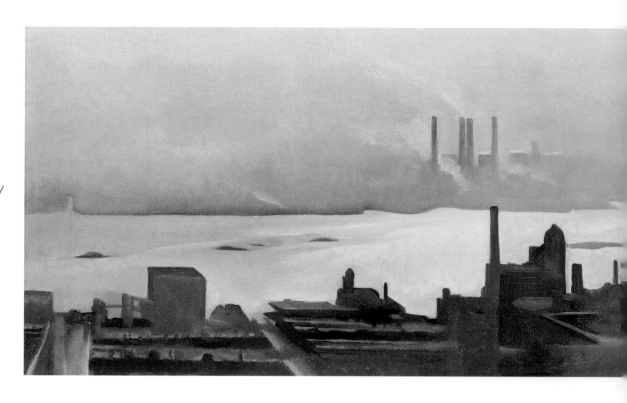

Fig. 33
Georgia O'Keeffe (1887-1986)
East River No.1, 1926
Oil on linen, 12 ⅛ x 32 ⅛ inches
Collection of Wichita Art Museum
Wichita, Kansas
Museum Purchase, Friends of the
Wichita Art Museum, Inc.,
Volunteer Alliance, 1977-1979
Reproduced with permission.
©2013 Georgia O'Keeffe Museum/
Artists Rights Society
(ARS), New York

— anonymity creating not freedom but rather isolation and alienation. Not only is Ault's Precisionist city devoid of any human presence, but his deadpan vision of New York also subverts all natural elements — river, sky — conveying them as sick and powerless, overwhelmed by industrial progress.

Other artists chose to convey the burgeoning metropolis in a more optimistic light, but even so the city bears an aura of the austere and remote. Georgia O'Keeffe, who married Alfred Stieglitz in 1924, was an early practitioner of the Precisionist aesthetic and painted a number of urban landscapes during the 1920s. Her streetscapes emphasized the soaring verticality and slick facades of Manhattan's skyscrapers and employed aspects of straight photography, such as capturing the effect of sunspots on a camera lens in *The Shelton with Sunspots*. In 1925 she moved with Stieglitz into an apartment on the thirtieth floor of the Shelton Hotel (now the New York Marriott), located on 49th Street and Lexington Avenue. The Shelton's thirty-five floors made it one of the tallest skyscrapers in Manhattan and it providing unobstructed views to the north, south, and east. This panoramic vista from the artist's studio window, far above the cacophony of the streets below, had a powerful allure. The artist later remarked, "I know it's unusual for an artist to want to work way up near the roof of a big hotel, in the heart of a roaring city, but I think that's just what the artist of today needs for

stimulus…Today the city is something bigger, grander, more complex than ever before in history. There is a meaning in its strong warm grip we are all trying to grasp. And nothing can be gained by running away."[14]

From her lofty vantage point, O'Keeffe documented the constantly changing urban landscape, creating a series of paintings that explored the same section of waterfront along the East River, a scene studded with factories and smokestacks, at different times of the day. Hers was a project like Claude Monet's exploration of London, but is remarkably different in expression of a cityscape. The first in the series, *East River, No. 1* (1926) [Fig. 33], embodies the visceral lure of the skyscraper with its elevated vantage point and crystalline atmosphere. It offers a similar slice of the city as *From Brooklyn Heights* but seen from an entirely different perspective, one that only a skyscraper, hot-air balloon, or airplane provides. This god-like, bird's-eye vision offers a new language of dynamic experience, one in which the formal configuration of the city is experienced "not in terms of a realistic layout, but rather in terms of its architecture within a picture."[15]

Like Ault's earlier landscape, *East River* is firmly aligned within the Precisionist aesthetic, with its hard edges, slick surfaces of paint, and intense stillness. However, O'Keeffe presents a more positive vision of the modern metropolis. *East River* is an urban landscape, but it is also a portrait of the river, serene, and softly

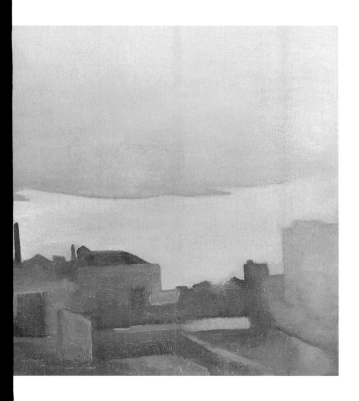

rendered in muted shades of gray. The puffs of smoke emerging from the stacks combine with the mist rising from the river to envelope the scene in a pearly atmosphere as the water gently carves its course, its tranquil waters undisturbed by tugs or barges. It is a vision evocative of the dreamy Thames nocturnes of James MacNeill Whistler or Monet's misty London scenes; and the mountain-top vantage point recalls earlier Hudson River School landscapes in which the wonder of the scenery unfolding below is enhanced by the height from which it is viewed. Such links to a visual past — 19th-century American landscape painting and early forms of modernism — authenticate O'Keeffe's modern experience by placing it within a historical context. Additionally, the nominal focus on the East River, rather than the factories surrounding it, reinserts nature into the industrial landscape, "superimposing order, peace,

and harmony upon our modern chaos."[16] Nature, with its smooth contours, softens the hard edges of the city and the overwhelming mechanization of urban modernity; it embraces and naturalizes the Machine Age metropolis, bolstering and authenticating urban life.[17]

The idealized view of technology and the urban landscape as expressed in *East River* legitimizes the New America, embodied in New York, its modernity and its material progress and successes. Machine Age culture and its worship of technology grew as the prosperous 1920s continued to unfold. Henry Ford called industry "the New Messiah" and hired Sheeler, who called factories "our substitute for religious expression," to photograph his brand new manufacturing complex at River Rouge in 1927.[18] The paintings he later produced from that photographic essay have become iconic for their embrace of the industrialized landscape and their equation of American industrialized architecture with the classical past (1930) [Fig. 34]. That same year was an apogee of sorts for the Precisionist aesthetic. The Machine Age Exposition, held at Steinway Hall in New York, under the auspices of the modernist magazine, *The Little Review*, juxtaposed paintings with actual machines and photographs of factories, grain elevators, and power plants. Installed by Marcel Duchamp, the exhibition celebrated artists who rendered

Fig. 34 Charles Sheeler (1883-1965)
American Landscape, 1930
Oil on canvas; 24 x 31 inches
Collection of the Museum of Modern Art, New York
Gift of Abby Aldrich Rockefeller
Digital Image © The Museum of Modern Art/ Licensed by SCALA/ Art Resource, NY

focus of the view is now the factory rather than the river. The landscape resonates with a sense of unease and alienation. Reflections ripple out from the factories across the water's surface, and their garish and unnatural blood-red color shocks. Stripped of its organic qualities and naturalizing power, the river becomes part of a mechanized urban tableau. The sun does not shine benevolently here. Instead, it is a giant robotic eye — one with strong visual resemblance to the searchlights that both illuminate and scan the city in *Metropolis*. Its rays rake across the water aggressively and are a far stretch from the benevolent sun that shines over the city in Marin's *Lower Manhattan.*

Even if the cool and rational Precisionist landscapes contained varying expressions and aesthetic responses to the modern city, they remained symbols of commercial culture, the foundation of which collapsed with the stock market crash in 1929. Georgia O'Keeffe stopped painting the industrial landscape entirely in 1929, disillusioned — as was most of the nation — with American capitalism and its towering symbols of economic power. The denaturalized, "over refined and inexpressive" visions of the metropolis and the impersonalized culture it represented seemed out of step with reality.[21] Some artists turned away from the city to paint instead idealized visions of America's heartland, and others found stability in the everyday life of the present," in a renewed celebration of the urban scene.[22] Some continued to celebrate New York, even as the Depression robbed skyscraper architecture and Manhattan of much of their artistic allure.

Edward Bruce's *Power* (c. 1933) [Cat. 10], is a glowing vision of New York and its commercial and industrial might that merges the crisp, mechanical forms of Precisionism with a more personalized approach to industry and technology and its future promise. At the time the painting was completed in 1933, Bruce, a former businessman and successful entrepreneur, had just been named head of the federal art relief programs, and some of the ideals of social rejuvenation that underpinned those efforts have filter into his depiction of Downtown Manhattan.[23] The palette is soft, with pastel colors kissed by the sun; the shapes

the imagery of the era "into dynamic beauty by pictorially rendering the pure form and design of indigenous American architecture… of smokestacks, factories, and gas tanks," and equated the history of technological progress with American history[19] (1927) [Fig. 35].

At the same time the Machine Age Exposition celebrated industrial imagery, other visual documents questioned the worship of technology. The now landmark film, *Metropolis*, by the German Expressionist filmmaker Fritz Lang, was also released in 1927. Lang initially conceived of the film in 1924, upon entering New York's harbor and witnessing for the first time the city's impressive skyline — both sublimely awful and immensely stimulating. Although the film celebrated the modern metropolis and the power of technology to transform contemporary life, it was also a cautionary tale about the inhumanity of technology and a pessimistic vision of a future based on it.[20]

While there is no evidence to suggest that O'Keeffe saw the film, the concerns it raised about the mechanization of the urban landscape were certainly in the air when she painted another of her East River series, *East River from the Shelton* (c. 1927–28) [Cat. 55]. The artist's earlier assertions about the positive influence of the city's "strong warm grip" on the modern artist notwithstanding, this scene, painted in the year *Metropolis* was released, is strikingly different from her earlier canvas. Cropped and with a lower vantage point, the

Cat. 10 Edward Bruce. *Power*, c. 1933

of the skyscrapers are more gently volumetric than the rigid boxes in Ault's *From Brooklyn Heights*, and gently slope upward into the sky. The celestial light bathing the city and river from above speaks to an overwhelming optimism and quasi-religious faith in the power of industry and man, one that will lead the nation — vis-à-vis Manhattan and the power of American industry it represents — out of crisis. Brooklyn Bridge, a previous generation's icon of modernity, functions as a counterpoint to modern Manhattan, and situates the metropolis into a historical continuum and a shared sense of pride and national identity grounded in American technological achievements and commercial power.

Bruce's overwhelmingly optimistic vision of the city and industrial progress were supported by "picture magazines" like *Fortune, Life,* and *Look,* all founded between 1929 and 1936. Their commissions of photographs as well as paintings of industrial subjects throughout the 1930s and 40s stimulated a continued appetite for technological forms.[24] *Fortune*

was the leader of the three in promoting industrial imagery, merging it on the page with visions of progress and profiles of the men and companies responsible for the economic

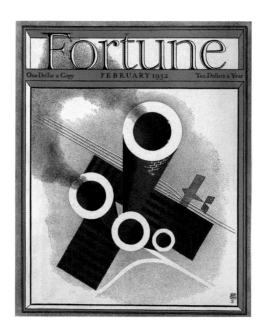

Fig. 36 Cover. *Fortune,* February 1932
Collection of the Hudson River Museum

Cat. 49 Reginald Marsh. *City Harbor*, 1939

back on Manhattan, he paints instead the industrial shoreline of New Jersey in a multi-layered and chaotic composition that swoops and whorls in a maelstrom of activity. Gritty wharves, belching chimneys, and busy tugs are rendered with swift, expressive strokes of paint, and pulse with raw power. The monumental ocean liner — the floating equivalent of the skyscraper—appears dwarfed by the ramshackle factories, hills, and spunky tugs that seem to push it out of the picture. The picture is as much a portrait of a working industrial harbor as it is a rebuke of the sleek and crystalline Precisionist metropolis.

Marsh also found the wharves lining the city's outer edges along the shores of Brooklyn and Queens irresistible subjects for his brush. Although better known today for his raucous portraits of New York street life, burlesque and vaudeville shows, and the packed beaches of Coney Island, Marsh's industrial landscapes, although devoid of his usual colorful inhabitants, are similarly rich with texture. In *City Harbor* (1939) [Cat. 49], and *Tugboat at Dockside* (1932) [Cat. 50], he masses derricks, smokestacks, masts, docks, and water towers into tight, rhythmic arrangements. Marsh's expressive approach is reminiscent of Marin's undulating views of Manhattan from twenty years earlier but this a transformed aesthetic, more socially conscious and sober and in keeping with the times. New York's skyline, seen in the distance in *Tugboat at Dockside*, is important only as a backdrop. These are not portraits of the idealized metropolis but explorations of the reality of the modern city and its working underbelly. It is sooty and drab; its timbers are worn and split; and its dockside piers are battered and weathered by the continuous slap of waves and tides. The dark smudge of smoke belching from the tug's stack is neither sleek, nor misty, nor romanticized. Stripped of mystery, the city is downright dirty. Even New York's famous

skyline, viewed from the docks of working-class Brooklyn, appears to have lost its glamorous sheen as in his *New York Skyline* (1937) [Cat. 51]. The Chrysler and Empire State buildings soar into the air, but revealed in the bright, even light of a midday sun, and rendered in Marsh's mud-brown palette, they are earthbound rather than scrapers of the sky.

To a degree Marsh's urban landscapes explore the desolation of the city's shoreline caused by its industrialization. George Parker's response to the urban decay along the city's rougher edges is more overt in the powerful *East River, N.Y.C.* (1939) [Cat. 60]. Smoke fills the scene, from the stacks of the ships to the furnace chimneys in the city across the river, to the smoke that will soon curl from the cigarettes being lit on the dock. Smoke hangs over the city like a viscous, greenish shroud. Turgid waves lapping at the hulls of the ships replace the smooth, crystalline waters in the cityscapes of Lozowick and Bruce. Parker puts people back into the industrial environment, a move that reflects the impulse for documentation of the city's social conditions in the New Deal era. And, in a reversal of Precisionist visual motif, Parker monumentalizes the figures of the workers against a backdrop of a diminished city. In his vision of the urban metropolis, the skyscraper does not majestically rise above the

Cat. 60 George Parker. *East River, N.Y.C.,* 1939

PAINTING MANHATTA

Fig. 38 *The Henry Hudson Bridge under construction,* June 19, 1936
Courtesy of MTA Bridge and Tunnels Special Archive
Photography: Richard Averill Smith

watery fray, but is mired deeply in it, struggling to be seen through the haze, and all but ignored by the workers standing on the docks.

While both Marsh and Parker included Manhattan's skyline as a backdrop to their scenes of the city's wharves and docks, John Noble and Aaron Douglas chose to excise the city altogether in their depiction of the urban landscape (as Lawson had done), focusing their attention instead on the development of the city's outer reaches. Noble's *Building of Tidewater* (c. 1937) [Cat. 53], likely documents the construction of a new petroleum refinery for the Tidewater Oil Company, which merged with Getty Oil the same year. Although his approach is documentary in nature, Noble incorporates aspects of the visual motifs of the Precisionist metropolis in his monumentalization of the pipeline and the juxtaposition of the smokestacks and towering construction crane against the grid-like structure of the refinery's valves and pipes. The completed refinery chimneys, barely seen in the distance in the left middle ground, echo New York's skyscraper skyline and reinforce the Tidewater plant's awesome sprawl across the landscape. By foregrounding and monumentalizing the power plant in his *Power Plant in Harlem* (1934) [Cat. 22], Aaron Douglas similarly demonstrates

that miles north of the city's center the visual imagery of the urban sublime still contained remarkable visual power.

Douglas takes as his subject the construction of one of many improvement projects that shaped New York's urban environment during the 1930s, most of which were new bridges and roadways overseen by Robert Moses, the city's master urban planner (who favored highways over mass public transit). Getting people in and out of the new metropolis still posed a challenge — the city has more than five hundred miles of shoreline and its rivers and bays are wide. The Port of New York (renamed the Port Authority of New York and New Jersey in 1971) had been established in 1921 to coordinate the development of New York Harbor, its rivers, and its transportation infrastructure, but it was not until the following decade that most of the bridges linking Manhattan, its outer boroughs, and the suburbs were constructed. If monumental skyscrapers had characterized the 1920s, then the titans of the 1930s were bridges. The Port's commissioners approved and supervised the construction of two bridges — George Washington (1931) and Bayonne (1931) — and five additional bridges were constructed under the jurisdiction of the Triborough Bridge and Tunnel Authority: the Triborough, 1936; Henry Hudson, 1936 (1936) [Fig. 38]; Marine Parkway, 1936; Bronx-Whitestone, 1939; and, Cross-Bay Parkway, 1939.[31] These developments transformed the city into a cohesive entity but as symbols of access and movement they also reshaped the ways artists experienced and recorded the urban landscape.

At the time of its construction

(1927-31), the George Washington Bridge was the longest single-spanned structure in the world. The awesome beauty of the bridge's naked frame, with its web of interlacing steel girders and cables in stark relief against the monumentality of the Palisades on the one side and the skyscrapers of Manhattan on the other, won over most critics. Its record length of 3,500 feet doubled the existing record, made it a modern marvel of engineering, and the architectural icon of the age. The bridge was designed to address the needs of the city's burgeoning automobile traffic but like the Brooklyn or Queensboro bridges it was also an aesthetically appealing and technologically innovative structure.

Certainly the French modernist architect Charles-Édouard Jeanneret-Gris (Le Corbusier) loved everything about its sublime grace and power and described it in language that verged on the elegiac. In 1936, he wrote:

The George Washington Bridge over the Hudson is the most beautiful bridge in the world. Made of cables and steel beams, it gleams in the sky... It is blessed. It is the only seat of grace in the disordered city. It is painted an aluminum color and, between water and sky, you see nothing but the bent cord supported by two steel towers. When your car moves up the ramp the two towers rise so high that it brings you happiness; their structure is so pure, so resolute, so regular that here, finally, steel architecture seems to laugh.[32]

Margaret Bourke-White, who photographed the bridge for a photo essay on New York's Port Authority for *Fortune* in 1933,[33] [Fig. 39], shared Le Corbusier's enthusiasm for the beauty of the bridge's pure form. Her close-cropped image of the bridge's latticed beams and gossamer cables is a sharp and bold embrace of the precision and beauty of the bridge's structure and a forceful evocation of its discovery and celebration of the "forms and abstract qualities in America's industrial landscape."[34]

George Ault also painted the George Washington Bridge (1932) [Fig. 40], shortly after its completion, but his approach to the structure was entirely different from Bourke-White's decontextualized images. Where Bourke-White focused on its formal and structural qualities and cropped out all natural elements from the scene — the banks of the Hudson River and the surrounding Palisades — Ault includes the grassy and tree-lined banks of the Hudson, its water shimmering and silver, with the shadow of the Palisades looming in the distance. His brushwork is just

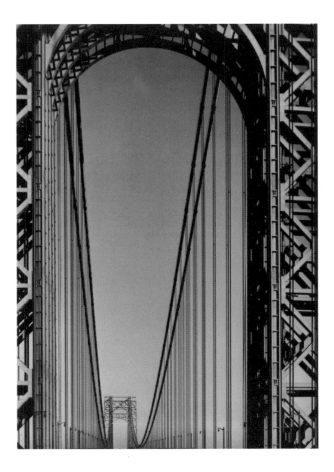

Fig. 39 Margaret Bourke-White (1904-1971)
The George Washington Bridge, 1933
Gelatin silver print; 13 ⅛ x 9 ³/₁₆ inches
Collection of The Metropolitan Museum of Art
Ford Motor Company Collection
Gift of Ford Motor Company and John C. Waddell, 1987
(1987.1100.339)
Photo © Estate of Margaret Bourke-White/ Licensed by VAGA, New York, NY
Image © The Metropolitan Museum of Art / Art Resource, NY

PAINTING MANHATTA

Fig. 40 George Ault (1891-1948)
George Washington Bridge, 1932. Oil on canvas, 24 x 20 inches
Private Collection
Photography: Josh Nefsky

approach, Ault ultimately remains ambivalent about the positive power of the metropolis. As one scholar has noted, the scene retains a faint ominous quality in the way the bridge strides across the landscape,[35] and the artist's decision to truncate the bridge mid-span suggests a degree of hostility toward industrial progress. Instead of directing the eye toward the sublime vision of New York's skyline, as Bruce does in *Power*, Ault selects a view that directs the eye northward, away from the city to the glistening water and lush hills beyond its boundaries — a direction he would himself travel in 1937, when he left the city to settle permanently in Woodstock.

If Ault expunged New York City in favor of cliffs, clouds, and water, to make a statement about

as controlled as in his earlier urban scene *From Brooklyn Heights*, but the curving, organic forms of the shoreline, echoed in the gentle sweep of the rail tracks and dirt road, suggest that — this far north — nature is not yet overpowered by the ordered world of the metropolis. The ethereal and dematerialized bridge rises against the dark shadow of the cliffs and its graceful skyscraper-like towers rise against a backdrop of the Palisades, natural wonders that had amazed and inspired artists of previous generations.

This relatively rural setting enables Ault to explore the intersection of industry and nature in a composition that blends visual motifs of the sublime from the past and the present, inviting the viewer to enter into a dialogue about the ways in which industry and its by-products shape and define modern life and the natural environment. One suspects that, despite the general softening of his

industrialization and urbanization, Aaron Douglas redirects the eye back to the urban grid in *Triborough Bridge* (1936) [Cat. 23], contextualizing the structure within the larger narrative of city life — a realist approach in concert with George Parker's dockside scene *East River*. Like the George Washington Bridge, the Triborough, a complex of three separate bridges that spans the East and Harlem Rivers, as well as the Bronx Kill, to connect Brooklyn, Queens, and Manhattan, was another project of the New Deal era designed to facilitate movement throughout the city. While it may not have been able to compete aesthetically with other bridge projects, the Triborough's massive length — seventeen and a half miles if one includes approaches, viaducts, and overwater jumps — was impressive.[36] Douglas records the bridge just after it opened — only one car is driving up its approach, and the construction

signs announcing the project still stand.

As in *Power Plant in Harlem*, Douglas employs sublime imagery and then grounds it in everyday experience. However, rather than exploring the bridge from a vantage point along the river, as Ault had done in his portrait of the George Washington Bridge, Douglas chose instead to paint the approach to the bridge in Harlem at 125th Street. A direct vantage point, also set in the streets of Harlem, refocuses the eye away from the realm of the skyscraper to one of the city's farthest north and most diverse reaches. Rather than exploring the grid-like structure of the lift towers, Douglas masks them behind a screen of trees and firmly anchors the bridge into the urban fabric — the scene is not really about the bridge, but is instead an exploration of its impact on the urban experience. The effects of urban improvements, like the Triborough Bridge, on the city's inhabitants are usually overlooked or sometimes implied in Precisionist landscapes but Douglas encourages a different discourse. His urban scene demonstrates how the bridge approach not only obscures what might once have been a view of the river but also how it encloses city dwellers into a rather bleak park, carved from the urban landscape. With the bridge on one side and elevated railway tracks on the other, movement is restricted by the very modern developments designed to enhance it.

If Douglas brought industrial iconography into the everyday, Ralston Crawford returned it to the heavens in his painting *Whitestone Bridge* (1939-40) [Cat. 20], a graceful suspension bridge linking the Bronx and Queens, and recently completed when Crawford painted it. The bridge's clean lines and ethereality captivated Crawford, a second-generation Precisionist, who stripped away external elements, natural as well as man-made, to focus on the bridge's essential forms. One of the last great bridge and urban development projects of the 1930s, the Whitestone, like the George Washington Bridge, was as much an aesthetically dynamic design as it was a practical structure made to handle commuter traffic. It was the first bridge to have no diagonal cross braces in its soaring 377-foot towers, a design that created a slender and immaterial structure, much like the skyscrapers rising above Manhattan several miles to the south. *Whitestone Bridge* revisits the Precisionist idiom in its celebration of the design's simplicity and lightness: pure geometry and clean architecture, unhindered by decoration. Crawford's upward view and foreshortening of the suspension cables emphasizes the approach to the towers. They become the gateways, not to the marshy wetlands and industrial wastes of the city on which they were constructed, but rather, magically, to the clouds.

Crawford's perspective was fitting given the bridge's purpose: to provide visitors easy access to the 1939 New York World's Fair in Flushing Meadow Park, which heralded "The World of Tomorrow" in its displays of streamlined trains, modernist architecture, and vast array of consumer goods. By the time the Fair opened, Americans had grown weary of a decade of Depression, and both it and Crawford's *Whitestone Bridge* captured their imagination with the promise of how technology could further enhance modern life. Crawford was a firm believer in technology's transformative potential, that it "represented the liberation of the world from poverty"[37] — a conviction that certainly influenced his *Whitestone Bridge*.

If Crawford's bridge leads us away from the city into unknown vistas, Inna Garsoïan and Marguerite Ohman return us to life within the urban grid. Their views of the East River offer more personal, snapshot-like experiences of the industrial landscape creating accounts of urban life that continue focus away from the massive skyscraper toward other aspects of the urban scene. Ohman's *View of the East River with the Manhattan Bridge, New York City* (1940) [Cat. 56], looks south toward the city but its towers are hidden from view despite the broad, panoramic scene that unfolds from her vantage point — which may be a tenement rooftop in Queens. Like O'Keeffe, Ohman is primarily interested in the river and its intersection with the surrounding industrial landscape, finding visual dynamism in the juxtaposition of the city's geometric patterns and shapes with the softer curves of the water. Her view, however, is

Cat. 26 Inna Garsoïan (1896-1984)
Eastside Drive, c.1940
Oil on canvas, 20 x 16 inches
Collection of the New-York
Historical Society
New York, New York
Gift of Nina Garsoïan, 2001.303

less a statement about the city as the symbolic embodiment of American technology and economic progress than it is a personal account of the urban landscape at a particular moment in time, a project that links her to earlier depictions of modern life.

Garsoïan's *Eastside Drive* (c. 1940) [Cat. 26], reverses Ohman's view, and looks north along the East River, away from the city toward the Queensboro and Hellgate Bridges. It documents the completion of a section of the Eastside Drive, also known as the Franklin Delano Roosevelt Drive, a New Deal project spearheaded by Robert Moses that follows Manhattan's eastern shoreline and connects to the Triborough Bridge at 125th Street. *Eastside Drive* is an exploration, too, of the intersection of the urban grid with the river but it is a softer approach, one that enhances and follows the natural curves of the water in the gentle contours of the Drive, along the eastern boundary of Manhattan. If the painting

lacks the crisp, hard edges of earlier Precisionist city scenes, however, it shares a strong connection to them in its sense of timelessness and detachment, largely achieved through the excision of most of the city's human inhabitants, except for a few tiny figures on a concrete promenade atop the Drive's southbound lanes. At the same time, Garsoïan firmly situates her view within personal experience. The elevated vantage point enables you to take a bird's-eye view of the city much as O'Keeffe did in her own East River scenes, but while O'Keeffe chose to eliminate all traces of her physical space — thereby magnifying her god-like perspective — Garsoïan firmly grounds her view from within the confines of an apartment or studio window. She includes in her view both the window's frame and the building's outer wall, a large vertical stripe across the canvas that frames the view and balances the sweeping curves of the river and roadway.

Garsoïan's direct and matter-of-fact

view of the city seems less a documentation of the urban landscape than a response to larger social issues and the crisis of war looming on the horizon. The section of the FDR she records, pristine and devoid of automobiles, is likely the recently constructed expanse of roadway between 23rd and 34th Streets that had been built on top of a landfill full of rubble brought from the Bristol Blitz and deposited along Manhattan's eastern shoreline. The empty and funereal aspect of her landscape suggests that it is as much a memorial to the destroyed city as it is a record of the continued construction of her own. Garsoïan's sobering vision reminds us that although constantly changing and always new, the world of tomorrow is built on the rubble of the past.

As the decade waned, images celebrating the modern industrial complex and urban landscape became increasingly anachronistic. If the Depression refocused artistic vision away from the towering symbols of New York's economic power, the global devastation of World War II destroyed the belief in industry as a beneficent force that underpinned Machine Age idealism and its images of a sublime and serene metropolis. Following the war, artists attempting to grapple with its meaning would dispense with realism altogether, forging a new "sublime" idiom for urban life in the post-

war era. Even Crawford, one of the few artists who remained dedicated to the industrial and Machine Age language of Precisionism, may have had some doubts after *Fortune* sent him to record the atomic tests at Bikini Atoll in 1946. His near-abstract canvases, comprised of bright, jagged fields of color and rent with screams of black, look as if someone had taken his earlier landscapes and violently shaken them — as, indeed, the bomb had done to the *U.S.S. Nevada* (1946) [Fig. 41], one of the target structures that was placed within in the bomb's range to test its impact.

While very few who attended the New York World's Fair in 1939 could have envisioned what the world of tomorrow might actually bring, they likely had little doubt that it would, in the main, be some version of what New York already symbolized, only more modern. In hindsight, Crawford's *Whitestone Bridge*, with its decontextualized vision leading away from the metropolis off into the sublime skies, proved extremely prescient. With its implied termination among the clouds, *Whitestone Bridge*, quite literally offers a bridge to the future, and symbolically resituates New York within the collective imagination as an embodiment of what that future contains. At the same time, like Ault's *George Washington Bridge*, Crawford's *Whitestone Bridge* represents an actual demographic shift, one that leads away from the city to the suburbs, a cultural re-focus that would shape visions of New York in the post-World War II era.

Fig. 41 Ralston Crawford (1906-1978)
U.S.S. Nevada, 1946
Oil on canvas, 15 ½ x 21 ¾ inches
Courtesy of Alexandre Gallery
© Ralston Crawford Estate

1 John C. Van Dyke, *The New New York: A Commentary on the Place and the People* (New York: Macmillan, 1909), 30.

2 Wanda Corn, *The Great American Thing: Modern Art and National Identity, 1915-1935* (Berkeley: University of California Press, 1999), 175.

3 John Pulz, "Austerity and Clarity: New Photography in the United States, 1920-1940," Michel Frizot, *The New History of Photography* (Cologne: Könemann, 1998), 477.

4 Peter C. Bunnell, "Towards new Photography: Renewals of Pictorialism," in *Frizot*, 326.

5 When the film was initially shown in New York in July 1921, as *New York the Magnificent*, there were no intertitles; it was accompanied by popular tunes from an orchestra, and the audience was encouraged to sing along. Two years later, the film was screened in Paris under the title *Fumée de New York (Smoke of New York)* as part of an avant-garde program organized in part by Marcel Duchamp. It was not until the film was picked up by the International Film Arts Guild (IFAG) and shown in the Cameo Theatre in new York in 1926 that it received broad media coverage. Charles Brock, *Charles Sheeler: Across Media* (National Gallery of Art, 2006), 45. See also Harriet Underhill, *New York Tribune* (July 26, 1921), 6.

6 Peter Conrad, *The Art of the City: Views and Versions of New York* (New York: Oxford University Press, 1984), 80.

7 William E. Leuchtenburg, *The Perils of Prosperity* (Chicago: University of Chicago Press, 1958), 188.

8 Barbara Haskell, *The American Century: Art and Culture, 1900-1950* (New York: The Whitney Museum of American Art, 2000), 147.

9 Karen Lucic suggests that Sheeler was ultimately ambivalent to the urban landscape, and denatured it as much as possible to convey its dehumanizing potential. Additionally, Lucic asserts that Manhatta's "naturalization of the metropolis may be due to Strand's role in the project" even though it was initiated by Sheeler. "In his subsequent work, the artist never again expressed a Whitmanesque optimism toward his subjects, nor did he repeat the use of nature to soften his depictionso furban modernity." *Karen Lucic, Charles Sheeler and the Cult of the Machine* (Cambridge, MA: Harvard University Press, 1991), 53.

10 Stephen Bourgeois, "Introduction," *A Catalogue of Paintings by Stefan Hirsch* (New York: Bourgeois Galleries, 1927) quoted in Andrew Hemingway, *The Mysticism of Money: Precisionist Painting and Machine Age America* (London: Periscope, 2013), 71. Stephen Bourgeois was a gallery-owner and a promoter of Machine Age imagery. Bourgeois wrote these words concerning the work of another Precisionist, Stefan Hirsh, but they are equally applicable to Ault's urban vision as represented here.

11 Andrew Hemingway, *The Mysticism of Money: Precisionist Painting and Machine Age America* (London: Periscope, 2013), 169. Hemingway suggests that Ault was pessimistic, hostile even, toward the city, a sentiment recorded by Martin Friedman, who quoted the artist as referring to skyscrapers as "tombstones of capitalism," and Manhattan as an "inferno without the fire." Martin Friedman, *The Precisionist View in American Art* (Minneapolis: Walker Art Center, 1960), 35.

12 Andrew Hemingway, *The Mysticism of Money: Precisionist Painting and Machine Age America* (London: Periscope, 2013), 156. Hemingway notes Ault's "revulsion from technological modernity, his feelings of homelessness in the contemporary world, and his increasing sense of political despair."

13 Waldo Frank, "Vicarious Fiction," *The Seven Arts* 1 (January 1917), 294. For similar critiques of the industrialization and mechanization of modern urban life, see also Paul Rosenfeld, "Alfred Stieglitz," *The Dial*, 70 (April 1921), 401, and Thorstein Veblen, "The Place of Science in Modern Civilisation," *The American Journal of Sociology* 11 (March 1906); reprinted in *The Place of Science in Modern Civilisation and Other Essays* (New York: B. W. Huebsch, 1919).

14 Georgia O'Keeffe, quoted in B. Vladimir Berman, "She Painted the Lily and Got $25,000 and Fame for Doing it," *New York Evening Graphic Magazine* Section, May 12, 1928.

15 Bunnell, 319.

16 Leo Marx, *The Machine in the Garden* (New York: Oxford University Press, 1964), 355-56. Marx wrote these remarks in regards to Charles Sheeler's *American Landscape*, but they seem equally fitting to O'Keeffe's project in her *East River* series.

17 Lucic, 53.

18 Charles Sheeler quoted in Karen Tsujimoto, *Images of America: Precisionist Painting and Modern Photography* (University of Washington Press, 1982), 153. Karen Lucic has argued that assertions such as these may actually reflect Sheeler's ambivalence toward the cultural dominance of industry and industrial imagery, rather than an embrace of it. See Lucic, 74.

19 Haskell, 156. See also Jean Heap, *Machine Age Exposition: Catalogue* (New York: Little Review, 1927). The catalogue included essays by Hugh Ferriss, Alexander Archipenko, and Louis Lozowick, and had a cover by Ferdnand Léger.

20 Donald Albrecht, *Designing Dreams: Modern Architecture in the Movies* (New York: Harper & Row, 2000), 156-157.

21 Gail Stavitsky, "Reordering Reality: *Precisionist Directions in American Art, 1915-41*," Gail Stavitsy, Precisionism in America, 1915-1941: *Reordering Reality* (New York: Harry N. Abrams, 1995), 24.

22 Haskell, 256.

23 In 1933, Bruce was appointed Chieft of the short-lived Public Works of Art Project, a federal New Deal program within the U.S. Treasury Department that hired artists to decorate public buildings and parks. In 1934, Bruce helped to establish and was appointed the Director of the Treasury Department's Section of Painting and Sculpture, which was renamed the Section of Fine Arts in 1938. He wcs later appointed to the Commission of Fine Arts, where he served from 1940 until his death in 1943.

24 Karen Tsujimoto, *Images of America: Precisionist Painting and Modern Photography* (University of Washington Press, 1982), 164.

25 "Purpose," *Fortune*, February 1930, 38.

26 "Portrait of a Contented Man," *Fortune* 3 (May 1931), 73-75. As the article notes, after nearly twenty years in business in the Philippines and New York, Bruce gave up painting in 1922, at the age of forty-four, and went to Italy for three years to study with Maurice Sterne.

27 Michael Augspurger, *An Economy of Abundant Beauty: Fortune Magazine and Depression America* (Cornell University Press, 2004), 73.

28 Augspurger, 73.

29 Edward Bruce as quoted in Haskell, 220.

30 Van Dyke, 31.

31 *The Goethals* and *Outerbridge Crossing Bridges* were both completed in 1928. An additional twenty-one bridges were constructed between 1921 and 1942 under the auspices of the New York Department of Transportation. For a complete list, see Sharon Reier, *The Bridges of New York* (Mineola, New York: Dover Publications, 1977), 154-157.

32 Le Co-busier (Charles Edouard Jeanneret), "A Place of Radiant Grace." *When the Cathedrals Were White* (1936), as reprinted in Kenneth T. Jackson and David S. Dunbar, eds., *Empire City: New York Through the Centuries*, 616.

33 "Port of New York Authority," *Fortune*, September 1933.

34 Elizabeth Sacartoff, *A New Realism*, exh. cat. (Cincinnati: Cincinnati Art Museum, 1941), 3.

35 Andrew Hemingway, *The Mysticism of Money: Precisionist Painting and Machine Age America* (London: Periscope, 2013), 203.

36 Reier, 118-130.

37 Ralston Crawford, from an unpublished essay by Malcolm Preston (dated late 1940s), as quoted in Haskell, 159.

38 Michael Pollack, "Not in Their Backyard," *New York Times*, June 26, 2009. The German Luftwaffe bombed Bristol heavily in 1940. American ships carried supplies to the city, loaded their hulls with rubble for ballast, and dumped it in a landfill between 23rd and 34th Streets, an a spot now known as the Bristol Basin.

INDUSTRIAL SUBLIME

The Paintings

1

Kurt Albrecht (1884-1964)
UNTITLED (BROOKLYN BRIDGE), c.1920

Oil on canvas, 28 x 37 inches
Collection of Martin J. Maloy

V ERY LITTLE IS KNOWN about Kurt Albrecht, a painter of urban landscapes and street scenes, who was born in Germany in 1884. While only in his mid-twenties, Albrecht had two paintings selected for inclusion in the annual Great Art Exhibitions of 1909 and 1910 in Berlin. At some point, probably in the late teens, Albrecht came to New York and produced a body of work depicting its lively and colorful street life. Brooklyn Bridge, with deft brushwork and delicate color demonstrates the artist's skill as well as his delight in encountering the sprawling modern metropolis. Although unknown in America, Albrecht achieved enough acclaim in his native country to be included in a 2006 exhibition at the Schirn Kunsthalle Frankfurt, *The Conquest of the Street*, which included works by other painters of the urban scene such as Claude Monet and Camille Pissarro. KMJ

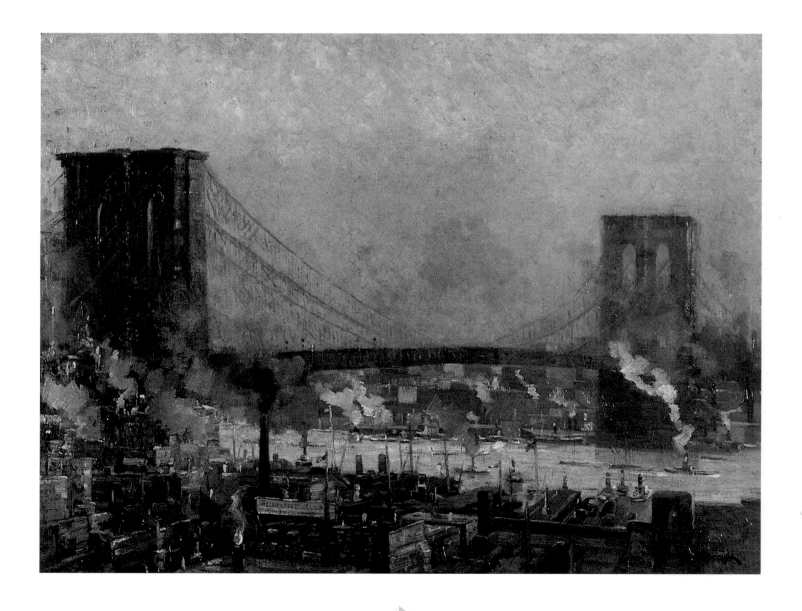

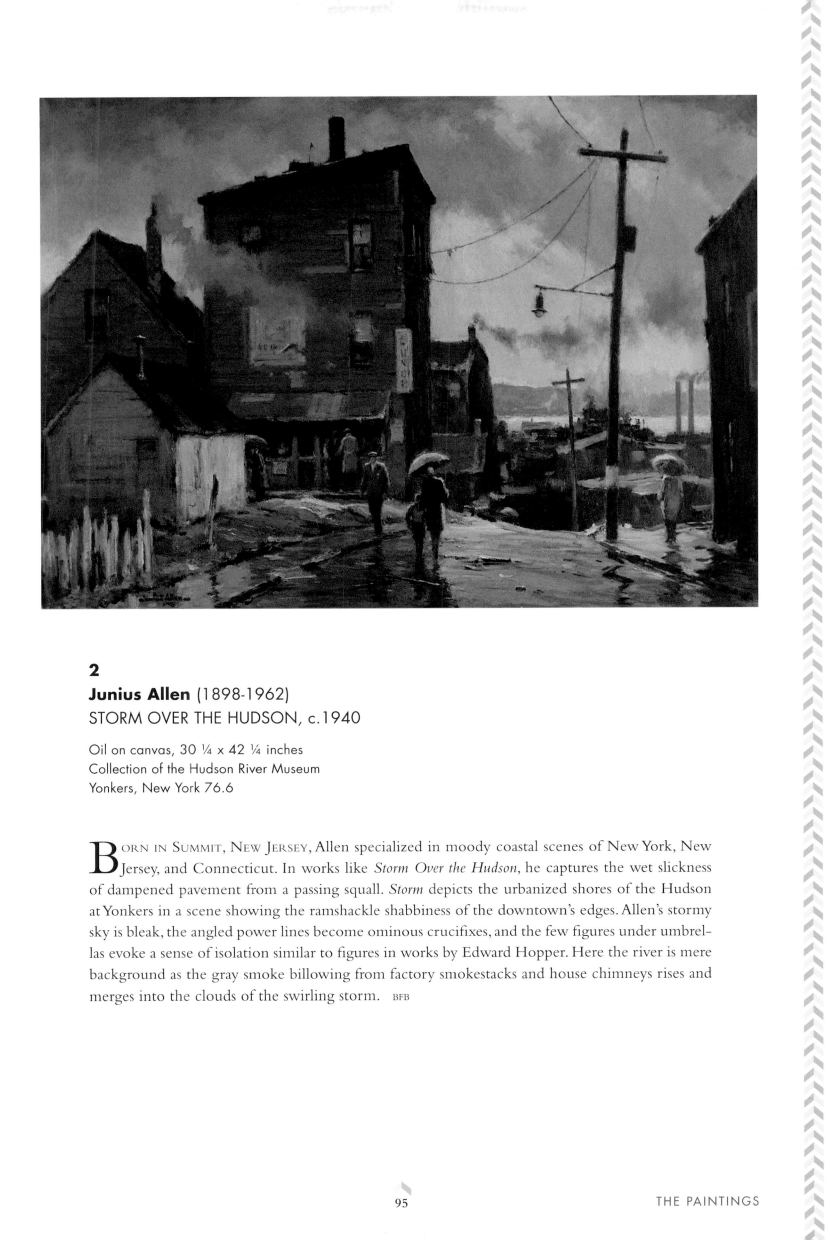

2
Junius Allen (1898-1962)
STORM OVER THE HUDSON, c.1940

Oil on canvas, 30 ¼ x 42 ¼ inches
Collection of the Hudson River Museum
Yonkers, New York 76.6

Born in Summit, New Jersey, Allen specialized in moody coastal scenes of New York, New Jersey, and Connecticut. In works like *Storm Over the Hudson*, he captures the wet slickness of dampened pavement from a passing squall. *Storm* depicts the urbanized shores of the Hudson at Yonkers in a scene showing the ramshackle shabbiness of the downtown's edges. Allen's stormy sky is bleak, the angled power lines become ominous crucifixes, and the few figures under umbrellas evoke a sense of isolation similar to figures in works by Edward Hopper. Here the river is mere background as the gray smoke billowing from factory smokestacks and house chimneys rises and merges into the clouds of the swirling storm. BFB

THE PAINTINGS

3
George Ault (1891-1948)
FROM BROOKLYN HEIGHTS, c.1925-1928

Oil on canvas, 30 x 20 inches
Collection of the Newark Museum, Newark, New Jersey
Purchase 1928 The General Fund, 28.1802

AULT STUDIED PAINTING at the Slade School of Art and St. John's Wood Art School in London, where his family had moved while he was a boy. He returned to the United States in 1911 and settled in Hillside, New Jersey, where he began painting impressionist landscapes. Ault adopted the more contemporary style and the iconography of urban modernism seen in *From Brooklyn Heights* a few years later, probably through contact with artists like Oscar Bleumner, Edward Bruce, Georgia O'Keeffe, and Louis Lozowick. Although critics celebrated his "personal sense of the relation of form and color," others found Ault's combination of boxy shapes and a restricted palette somber and disquieting. This view, painted from his studio window, depicts New York with clock-like precision, the crisp geometric forms suggesting the sleek Art Deco skyscrapers of Manhattan's skyline. KMJ

4
Gifford Beal (1879-1956)
ON THE HUDSON AT NEWBURGH, 1918

Oil on canvas, 36 x 58 ½ inches
The Phillips Collection, Washington, D.C.
Estate of Gifford Beal
Courtesy of Kraushaar Galleries, New York

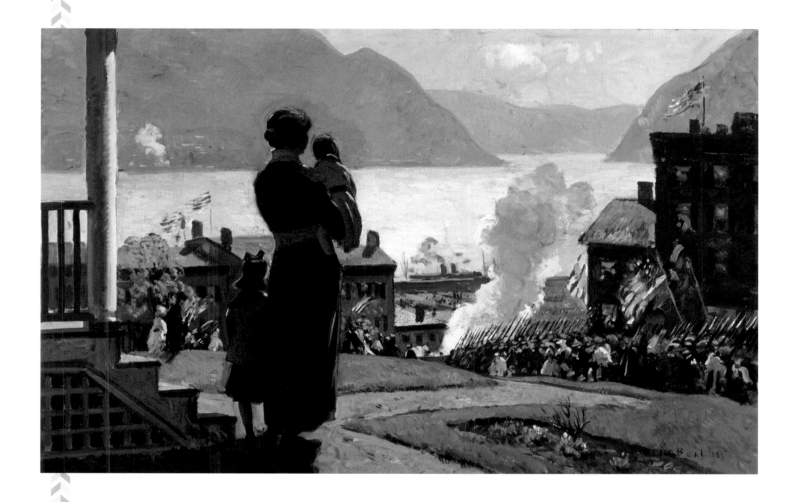

BEAL CREATED GRANDLY BEAUTIFUL PAINTINGS but he was something of a retrograde figure in American art. One critic in the 1920s described him as the "sole surviving Hudson River School painter" after the "desertion" of Ernest Lawson and Van Dearing Perrine, and stated flatly that the School had largely died with "Kensett, Cole, Doughty, Durand, and Bierstadt." Nevertheless, *On the Hudson at Newburgh*, painted as the United States entered World War I, represents a significant accomplishment, in which Beal captures the sublimity of Hudson River School painting, and grafts onto it a reverential awareness of the rising place of the modern world in the traditional landscape. BFB

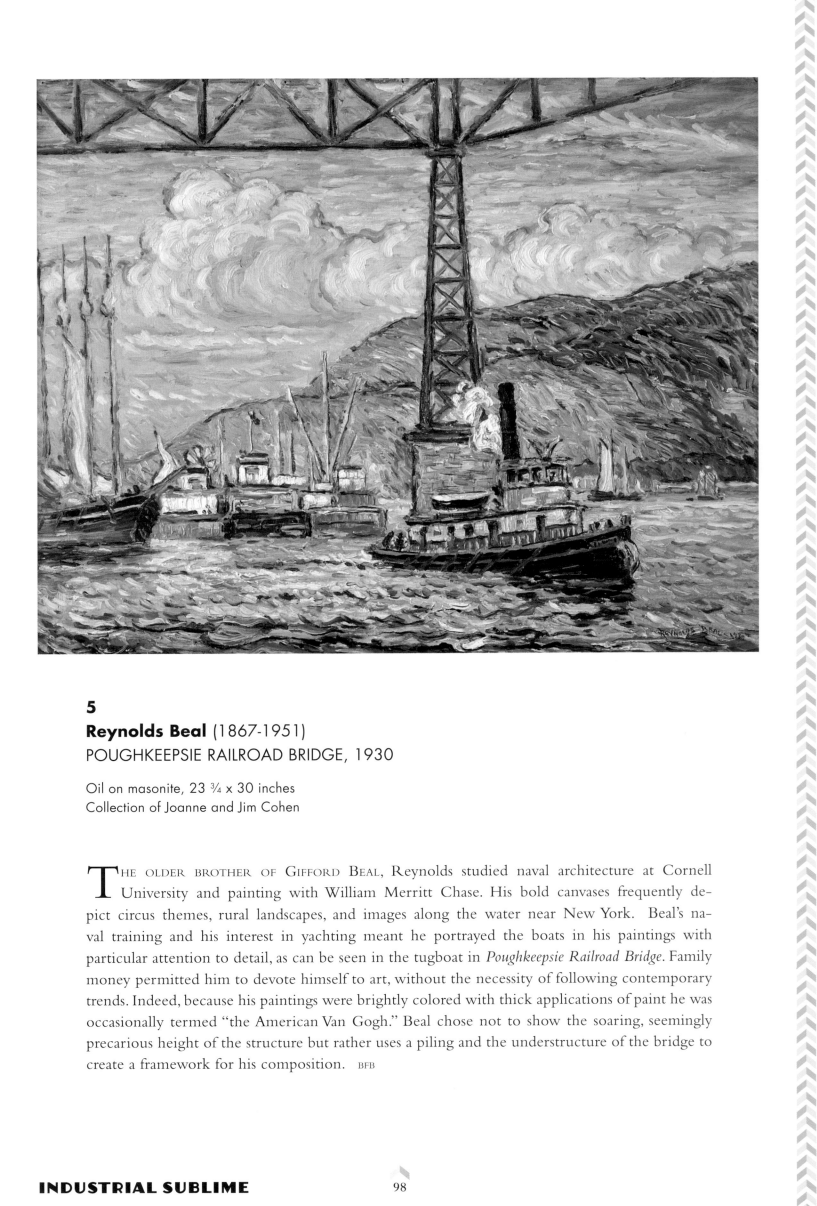

5
Reynolds Beal (1867-1951)
POUGHKEEPSIE RAILROAD BRIDGE, 1930

Oil on masonite, 23 ¾ x 30 inches
Collection of Joanne and Jim Cohen

THE OLDER BROTHER OF GIFFORD BEAL, Reynolds studied naval architecture at Cornell University and painting with William Merritt Chase. His bold canvases frequently depict circus themes, rural landscapes, and images along the water near New York. Beal's naval training and his interest in yachting meant he portrayed the boats in his paintings with particular attention to detail, as can be seen in the tugboat in *Poughkeepsie Railroad Bridge*. Family money permitted him to devote himself to art, without the necessity of following contemporary trends. Indeed, because his paintings were brightly colored with thick applications of paint he was occasionally termed "the American Van Gogh." Beal chose not to show the soaring, seemingly precarious height of the structure but rather uses a piling and the understructure of the bridge to create a framework for his composition. BFB

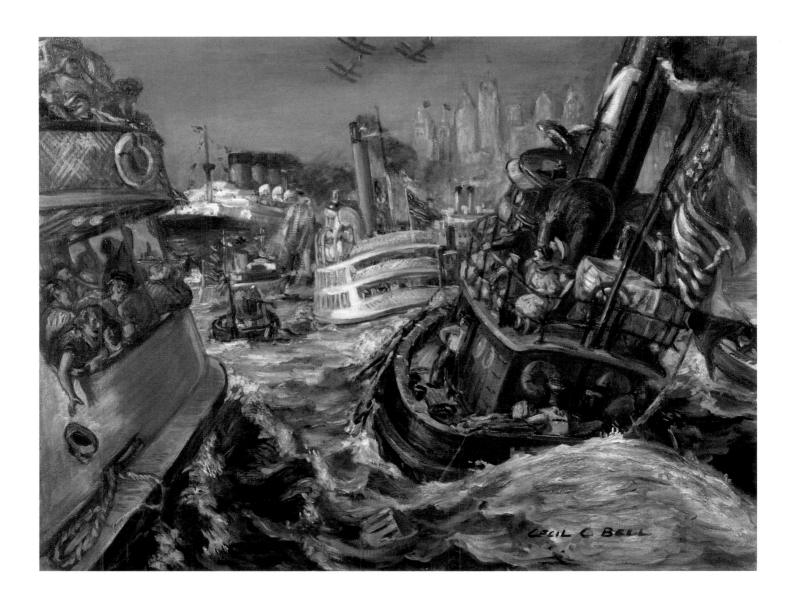

6

Cecil Crosley Bell (1906-1970)

WELCOMING THE QUEEN MARY, c.1937

Oil on canvas, 36 x 48 inches
Collection of the Staten Island Museum, Staten Island, New York
Gift of Agatha Bell Kower, A1973.12.1

Bell was born in Seattle and moved to New York City in 1930, where he began his studies at the Art Students League. He is one of the best-known students of Ashcan School painter John Sloan, and embraced his teacher's signature rollicking style when depicting scenes of the urban populace. *Welcoming the Queen Mary* ranks among Bell's grandest and most satisfying canvases from his many that show New York Harbor and the Staten Island ferries, one loaded with sightseers on the left side of this painting. Amongst the heaving ships, the skyline, and celebratory planes flying in formation overhead, Bell's composition rises to a level that could be termed the "Populist Sublime." The energy in Bell's painting reflects the revitalization of Urban Scene painting in the 1930s, most notably by Reginald Marsh. The vigor in Bell's composition was also adopted by older artists such as Ernest Lawson in his work *Hoboken Waterfront* [Cat. 35]. BFB

7
George Bellows (1882-1925)
WINTER AFTERNOON, January 1909

Oil on canvas, 30 x 38 inches
Collection of the Norton Museum of Art, West Palm Beach, Florida
Gift of R.H. Norton, 49.1

West Palm Beach only

RAISED IN COLUMBUS, OHIO, Bellows was a student of Robert Henri but his youth prevented him from submitting his work to the landmark 1908 exhibition "The Eight," which included other key Ashcan School figures, such as Luks, Sloan, and Henri, artists Bellows was now closely identified with. Although Bellows is best known for his boxing scenes, he was a magnificent painter of the urban landscape. *Winter Afternoon* is a particularly strong example of the urban winter scenes Bellows created between 1908 and 1913. In them, Bellows employs distinctive icy blue–white coloration, lusciously applied paint, and strong composition highlighted by snow to create a series of paintings that stand near the pinnacle of early American Modernism. BFB

8

Oscar Bluemner (1867-1938)

HARLEM RIVER, 1912

Watercolor on paper, 14 x 20 inches
Collection of Artis - Naples, The Baker Museum
Museum Purchase, 2000.15.012

ᴮORN NEAR HANOVER, GERMANY in 1867, Oscar Bleumner studied painting and architecture at Berlin's Royal Technical Academy, and he received his degree in 1892. A few months later he traveled to Chicago, finding work as a freelance draftsman for the World's Columbian Exposition. He later moved to New York, where, in 1903, he submitted the winning design for the Bronx Borough Courthouse. Around 1910, under the aegis of Alfred Steiglitz, Bleumner shifted his focus to painting but his dramatic Cubist forms and chromatically structured landscapes reflect his early architectural training. His watercolors like *Harlem River*, which was exhibited at the Armory Show in 1913, have softer edges but their rich colors pay homage to Symbolist painting and German Expressionism, and offer a bold counterpoint to the impressionist cityscapes popular at the time.

KMJ

9

Daniel Putnam Brinley (1879-1963)
HUDSON RIVER VIEW (SUGAR FACTORY AT YONKERS), c.1915

Oil on canvas, 31 ⅞ x 30 ⅛ inches
Collection of the Hudson River Museum, Yonkers, New York
Museum Purchase, 95.3.1

DANIEL PUTNAM BRINLEY GREW UP IN COS COB, Connecticut and studied painting with John Henry Twachtman at the artist colony there and at the Art Students League in New York. During a trip to Europe, Brinley became associated with artists John Marin and Max Weber, and his work began to exhibit more modernist tendencies. Upon his return to New York, Brinley exhibited at Alfred Steiglitz's Gallery 291 and was instrumental in the organization of the Armory Show. As seen in *Hudson River View*, Brinley's mature style is a vibrant mélange of impressionism and the flattened forms and structural concerns of modernism. KMJ

10
Edward Bruce (1879-1943)
POWER, c.1933

Oil on canvas, 30 x 45 inches
The Phillips Collection, Washington, D.C.
Gift of Mrs. Edward Bruce, 1957

Yonkers only

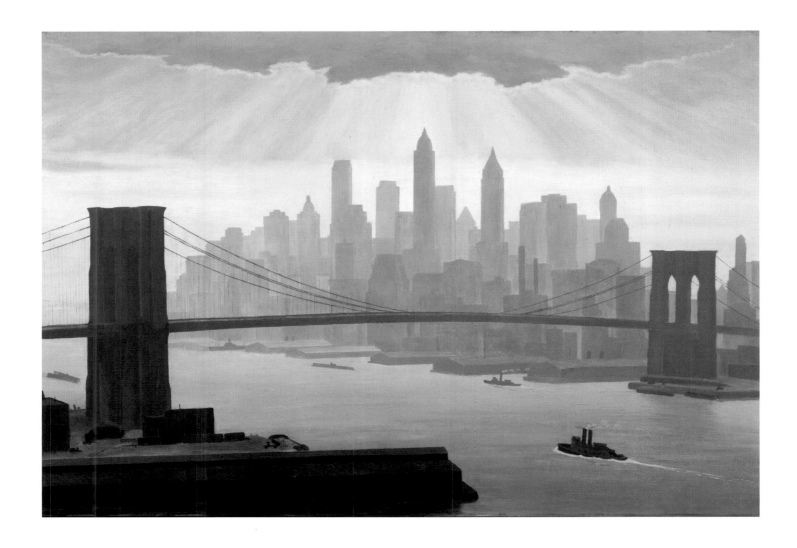

EDWARD BRUCE BEGAN PAINTING at an early age but he trained as a lawyer, receiving a law de-
gree from Columbia in 1904. Bruce amassed a fortune practicing international law in New
York and Manila, Philippines, before shifting his focus to banking and trade in the Far East. While
abroad, he began collecting Asian art and it may have been this pastime that led him to abandon
business at the age of forty-three to focus on making art. Bruce spent the next six years studying
painting with Maurice Stern in Italy, before returning to New York in 1929. The son of a minister,
he infused his landscapes with a spiritual quality, seen here in the shafts of light that break through
the clouds and envelope Manhattan in radiant aura. KMJ

THE PAINTINGS

11

Theodore Earl Butler (1861-1936)

BROOKLYN BRIDGE, 1900

Oil on canvas, 30 ¼ x 40 inches
Courtesy of Hawthorne Fine Art. LLC, New York, New York

Yonkers only

B UTLER, WHO WAS BORN IN COLUMBUS, OHIO, studied at the Art Students League of New York with William Merritt Chase and Thomas Wilmer Dewing. Butler had considerable artistic success after studying in Paris, and he married two of Claude Monet's stepdaughters in succession, while moving between France and New York and acting as a cultural link for American artists abroad. The influence of Monet can be seen in Butler's fizzy, celebratory painting done in highly keyed roses and blues. In this painting he captures the excitement of the dawn of the new "American" century, amid billowing smoke, a soaring bridge, and a flag waving jauntily from the top of a turret. BFB

12

Carlton Theodore Chapman (1860-1925)

THE EAST RIVER, NYC, 1904

Oil on canvas, 17 x 35 inches
Collection of the New-York Historical Society, New York, New York
Gift of Mrs. Carlton T. Chapman, 1938.425

Yonkers only

BORN IN NEW LONDON, OHIO, Chapman spent his summers as a youth in his uncle's shipyard in Maine, which likely stimulated his taste for marine scenes. After studying at the National Academy in New York and the Académie Julian in Paris, Chapman was commissioned to create illustrations of scenes of marine battles for a historical volume, *Naval Actions of the War of 1812*. Chapman's illustrative skill is seen in *The East River*, where he chooses a surprisingly neutral position from the mouth of the river to depict the bridge. By pulling back to paint the full elegance of the curving span, he sacrifices both the drama of the bridge's distinctive gothic arches as well as the scale of the bridge's monumentality to its surrounding buildings, both of which were visual catnip to other artists of the time. BFB

13

Clarence Kerr Chatterton (1880-1973)
TUGBOAT ON THE HUDSON, 1912

Watercolor and gouache on board, 17 ¾ x 24 ½ inches
Private Collection
Photography: Shannon's Fine Art Auctioneers

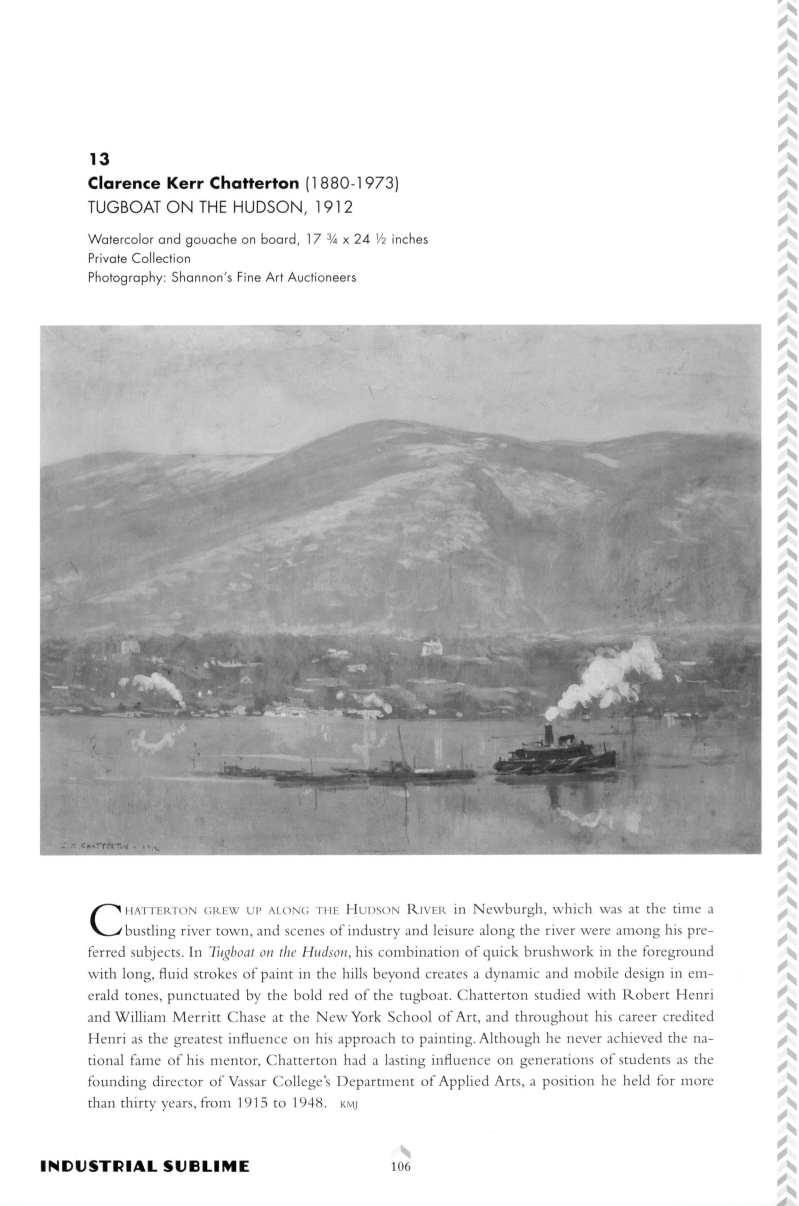

CHATTERTON GREW UP ALONG THE HUDSON RIVER in Newburgh, which was at the time a bustling river town, and scenes of industry and leisure along the river were among his preferred subjects. In *Tugboat on the Hudson*, his combination of quick brushwork in the foreground with long, fluid strokes of paint in the hills beyond creates a dynamic and mobile design in emerald tones, punctuated by the bold red of the tugboat. Chatterton studied with Robert Henri and William Merritt Chase at the New York School of Art, and throughout his career credited Henri as the greatest influence on his approach to painting. Although he never achieved the national fame of his mentor, Chatterton had a lasting influence on generations of students as the founding director of Vassar College's Department of Applied Arts, a position he held for more than thirty years, from 1915 to 1948. KMJ

14
James Rene Clarke (1886-1969)
WASHINGTON BRIDGE, 1920

Watercolor on paper, 14 x 20 inches
Collection of the Hudson River Museum, Yonkers, New York
Gift of the artist, 61.8.1

WASHINGTON BRIDGE, originally known as the Harlem River Bridge, then, the Manhattan Bridge, opened in 1889, spanning the Harlem River, and making the relatively rural Bronx more accessible for development. Eventually, with the opening of the George Washington Bridge across the Hudson in 1931, the Harlem Bridge became part of the Interstate Highway System. One of its two steel arches spans the Harlem River, the other, the tracks of the Penn Central Railroad. Clarke, a Yonkers' resident, was a commercial illustrator and advertising executive for most of his career, but he worked as a curator at the Hudson River Museum as well. He excelled at watercolor and painted local landmarks in and around Yonkers. Because of his intense interest in architecture, many of his works were painted in winter, allowing him to capture the area's architecture unencumbered by surrounding foliage. BFB

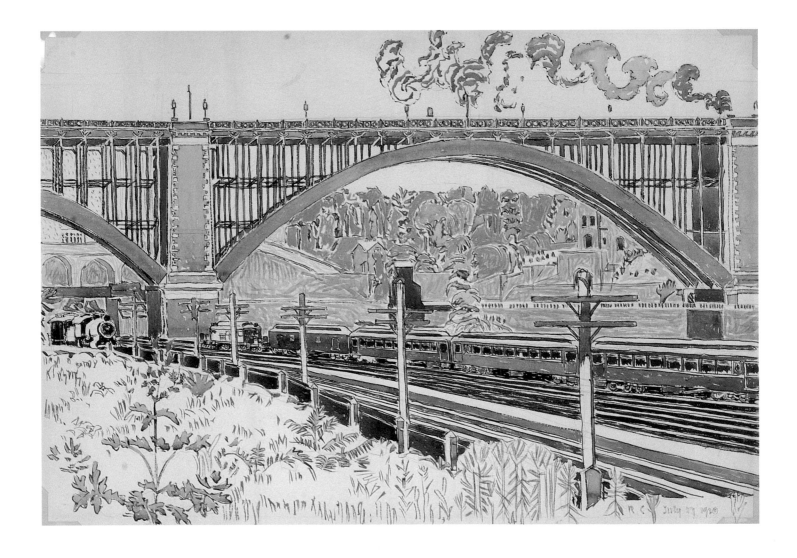

THE PAINTINGS

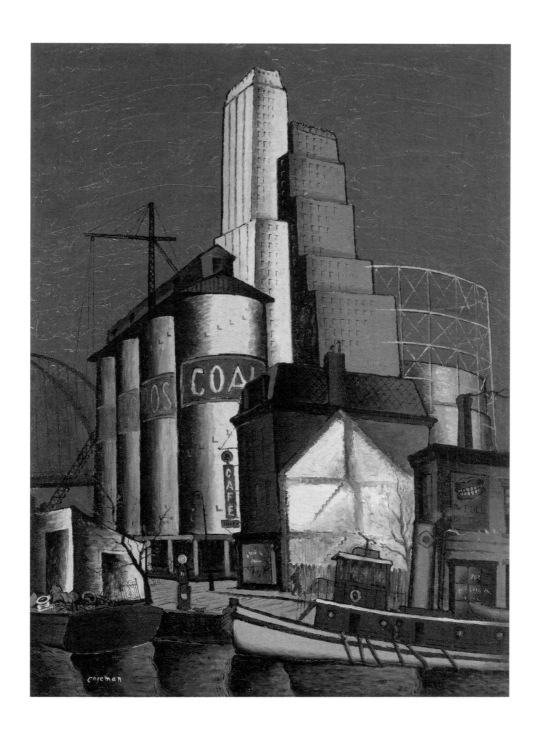

15
Glenn Coleman (1887-1932)
THE DOCK, n.d.

Oil on canvas, 34 x 25 inches
Private Collection
Courtesy Aaron Payne Fine Art, Santa Fe, New Mexico
Photography: Alan Gilbert

Despite Coleman's early interest in city life and street scenes, it was the architecture of the metropolis that became the dominant theme of his painting. Like many artists of his generation, Coleman became interested in Cubism and the paintings of his mature career, such as *The Dock*, demonstrate a strong command of structure and design. Here Coleman combines the hard, square edges of skyscrapers with the rounded forms of coal elevators, bridge spans, gas barrels, and the hull of a tugboat on the river, to create a dynamic portrait of the modern city as seen from its outermost edges. KMJ

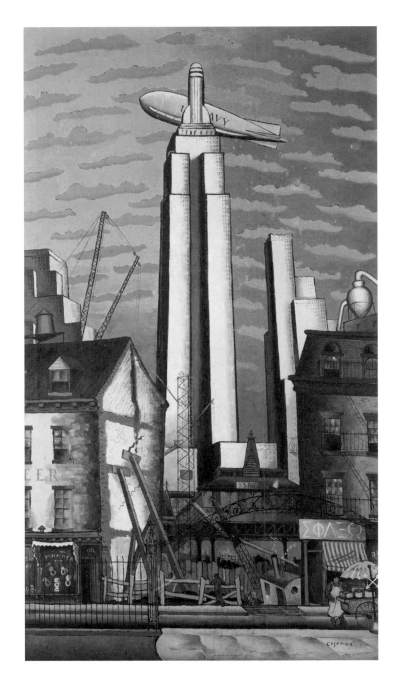

16

Glenn Coleman

EMPIRE STATE BUILDING, c.1930-32

Oil on canvas, 84 x 48 inches
Collection of Max Ember

STRIKING IN BOTH ITS DESIGN and physical size, Glenn Coleman's *Empire State Building* embodies the ambition of modern New York City and its most iconic building, which was completed in 1931. Never very successful financially, Coleman occasionally found work as an illustrator for publications like the controversial magazine, *The Masses*. The socialist politics of the magazine filtered into his life and work. In this painting of the 102-story building that was the world's tallest for forty years after its completion, Coleman paints a scene in which the sleek Art Deco skyscraper dwarfs the older, ramshackle buildings that line the piers along the Hudson River, its menacing quality enhanced by the composition's oblique vantage point and the skyscraper's sheer and impenetrable Cubist forms. Painted shortly before his early death on Long Island in 1932, *Empire State Building* perhaps reflects Coleman's ultimate ambivalence to the city and his own thwarted ambitions. KMJ

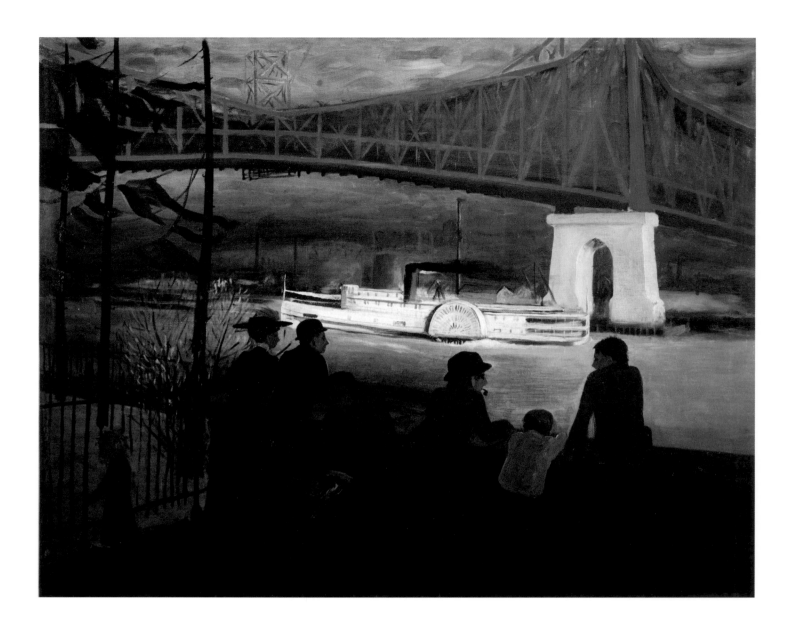

17

Glenn Coleman

QUEENSBORO BRIDGE, EAST RIVER, c.1910

Oil on canvas, 30 ⅛ x 38 ⅛ inches
Collection of the Hirshhorn Museum and Sculpture Garden
Smithsonian Institution, Washington, D.C.
Gift of Joseph H. Hirshhorn, 1966
Photography: Lee Stalsworth

A NATIVE OF OHIO, Glenn Coleman arrived in New York in 1905, following an apprenticeship as an illustrator for an Indianapolis newspaper. He studied briefly with Robert Henri and Everett Shinn, and his early paintings, like *Queensboro Bridge, East River*, reflect an Ashcan sensibility with their interest in city life, dark palette, and swift, fluid brushwork. Coleman's active and layered composition creates a picture with three distinct subjects. In the upper part of the canvas, the new bridge with its red steel carapace boldly strides across the East River, while below it, the white bridge pier and a steamboat glitter in the waning light of early evening. In the shadow of the bridge and unseen tenement buildings, Coleman gives us a vignette of city life — pedestrians taking an evening stroll as, nearby, laundry flaps in the breeze. KMJ

18
Colin Campbell Cooper (1856-1937)
HUDSON RIVER WATERFRONT, N.Y.C, c. 1913-1921

Oil on canvas, 36 x 29 inches
Collection of the New-York Historical Society, New York, New York
Gift of Miss Helene F. Seeley, in memory of the artist and his wife, 1943.180

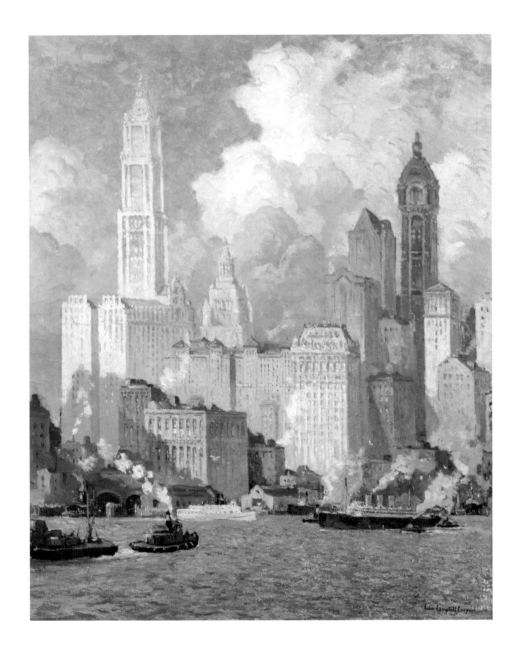

COOPER'S DRAMATIC VIEW of New York City's skyline captures the wonder and fascination it held for visitors and inhabitants alike, with its Woolworth and Singer Buildings scraping the sky and glinting in the morning sun. Art historian John C. Van Dyke compared the view of New York from the water — towering, prismatic, and luminous — to that of Venice: superbly picturesque and grandly beautiful. Even after Cooper moved to California in 1921, he continued to paint New York subjects with the same grandeur of expression and color seen in *Hudson River Waterfront*. KMJ

19

Colin Campbell Cooper

MANHATTAN BRIDGE FROM HENRY STREET, n.d.

Pastel on paper, 10 ⅞ x 8 ⅛ inches
Collection of John and Sally Freeman

ONE OF THE BEST-KNOWN CITY PAINTERS of his generation, Cooper was born in Philadelphia. He studied with Thomas Eakins at the Pennsylvania Academy of the Fine Arts before leaving for Paris in 1889 for further study at the Académie Julian. Cooper established a studio in New York in 1904 and quickly earned a reputation for his impressionist city landscapes. *Manhattan Bridge from Henry Street* demonstrates his mastery of the pastel medium in which he employed a positive-negative approach to his subject by filling in around it, using the brown surface of the paper to convey the bridge's massive, skeletal structure. KMJ

20

Ralston Crawford (1906-1978)

WHITESTONE BRIDGE, c.1939-1940

Oil on canvas, 40 ¼ x 32 inches
Collection of the Memorial Art Gallery of the University of Rochester, Rochester, New York
Marion Stratton Gould Fund, 51.2
© Ralston Crawford Estate

West Palm Beach only

RALSTON CRAWFORD GREW UP IN BUFFALO and throughout his career he embraced the kind of industrial scenery that had formed the backdrop of his childhood. In his early twenties, Crawford went to work on a tramp steamer in the Caribbean, and his interest in wharves, docks, and ships similarly informed his work as an artist. Crawford began studying painting in 1927, acquiring an exposure to modernism at the Barnes Foundation in Marion, Pennsylvania and under Hugh Breckenridge at the Pennsylvania Academy of the Fine Arts. Although he explored abstraction in the 1940s and 50s, Crawford is best known for the linear Precisionist style he employs in *Whitestone Bridge*. Like its subject, constructed to route traffic for the 1939 World's Fair away from Manhattan, Crawford's *Whitestone Bridge* is futuristic, sleek, and streamlined, the embodiment of the era's aspirations for and belief in the World of Tomorrow, which was the theme of the Fair. Instead of striding boldly across a river, Crawford's elegant bridge is more like an airplane, leading us up and away from the sprawling metropolis into the stratosphere. KMJ

THE PAINTINGS

21
Francis Criss (1901-1973)
JEFFERSON MARKET COURT HOUSE, 1935

Oil on canvas, 35 x 23 ⅛ inches
Collection of the Samuel P. Harn Museum of Art
University of Florida, Gainesville, Florida
Gift of William H. and Eloise R. Chandler
Reproduction permission granted from the Estate of Francis Criss
Photography: Randy Batista

BORN IN LONDON, Francis Criss immigrated to Philadelphia with his family in 1905. As a young child he was stricken with polio, and with lessened mobility he took up painting and drawing. He later enrolled at the Pennsylvania Academy of the Fine Arts, where he won a Cresson Fellowship to study in Europe at age fifteen. His early successes were capped in 1931, when the Whitney Museum purchased his painting *Astor Place*. Criss was nimble in a variety of styles, and his work demonstrates an eclectic array of influences. *Jefferson Market Court House* displays a command of the Precisionist vocabulary: industrial subjects rendered in a linear, abstracted style, and blended with a surrealist quality that became Criss's hallmark. The pointed and decorated Ruskinian gothic courthouse, juxtaposed with the curved elevated lines and the box-like buildings behind it, present an irresistible means to explore spatial relationships as well as the multi-faceted architectural fabric of the modern city. KMJ

22
Aaron Douglas (1899-1979)
POWER PLANT IN HARLEM, 1934

Oil on canvas, 20 ¼ x 22 ⅓ inches
From the Hampton University Museum Collection, Hampton, Virginia

ARON DOUGLAS WAS A KEY FIGURE in the Harlem Renaissance during the 1920s and 30s and *Power Plant in Harlem* demonstrates his sensitivity to the urban landscape. The title of this painting is slightly misleading because the Sherman Creek Generating Station Douglas depicts is located at the intersection of 201st Street and the Harlem River in the Inwood neighborhood of Upper Manhattan, rather than in Harlem. The station, built in 1913, was one of a number of power plants erected to meet New York City's ever-rising demand for electricity. Despite the modern usage of the structure, Douglas imbues the station with the sublime timelessness of an Egyptian pyramid. BFB

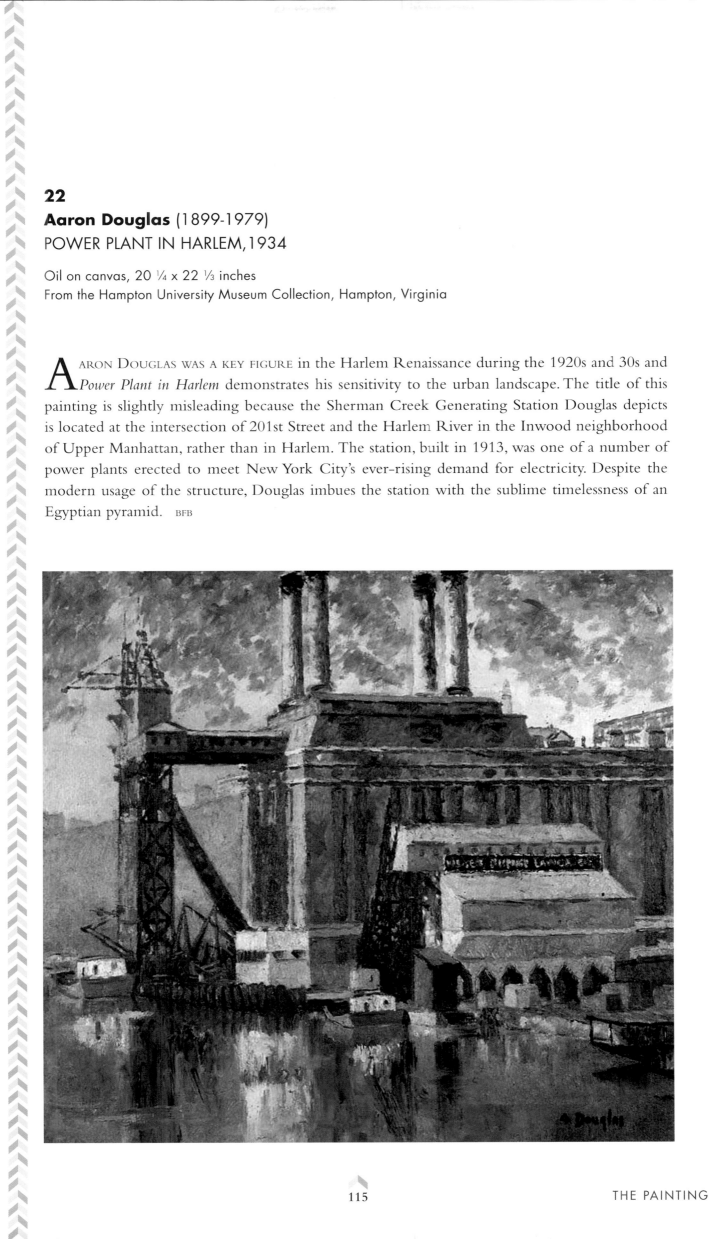

23
Aaron Douglas
TRIBOROUGH BRIDGE, 1936

Oil on canvas, 28 ¼ x 32 ¼ inches
Courtesy of the Amistad Research Center, New Orleans, Louisiana

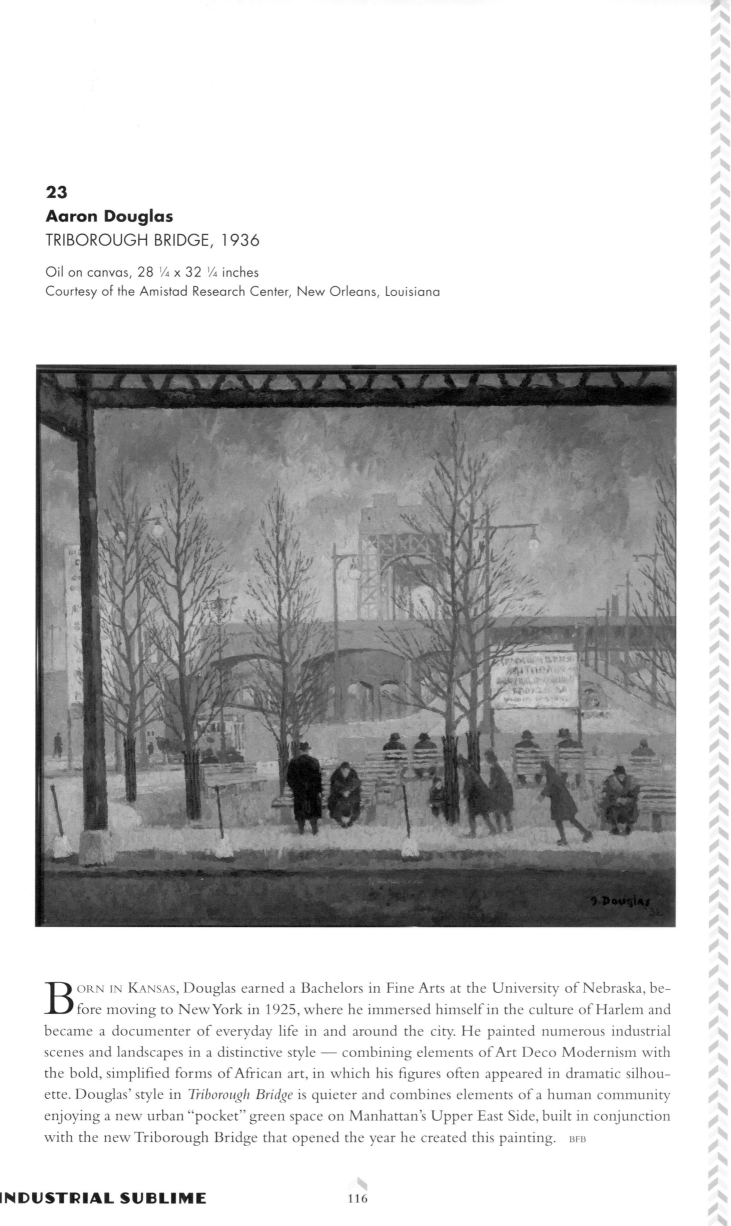

Born in Kansas, Douglas earned a Bachelors in Fine Arts at the University of Nebraska, before moving to New York in 1925, where he immersed himself in the culture of Harlem and became a documenter of everyday life in and around the city. He painted numerous industrial scenes and landscapes in a distinctive style — combining elements of Art Deco Modernism with the bold, simplified forms of African art, in which his figures often appeared in dramatic silhouette. Douglas' style in *Triborough Bridge* is quieter and combines elements of a human community enjoying a new urban "pocket" green space on Manhattan's Upper East Side, built in conjunction with the new Triborough Bridge that opened the year he created this painting. BFB

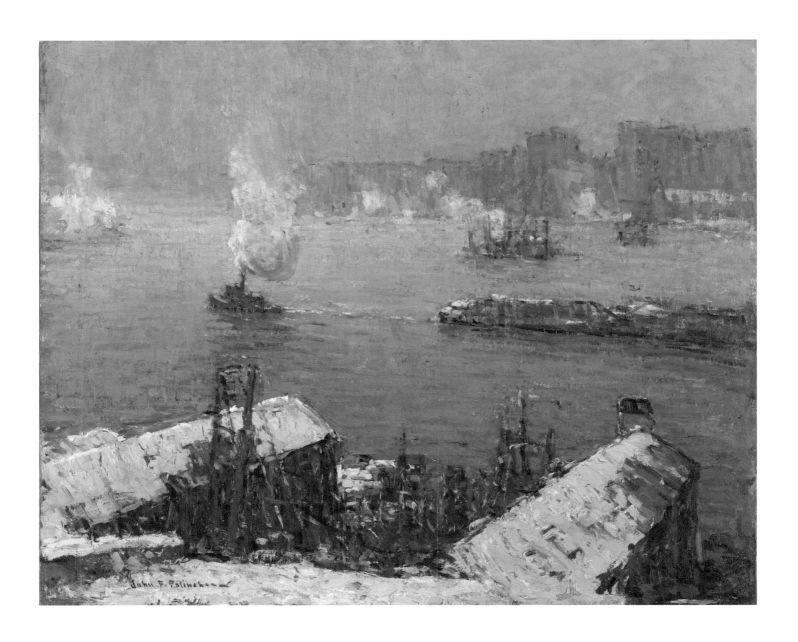

24
John Folinsbee (1892-1972)
THE HARBOR, 1917

Oil on canvas, 24 x 30 inches
Private Collection
© 2013 John F. Folinsbee Art Trust
Photography: John Bigelow Taylor

ALTHOUGH FREQUENTLY ASSOCIATED with Pennsylvania Impressionism, scenes of New York form a significant body of John Folinsbee's early work, and industrial imagery remained a dominant theme throughout his career. Largely self-taught, Folinsbee studied briefly with Jonas Lie, who urged his young friend to explore the dynamic pictorial possibilities of the modern city. From the windows of his mother-in-law's Brooklyn townhouse, the view of New York's wharves, bustling harbor, and skyline provided rich subject matter. Folinsbee made numerous sketches of the tugboats and warehouses that appear in *The Harbor*, some of which also became stand-alone paintings. The scintillating color and structured brushwork characteristic of his work from this period is seen to great advantage here. KMJ

25
John Folinsbee
QUEENSBOROUGH BRIDGE, 1917

Oil on canvas, 32 x 40 inches
Collection of Nina and Stephen Cook
© 2013 John F. Folinsbee Art Trust
Photography: John Bigelow Taylor

With its dramatic span across the river and the spider-web geometry of its massive silver trusses, the Queensborough Bridge was the quintessential symbol of New York in a new 20th century, and a perfect subject for John Folinsbee. He may have drawn inspiration from J. Alden Weir's *The Bridge: Nocturne (Nocturne: Queensboro Bridge)* [Cat. 81], which, like his own view, depicts the bridge seen over the rooftops of Midtown Manhattan. Here Folinsbee combines quick vertical strokes of paint to suggest the bridge's network of steel beams and uses shorter horizontal strokes for the nearby factory smokestacks, creating the shimmering optical illusion of viewing the bridge through falling snow. KMJ

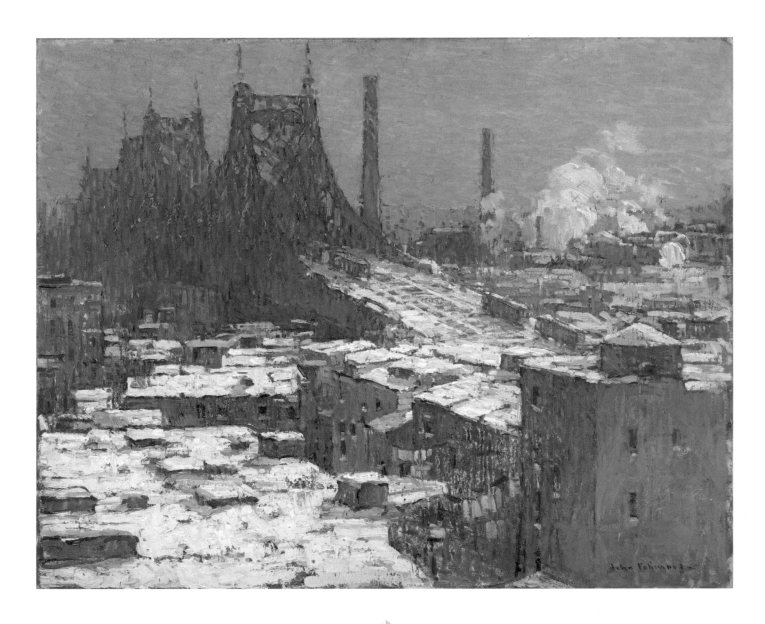

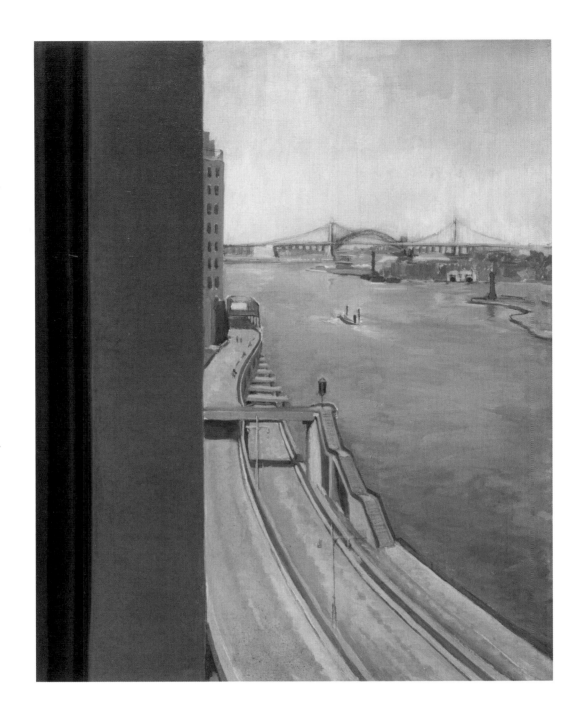

26
Inna Garsoïan (1896-1984)
EASTSIDE DRIVE, c.1940

Oil on canvas, 20 x 16 inches
Collection of the New-York Historical Society, New York, New York
Gift of Nina Garsoïan, 2001.303

A S A YOUNG GIRL, Inna Garsoïan fled the Russian Revolution with her family and settled in Paris, where she later became an art student. She began her career as a costume designer for the Ballet Russe, and by the time she arrived in New York Garsoïan had already established herself as a designer, illustrator, and painter. Her landscapes demonstrate an affinity for shapes pared down to their most essential elements, rendered in a bleached pastel palette. The stark and spare *Eastside Drive* presents us with an urban environment that is threatening and alienating, dominated by architecture and nearly devoid of any human presence. Such emphatic geometry and sublime emptiness counter the giddy embrace of the metropolis by the previous generation, suggesting instead that the modern city is inhospitable to human life. KMJ

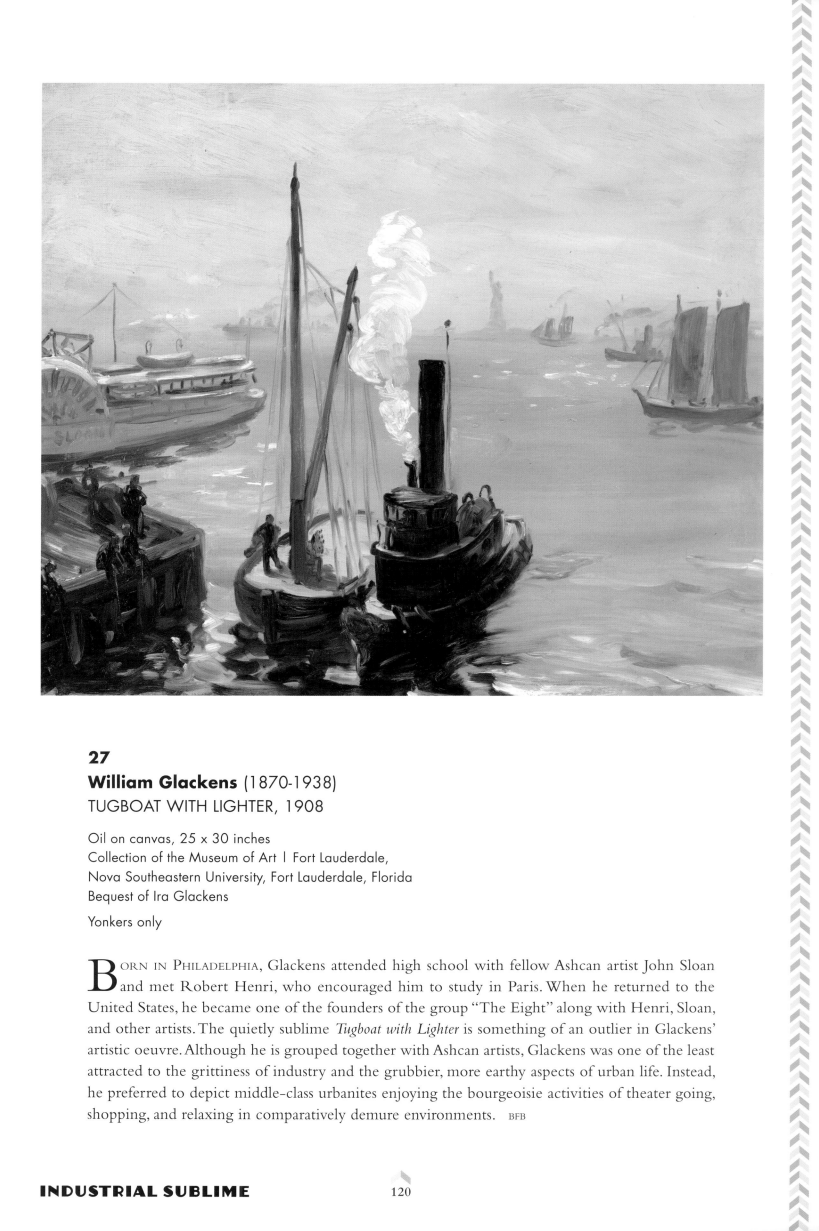

27
William Glackens (1870-1938)
TUGBOAT WITH LIGHTER, 1908

Oil on canvas, 25 x 30 inches
Collection of the Museum of Art | Fort Lauderdale,
Nova Southeastern University, Fort Lauderdale, Florida
Bequest of Ira Glackens

Yonkers only

BORN IN PHILADELPHIA, Glackens attended high school with fellow Ashcan artist John Sloan and met Robert Henri, who encouraged him to study in Paris. When he returned to the United States, he became one of the founders of the group "The Eight" along with Henri, Sloan, and other artists. The quietly sublime *Tugboat with Lighter* is something of an outlier in Glackens' artistic oeuvre. Although he is grouped together with Ashcan artists, Glackens was one of the least attracted to the grittiness of industry and the grubbier, more earthy aspects of urban life. Instead, he preferred to depict middle-class urbanites enjoying the bourgeoisie activities of theater going, shopping, and relaxing in comparatively demure environments. BFB

28
Robert Henri (1865-1929)
CUMULUS CLOUDS, EAST RIVER, c. 1901-02

Oil on canvas, 25 ¾ x 32 inches
Collection of the Smithsonian American Art Museum, Washington, D.C.
Gift of Mrs. Daniel Fraad in memory of her husband

HENRI WAS ONE OF THE KEY FIGURES of the Ashcan Movement, and an entire generation of younger painters as diverse as George Bellows, Stuart Davis, Edward Hopper, and Rockwell Kent owed something of their mature styles to his influence. Henri was intimately concerned with the creation of a genuinely American school of painting that rejected academic realism. The two pictures by Henri in this exhibition show his interest in New York's rivers. Although both pictures contain elements of gritty waterfront life, the lushly sublime dawn in *Cumulus Clouds, East River* softens the harshness of the surroundings and becomes, instead, the subject of the painting. BFB

29
Robert Henri
EAST RIVER EMBANKMENT, WINTER, 1900

Oil on canvas, 25 ¾ x 32 ⅛ inches
Collection of the Hirshhorn Museum and Sculpture Garden
Smithsonian Institution, Washington, D.C.
Gift of the Joseph H. Hirshhorn Foundation, 1966
66.2435

Henri was a seminal figure among Ashcan artists and he was capable of a vigorous, almost strident vulgarity in his portraits of New York's working class in the first decades of the 20th century. But Henri proves himself to be a delicate and subtle colorist in *East River Embankment, Winter.* Using a highly restricted tonal palette, he reveals his admiration for James McNeill Whistler, whose famous style, partly derived from the Japanese aesthetic, employs the flattened perspective with which Whistler sought to overturn ideas embraced by Hudson River School painters, what he called "damned realism, and beautiful nature, and the whole mess." Nevertheless, Henri endows his winter twilight scene with a soft and vaporous beauty. BFB

30
Arnold Hoffman (1886-1966)
UNTITLED (WEEHAWKEN), c.1925

Oil on canvas, 37 x 47 inches
Collection of Martin J. Maloy

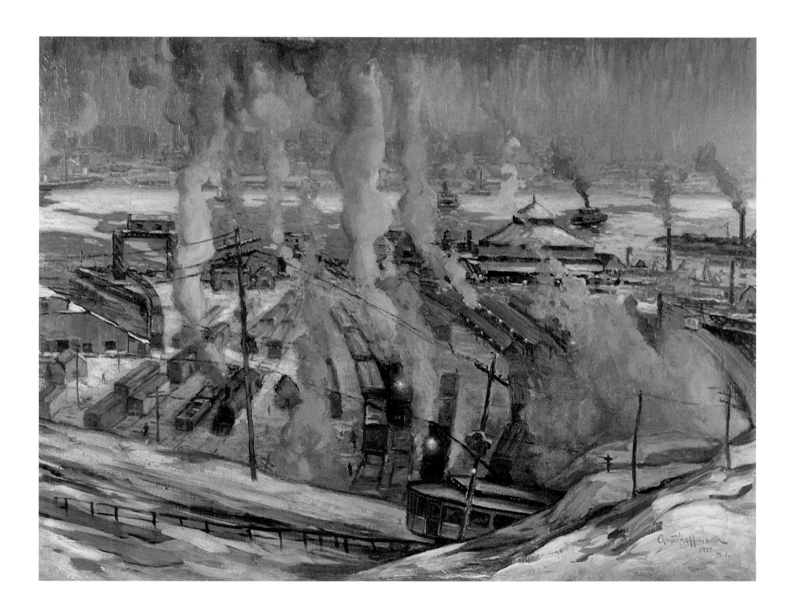

H OFFMAN WAS BORN IN ODESSA, RUSSIA. Upon moving to New York, he exhibited at the
Whitney Museum of American Art and the National Academy of Design and worked as a
portraitist, teacher, and lithographer. In this painting, Hoffman presents a vision of the huge rail
yards at Weehawken as a kind of Dante-esque view of Hades, in which the smoke of trains, boats,
and factories pours forth and threatens to consume the entire landscape as a fiery orange streetcar
prepares to descend to its subterranean depths. BFB

THE PAINTINGS

31
Max Kuehne (1880-1968)
LOWER MANHATTAN, 1913

Oil on panel, 24 x 30 inches
Collection of Erik Davies

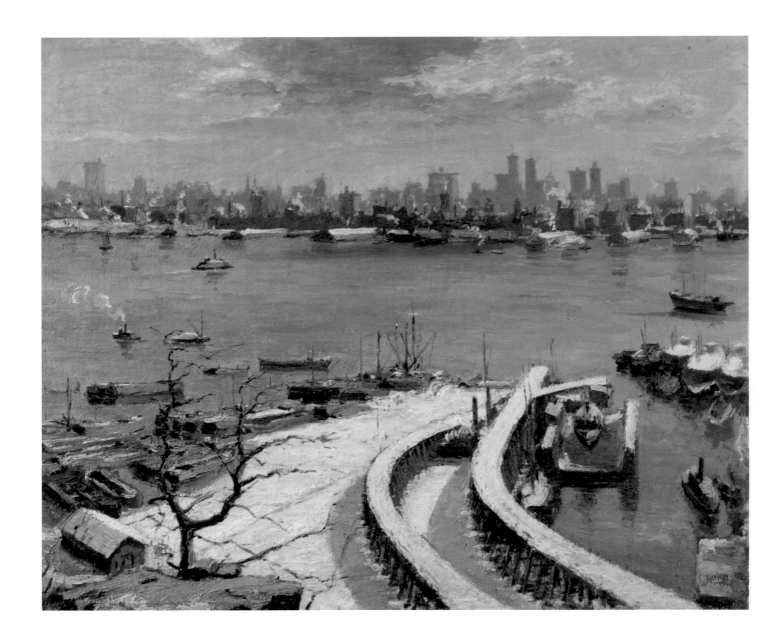

KUEHNE, WHO WAS BORN IN HALLE, GERMANY. immigrated to America as an adolescent and settled in Flushing, Queens. He studied with artist William Merritt Chase and later with Robert Henri, who encouraged Kuehne to focus on scenes of urban life and to study in Europe, where he traveled with Ernest Lawson. Upon returning to New York, Kuehne's palette tended towards the darker Spanish influence of painting as translated through Manet but by 1912 his tones had lightened, and he began producing brighter paintings "full of sparkling sunlight," of which *Lower Manhattan* is a prime example. Kuehne uses the curving New Jersey dock in the foreground as the entry point into the picture, while within easy view across the Hudson, Manhattan's shore and skyline beckon. BFB

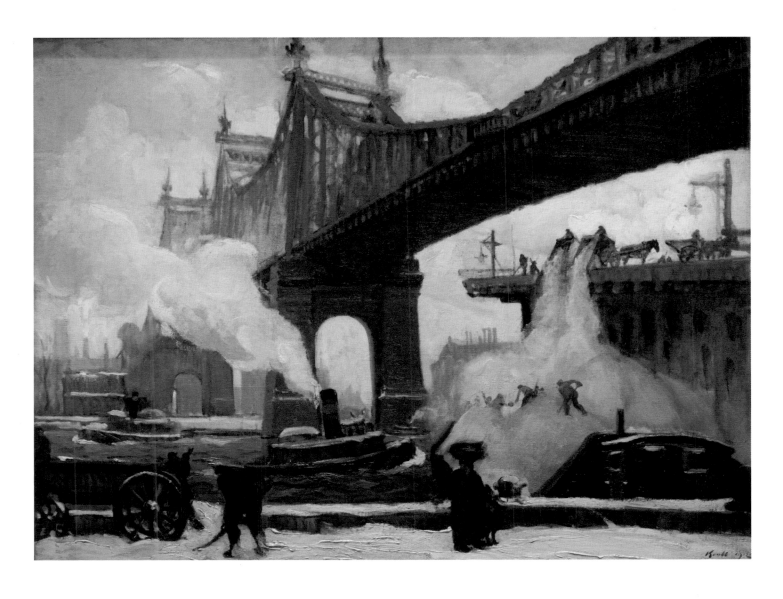

32

Leon Kroll (1884-1974)
QUEENSBOROUGH BRIDGE, 1912

Oil on canvas, 36 x 48 ¼ inches
Courtesy of the Fralin Museum of Art at the University of Virginia, Charlottesvi le, Virginia
Bequest of Mrs. Leon Kroll, 1979.72.1

B EST KNOWN AS A FIGURE PAINTER, Leon Kroll, a native New Yorker, began painting the city's urban landscape when he returned from study abroad. The new bridge, a feat of engineering at the time, offered an irresistible subject for the young artist. Looking up at the bridge from below, Kroll emphasizes its massive scale as well as the rhythmic patterns created by its granite piers and the iron grillwork of its spans as they slice across his canvas. The monumental structure soars above the bustling activity along the waterfront, its great presence dwarfing the tugs and the mounds of snow cleared from Manhattan's busy streets. KMJ

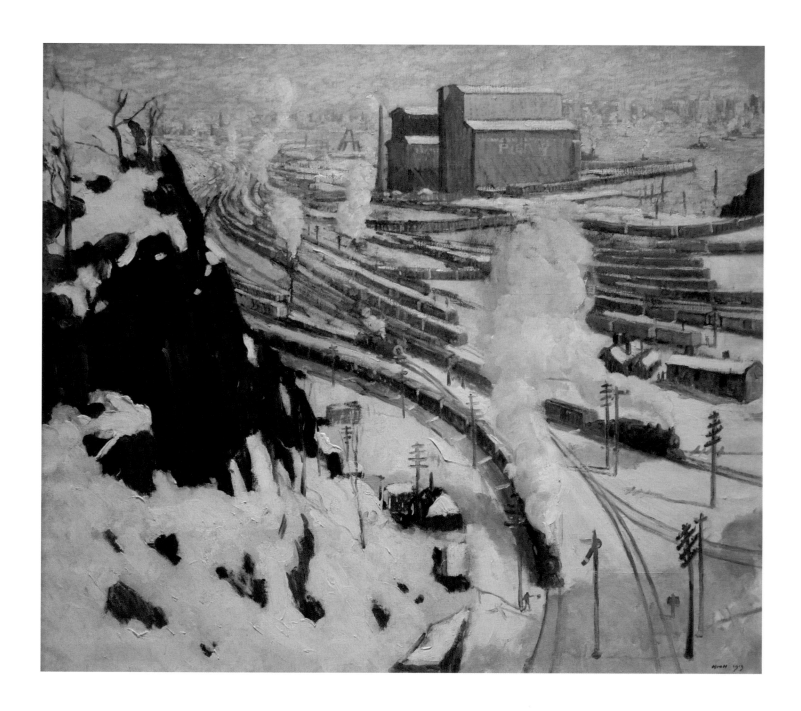

33

Leon Kroll

TERMINAL YARDS, 1913

Oil on canvas, 46 ½ x 52 ½ inches
Collection of the Flint Institute of Arts, Flint, Michigan
Gift of Mrs. Arthur Jerome Eddy, 1931.4

THE SUBLIME PANORAMIC VISTA of New York and the industrial shores of New Jersey seen from Weehawken Heights attracted numerous artists, among them Leon Kroll, who chose to juxtapose the natural, rugged surfaces of the Palisades with the regular geometry of man-made structures. The two vertical elements are stitched together by the sinuous arcs of railroad lines and the prismatic skyline of Manhattan, a strong, jagged horizontal that stretches across the distant landscape from one end of the canvas to another. The vertiginous vantage point, as if Kroll were poised on the cliff's edge, creates an awesome, sweeping design, one that earned the approval of the pioneering collector Arthur Jerome Eddy, who purchased it from the 1913 Armory Show. KMJ

34
Ernest Lawson (1873-1939)
BROOKLYN BRIDGE, c. 1917-20

Oil on canvas, 20 ⅜ x 24 inches
Collection of the Terra Foundation for American Art, Chicago, Illinois
Daniel J. Terra Collection, 1992.43
Photography: © Terra Foundation for American Art

For artists of Ernest Lawson's generation, the Brooklyn Bridge was an icon of modernity and one of New York's most important symbols but by the time Lawson created this portrait of the bridge other feats of engineering — sleek skyscrapers and bridges, elegant and slim — had begun to capture the imagination of a new crop of artists. Cloaked in a romantic, moonlit haze, Lawson's bridge emerges from the shadows, its gothic piers evocative of an ancient monument. Like the mansard roofs of the Ferry House nearby, it is a historical marker of change in a city where the old is regularly torn down to make way for the new. KMJ

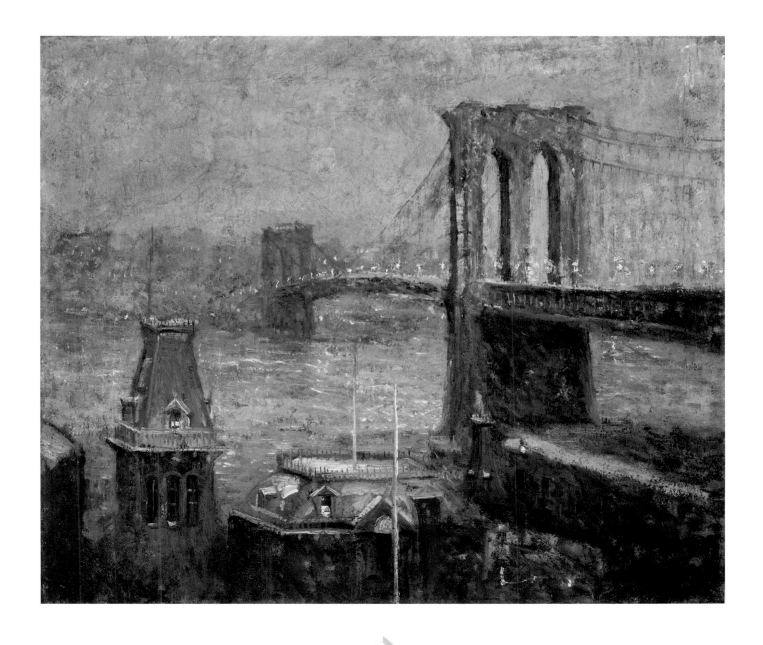

35
Ernest Lawson
HOBOKEN WATERFRONT, c.1930

Oil on canvas, 40 x 50 inches
Collection of the Norton Museum of Art, West Palm Beach, Florida
Gift of R. H. Norton, 46.12

Ernest Lawson's *Hoboken Waterfront* is a vigorous and brawny late-career work. One of the original members of The Eight, a group of American painters who furthered the advance of modernism, Lawson was drawn to scenes of urban life, which he painted in a rich palette with a thick application of paint and bold strokes of his brush. In this painting, he nimbly manipulates our sense of scale in a layered, tumultuous jumble of buildings, ships, and turbulent waters that conveys the dizzying pace of modern life in the metropolis. KMJ

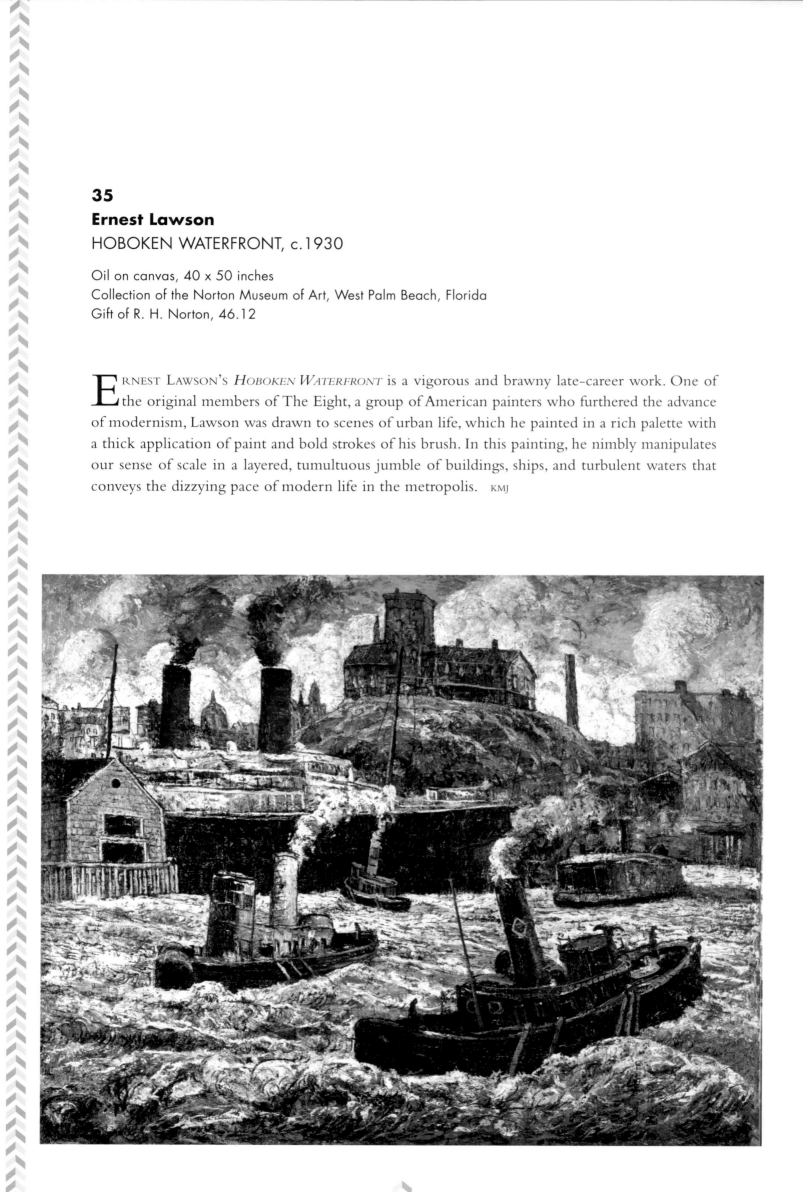

36
Ernest Lawson
RAILROAD TRACK, c.1905

Oil on canvas, 25 x 20 inches
Collection of the Norton Museum of Art, West Palm Beach, Florida
Gift of R. H. Norton, 53.106

THE IMPRESSIONISTIC *RAILROAD TRACK* is representative of Lawson's early work, the quick, squared brushwork and higher-keyed color illustrative of his studies with J. Alden Weir and John Twachtman. Lawson was interested in the intersection of urban and rural environments, particularly on New York's outer edges as the rapidly expanding city developed areas like University Heights that still had a rural quality early in the 20th century. Lawson's subject here is the former hilltop campus of New York University, now Bronx Community College, seen from the railroad crossing at Spuyten Duyvil at Tibbet's Creek (now filled in), as it makes a dramatic arc across the section of the Bronx, today called Riverdale. KMJ

41
Jonas Lie (1880-1940)
AFTERGLOW, c.1913

Oil on canvas, 50 ¼ x 60 ⅜ inches
Collection of the Art Institute of Chicago, Chicago, Illinois
Friends of American Art Collection, 1914.389

L IKE SO MANY ARTISTS of his generation, Jonas Lie, who immigrated from Norway in 1893, was
fascinated by the rising towers and bustling waterfronts of the "new New York," and around
1910 he began to focus on city scenes. *Afterglow*, which received the first Hallgarten Prize at the
National Academy in 1914, is a poetic portrait of the city at the end of a wintry day, when tugs
navigate silvery ice floes as they return to their docks, and the city is enveloped in a mysterious
atmosphere of blinking lights, mist, and steam. The momentarily becalmed city rises, majestic and
golden, like a beacon in the haze. KMJ

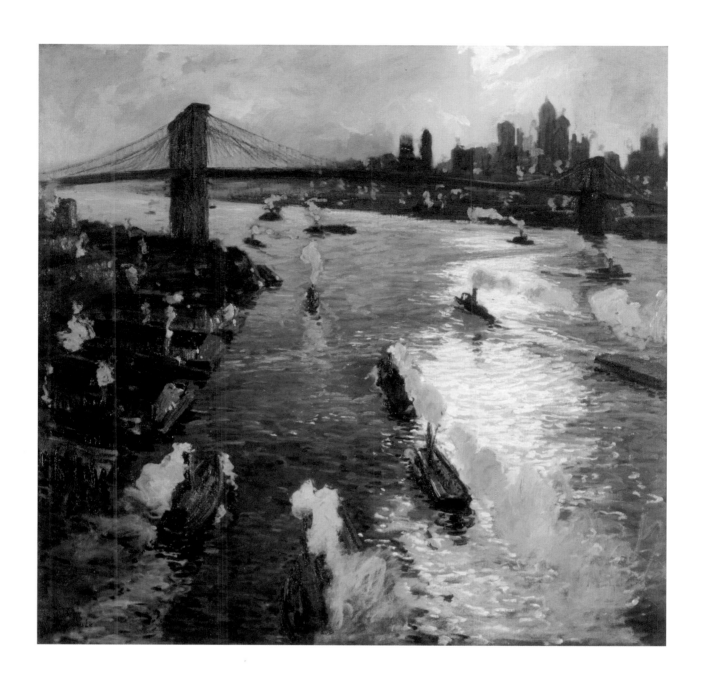

42

Jonas Lie

PATH OF GOLD, c.1914

Oil on canvas, 34 x 36 inches
Collection of the High Museum of Art, Atlanta, Georgia
J. J. Haverty Collection, 49.40

IN 1914 A WEALTHY PATRON supported Jonas Lie's travel to Panama to document the construction of the new Panama Canal, which, like the island of Manhattan, was a symbol of America's industrial might and global power. Upon his return, Lie viewed the city with eyes transformed — his city canyons and flowing rivers becoming what one critic called "vital forceful constructions." *Path of Gold*, with its strong diagonal river, framed on one side by the hills of Brooklyn, and on the other by the mountainous skyline of Manhattan, has strong correspondences to Lie's *Culebra Slide* (West Point Museum), which depicts an artificial valley that cuts through the continental divide to form part of the Panama Canal. Both paintings were included in a December 1914 exhibition of Lie's work, alongside twenty-one additional Panama Canal scenes and nearly thirty urban landscapes. KMJ

43

Jonas Lie

BRIDGE AND TUGS, c.1911-1915

Oil on canvas, 34 ½ x 41 ½ inches
Collection of the Georgia Museum of Art
University of Georgia, Athens, Georgia
Museum Purchase with funds provided by
C.L. Morehead, Jr., GMOA 2001.179

*B*RIDGE AND TUGS is a muscular counterpoint to the more romantic evocations of the Brook-
lyn Bridge frequently painted by Jonas Lie's contemporaries. Spanning the canvas, the bridge
looms above the river solid and gigantic. Lie favored this approach to the bridge and painted a
number of canvases from the perspective of looking up at the bridge from the water or wharf side.
A 1912 article about Lie called him a "scientist and a poet," remarking that his urban landscapes,
like this picture of the Brooklyn Bridge, were "splendid mathematical constructions" of color and
form. KMJ

44

Louis Lozowick (1892-1973)

LOWER MANHATTAN, 1932

Oil on canvas, 24 x 12 inches
Collection of Elie and Sarah Hirschfeld

Louis Lozowick immigrated to the United States from the Ukraine in 1906, and studied with Leon Kroll at New York's National Academy of Design. Lozowick may have been influenced by his teacher's interest in cityscapes but contact with the Russian avant-garde on his return travels to that country led him to adopt a hard-edged linear style. Preparing his 1936 mural diptych for the New York City General Post Office (opposite Pennsylvania Station), Lozowick made lithograph and oil studies. The mural and lithographs are monochromatic, but this oil study is rendered in the radiant colors of early morning to capture the sublime wonder of the city at sunrise. KMJ

45

George Luks (1866-1933)
ROUNDHOUSES AT HIGHBRIDGE, c.1909-1910

Oil on canvas, 30 x 36 inches
Collection of the Munson-Williams-Proctor Arts Institute, Utica, New York
Museum Purchase, 50.17

IN WHAT IS ARGUABLY among his most dramatic canvases, George Luks, from a vantage on the High Bridge, painted the roundhouse and rail yard at 170th Street and the Harlem River, which separates Manhattan from the Bronx. This elevated view provides a panoramic vista of the farthest reaches of Manhattan, including the Putnam (or Sixth Avenue) Railroad Bridge and MacComb's Dam Bridge — shadowy forms in the painting's lower middle ground. The commanding presence in the picture is the forceful plumes of smoke surging skyward from the silhouetted structure of the roundhouse, darkly present in the foreground. Our horror at all the pollution spewing into the atmosphere is mitigated by the theatrical, rosy glow of the setting sun that softens the sublime effect of the thick industrial haze. KMJ

46

George Macrum (1878-1970)

THE PILE DRIVER, 1912

Oil on canvas, 20 ¼ x 24 ⅛ inches
Collection of the Pennsylvania Academy of the Fine Arts, Philadelphia, Pennsylvania
John Lambert Fund

Born in Pittsburgh, Pennsylvania, George Macrum specialized in painting the urban landscape. *The Pile Driver* is one of at least two large paintings the artist made that features the pile drivers along the Yonkers waterfront. Pile drivers, which drove piles into the soft sand of the riverbed, were essential to the development of the city, and were frequent subjects for artists drawn to the industrial landscape. In *The Pile Driver*, Macrum juxtaposes the strong vertical scaffolding of the driver against the distant and rugged cliffs of the Palisades, providing another commentary on the collision of the natural environment and the city's relentless pursuit of commercial development. KMJ

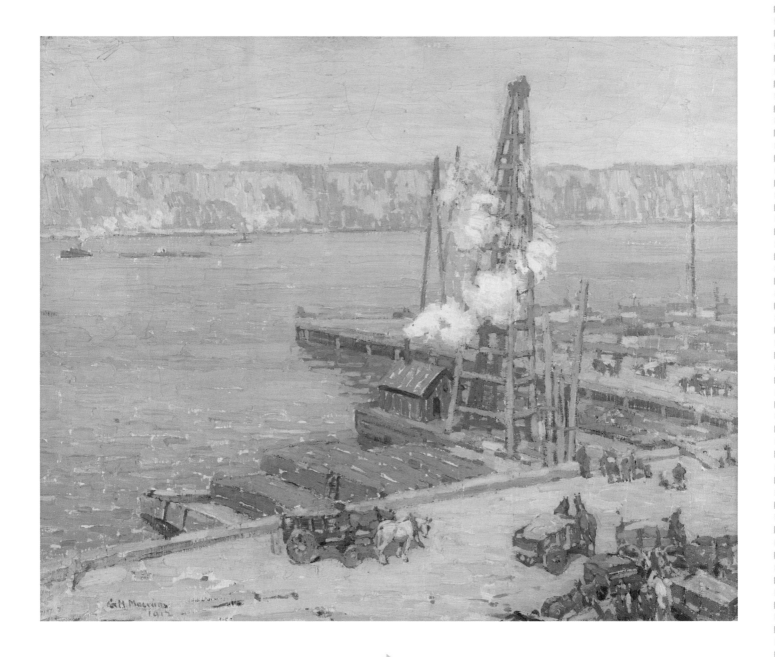

47

John Marin (1870-1953)

DOCKS AT WEEHAWKEN, OPPOSITE NEW YORK, 1916

Watercolor on paper, 13 ¾ x 15 inches
Collection of the Norton Museum of Art, West Palm Beach, Florida
Gift of Elsie and Marvin Dekelboum, 2005.49
© 2013 Estate of John Marin / Artists Rights Society (ARS), New York

WEEHAWKEN, NEW JERSEY, is situated on the western shore of the Hudson River, directly across from Midtown Manhattan at approximately 34th Street. Marin painted *Docks at Weehawken, Opposite New York* a few years after the 1913 completion of Grand Central Terminal at 42nd Street caused an explosion of development in Midtown that had been relatively modest up to that point. Unlike *Lower Manhattan from the River* [Cat. 48], this earlier work presents a more subdued and romantic vision of the developing city, one with a more regular skyline not yet punctuated by the pointy giants erected there in the late 1920s and 30s — the Empire State and Chrysler buildings. KMJ

48

John Marin (1870-1953)
LOWER MANHATTAN FROM THE RIVER, NO. 1, 1921

Watercolor, charcoal, and graphite on paper
21 ⅞ x 26 ½ inches
Lent by The Metropolitan Museum of Art, New York, New York
Alfred Stieglitz Collection, 1949, 49.70.122
© 2013 Estate of John Marin / Artists Rights Society (ARS), New York

Yonkers only

IN HIS VIBRANT AND PULSATING VIEW of the skyline from the water, *Lower Manhattan from the River, No. 1,* John Marin captures the energy and excitement of the modern metropolis as well as the awe inspired by its waterways, its soaring skyscrapers, and the deep caverns between. Marin's skyscrapers, slender and magnificent, rise like mountainous stalagmites to the sky where they meet the setting sun, which bathes them in a warm, benevolent glow. A master watercolorist, Marin was a member of the modernist circle of artists centered around Alfred Steiglitz and his Gallery 291. His paintings fused European Modernism with a decidedly American approach — lively brushwork, sparkling colors, and an energy and enthusiasm perfectly suited to depicting life in the modern city. KMJ

49
Reginald Marsh (1898-1954)
CITY HARBOR, 1939

Watercolor on paper, 15 x 21 inches
Collection of the Norton Museum of Art, West Palm Beach, Florida
Bequest of Felicia Meyer Marsh, 79.10
© 2013 Estate of Reginald Marsh / Art Students League, New York
Artists Rights Society (ARS), New York

MARSH WAS BORN IN PARIS to his American expatriate-artist parents, who were spending time in France. After graduating from Yale University, he worked as a staff artist on several publications, including *Vanity Fair* in the 1920s, before fulfilling his artistic promise in the 1930s when he came into his mature style. All three watercolors by Marsh in this exhibition eschew his usual flamboyantly human-interest subjects of crowded subways and vaudeville nightclubs to focus on the quieter, more somber aspects of New York's waterfront. The heavy dark lines and inky-black smoke belching forth in *City Harbor* are ominous and seem a portent for a world that would soon be at war. BFB

50
Reginald Marsh
TUGBOAT AT DOCKSIDE, 1932

Watercolor on paper, 13 ½ x 20 inches
Collection of the Boca Raton Museum of Art, Boca Raton, Florida
Bequest of Isadore and Kelly Friedman, 2007.5.17.
© 2013 Estate of Reginald Marsh / Art Students League, New York
Artists Rights Society (ARS), New York

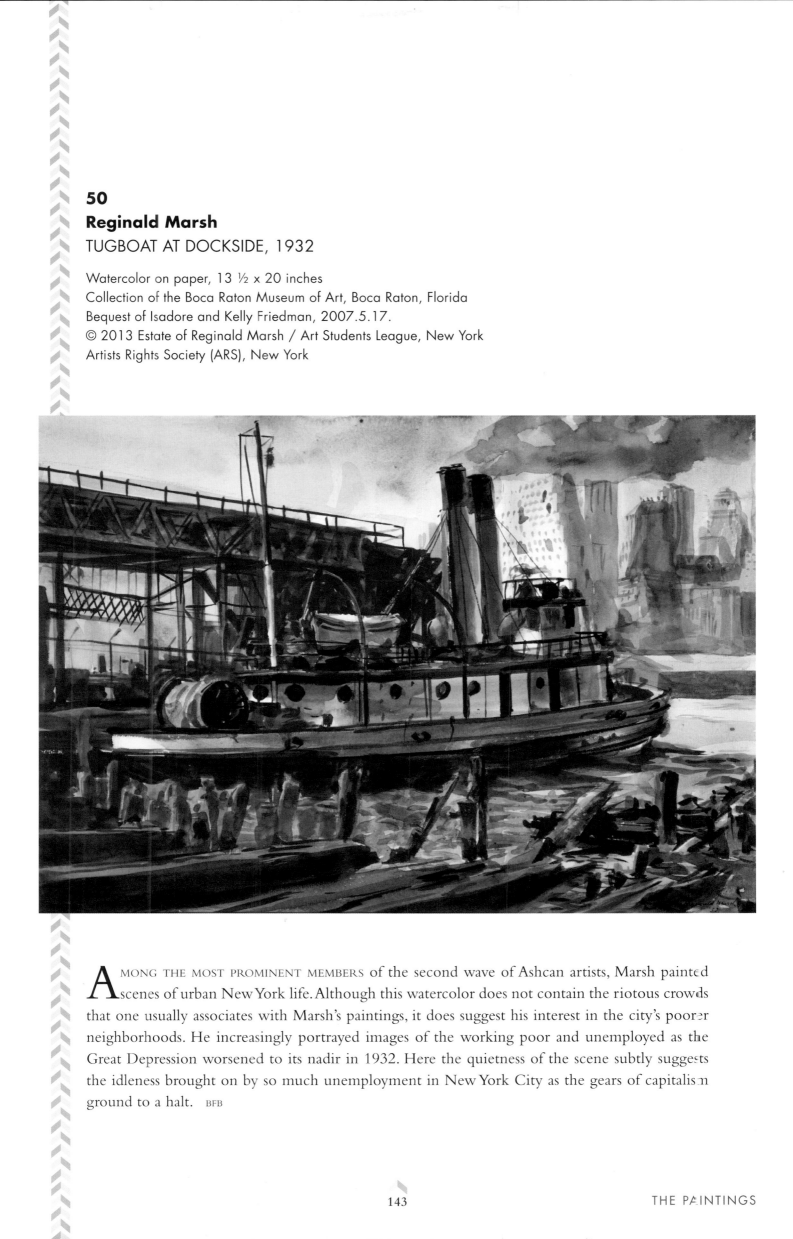

AMONG THE MOST PROMINENT MEMBERS of the second wave of Ashcan artists, Marsh painted scenes of urban New York life. Although this watercolor does not contain the riotous crowds that one usually associates with Marsh's paintings, it does suggest his interest in the city's poorer neighborhoods. He increasingly portrayed images of the working poor and unemployed as the Great Depression worsened to its nadir in 1932. Here the quietness of the scene subtly suggests the idleness brought on by so much unemployment in New York City as the gears of capitalism ground to a halt. BFB

51
Reginald Marsh
NEW YORK SKYLINE, 1937

Watercolor on paper, 19 x 13 inches
Courtesy of Arader Galleries, New York, New York
© 2013 Estate of Reginald Marsh / Art Students League, New York
Artists Rights Society (ARS), New York

MARSH SHOWED THIS LOVELY WATERCOLOR in an exhibition at the National Academy of Design in 1938. His paintings were often the antithesis of the sublime, depicting gritty interactions in the lives of everyday New Yorkers, but here he captures the grand magnificence of the city's landscape with no irony, showing more sky than skyscraper. By pulling his laser-sharp and satirical gaze away from the myriad street-level vulgarities found on every hand, he allows the city to soften and to become a source of poetic reverie. BFB

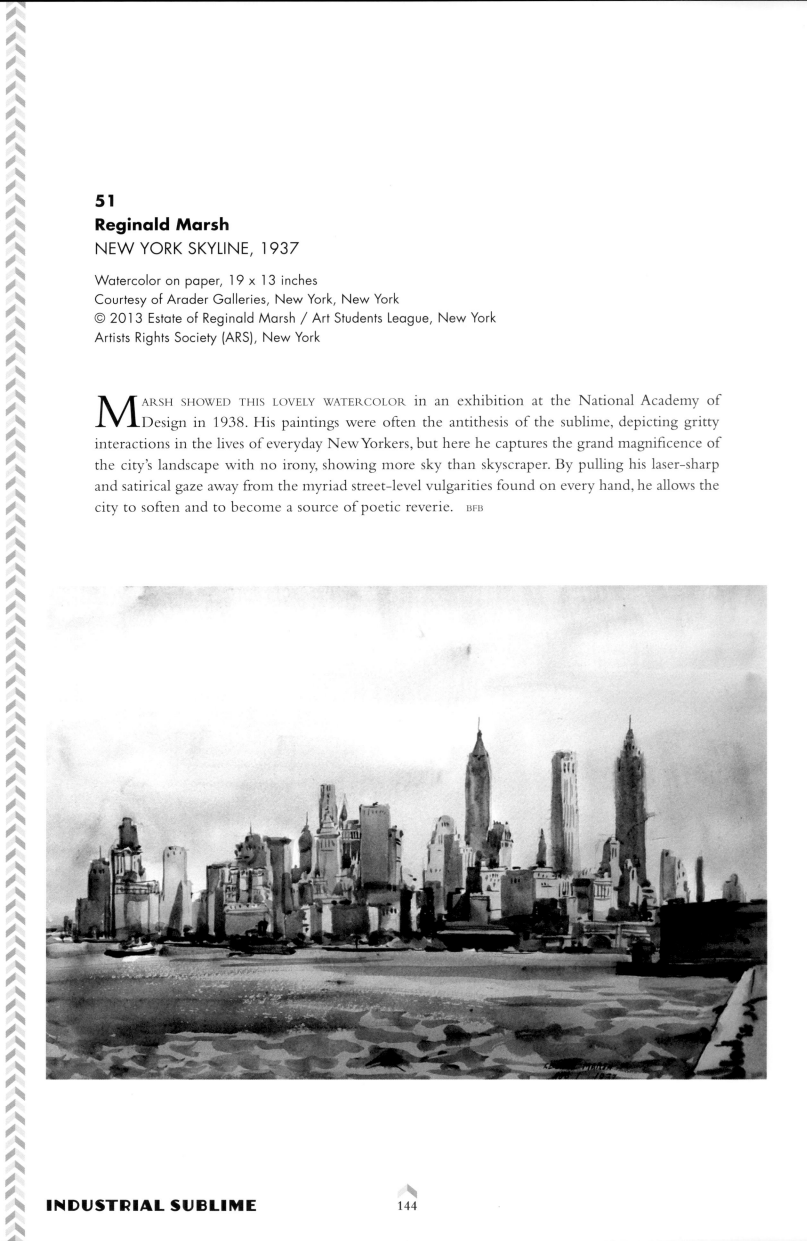

52
Alfred Mira (1900-1981)
RAILYARDS, WESTSIDE, c.1940

Oil on canvas, 20 x 25 inches
Collection of Erik Davies

MIRA DEPICTS A SUBLIME PANORAMIC VIEW of the New Jersey shoreline and docks, Manhattan's 30th street rail yards, and the comparatively new West Side Elevated Highway, which began construction in 1929. The work on the highway continued during the Great Depression at the same time that the New York Central Railroad was completing improvements to its west side lines from Spuyten Duyvil down to the tip of Manhattan, which advertisements termed "the lifeline of New York." Mira depicts the highway span between 29th and 37th streets, completed by 1933. His painting is a visual metaphor for the growing influence automobiles would wield in the city after World War II, when Robert Moses, "master builder" of mid-twentieth century New York City and its suburbs, and leader of numerous public authorities, expanded the city's highway system. BFB

THE PAINTINGS

53
John Noble (1913-1983)
THE BUILDING OF TIDEWATER, c.1937

Oil on canvas, 38 x 50 ¼ inches
The Noble Maritime Collection, Staten Island, New York
Gift of Mr. and Mrs. Harold G. Tucker

*T*HE *BUILDING OF TIDEWATER* shows the construction of a new refinery for the Tidewater Oil
Company in Bayonne, New Jersey. Noble makes dramatic use of the huge red tubes along
the waterside, waiting to be moved into position on the construction site, as we see already hap-
pening in the painting's background. He captures a sense of expectation and untapped power lying
in wait. The figures of the workers are dwarfed beside the tubes, whose shapes resemble whales,
water creatures that could swallow them whole. The tubes, resemble tunnels, too, tempting you
to look inside them to contemplate the void. Noble's work often depicted the waterfront in and
around his home near Snug Harbor on Staten Island. He eventually lived full time on the water-
front on a houseboat/studio he built from salvage. BFB

54

George Oberteuffer (1878-1937)

VIEW AT HELLSGATE BRIDGE, n.d.

Oil on board, 14 ¾ x 18 inches
Collection of Remak Ramsay

OBERTEUFFER, A GRADUATE OF PRINCETON UNIVERSITY, studied at the Pennsylvania Academy of Fine Arts, and received a Masters from the Art Institute of Chicago. As can be seen here, he was strongly influenced by French Impressionism, developing a vigorous, dashing style of bright colors, which he absorbed living for nearly twenty years in France. This impressionistic sketch was likely painted en plein air, and Oberteuffer captures the ruggedness along the water-front at a point between Astoria, Queens, Randall's Island, and the Bronx, over a portion of the East River known as "Hell Gate," all connected by the Hell Gate Bridge, completed in 1916. The bridge's name was a corruption of the Dutch "Hellegat" for "hell's hole" or "bright gate," so called because the original explorers found navigation hazardous at this juncture due to the intersection of different tide-driven currents. BFB

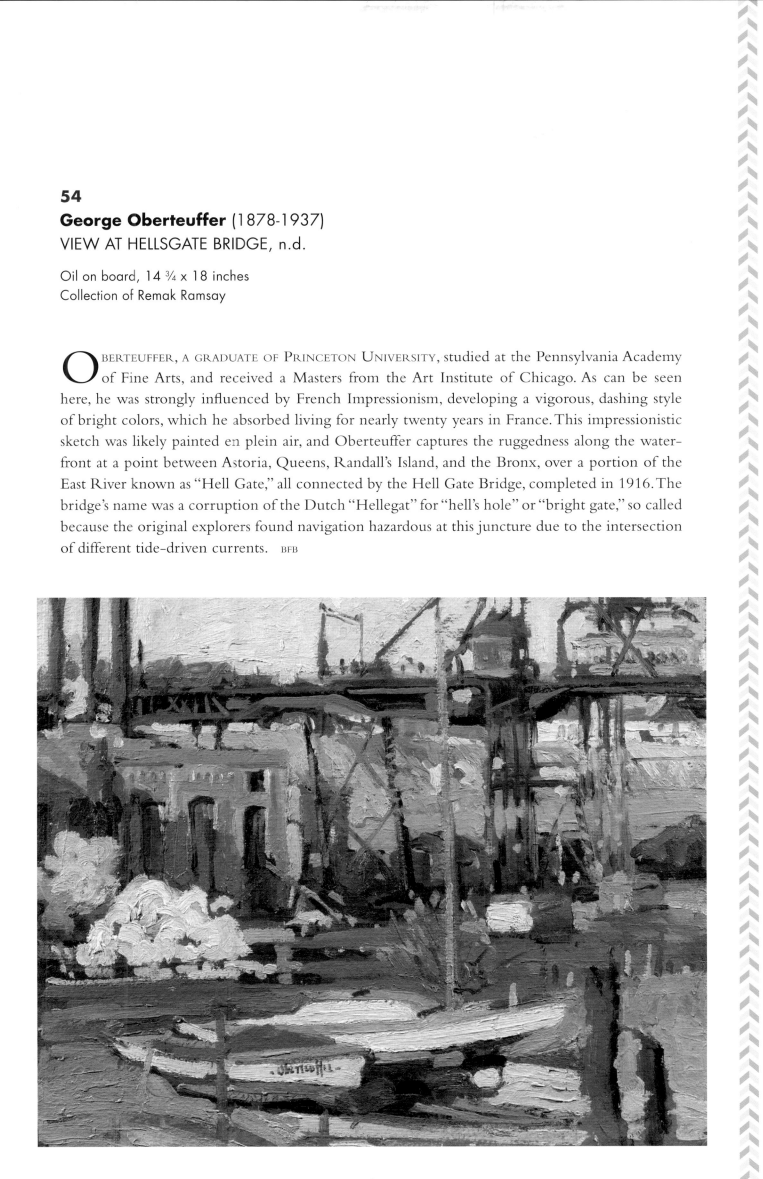

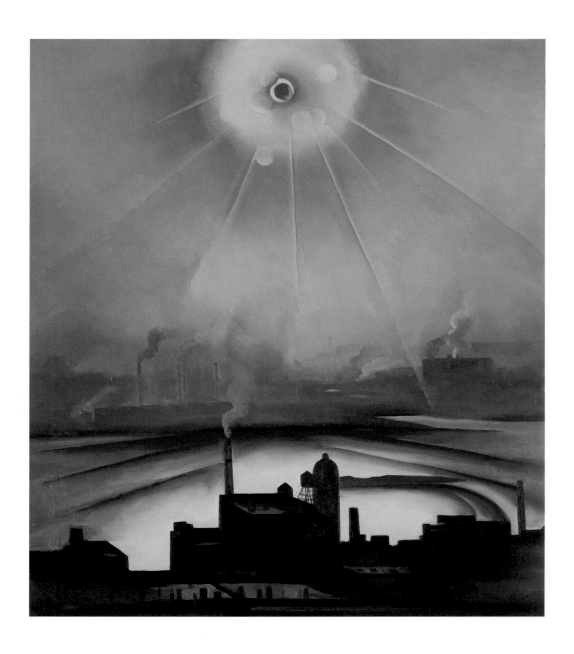

55

Georgia O'Keeffe (1887-1986)

EAST RIVER FROM THE SHELTON (EAST RIVER NO.1), c.1927-28

Oil on canvas, 26 x 22 inches
Collection of the New Jersey State Museum, Trenton, New Jersey
Purchased by the Association for the Arts of the New Jersey State Museum
with a gift from Mary Lea Johnson, FA1972.229
Reproduced with permission. ©2013 Georgia O'Keeffe Museum/Artists Rights Society (ARS), New York

Yonkers only

GEORGIA O'KEEFFE PAINTED a number of landscapes depicting the view from her studio in the thirtieth-floor apartment in the Shelton Hotel that she shared with her husband, Alfred Stieglitz. *East River from the Shelton (East River No. 1)* is unique in its palette as well as the squared format, which crops the panoramic view to focus on the factory in the lower foreground she silhouettes against the bold red reflection of the rising sun over the East River. O'Keeffe's New York paintings, like this one, suggest her growing feeling of ambivalence towards the city. While O'Keeffe was drawn to New York City's geometric shapes and patterns, she ultimately distanced herself from New York and stopped painting urban landscapes in the 1930s, when she began spending her summers in New Mexico. KMJ

56

Marguerite Ohman (1912?-1957)

VIEW OF THE EAST RIVER WITH THE MANHATTAN BRIDGE, NEW YORK CITY, 1940

Watercolor, graphite, and white gouache on paper, 31 x 22 ½ inches
Collection of the New-York Historical Society, New York, New York
INV. 14847

Yonkers only

L ITTLE IS KNOWN about the artist Marguerite Ohman, who was active in New York during the late 1930s and early 40s, and specialized in watercolor. A review of a 1936 exhibition of her work claims she studied with artist and author Pola Gauguin, the son of Paul Gauguin, but that has not been verified. Although Ohman's views of the city tend to be painted from rooftop vantage points with commanding panoramic vistas, they seem to offer us a more personal experience of the urban environment. In *View of the East River with the Manhattan Bridge,* the paths of the boats are rendered in sinuous curves on the water — curves that counteract the stentorian verticals and horizontals of steel, brick, and mortar — to give us a breath of fresh air, a sigh of relief that there is open country, somewhere, out in the distance. KMJ

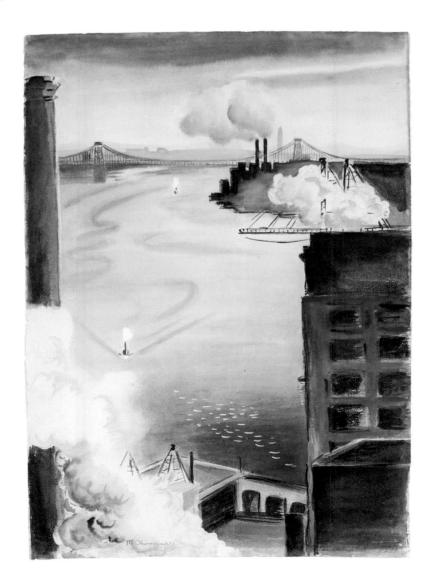

57

Marguerite Ohman

VIEW OF THE QUEENSBOROUGH BRIDGE FROM CENTRAL PARK,
NEW YORK CITY, c.1940

Watercolor, graphite, and white gouache on paper, 23 x 31 inches
Collection of the New-York Historical Society, New York, New York
INV. 14848

Yonkers only

WITH A STRONG SENSE OF DESIGN and command of pictorial space, *View of the Queensborough Bridge from Central Park, New York City* conveys an underlying current of claustrophobia and alienation as both people and nature are boxed in and rigidly controlled by the city that surrounds them. Central Park, a massive green space in the middle of Manhattan and the physical location of this scene, is nowhere in view. Nature is relegated to plants in boxes on a balcony — which, with stems as straight and regular as the buildings that surround them, seem as unnatural as the man–made edifices. KMJ

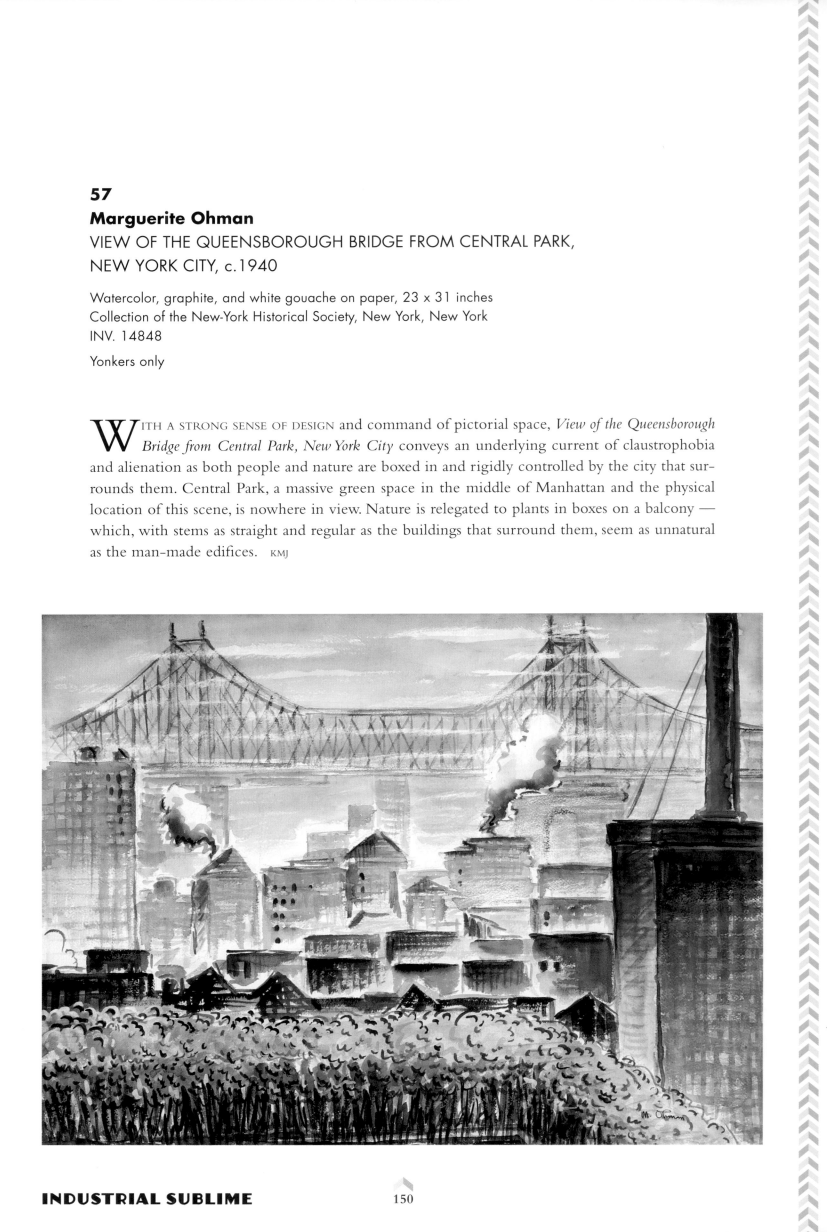

58
Marguerite Ohman
VIEW OF THE EAST RIVER WITH QUEENSBOROUGH BRIDGE,
NEW YORK CITY, c.1940

Watercolor and graphite on paper, 19 x 25 inches
Collection of the New-York Historical Society, New York, New York
INV.14851

West Palm Beach only

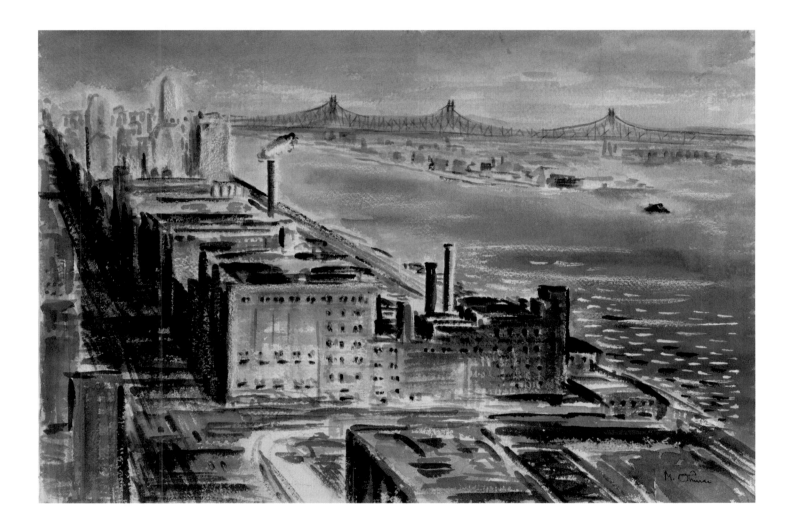

IN CONTRAST TO SOME of her more claustrophobic scenes of the city, Ohman, here, gives us a sense of New York City's sprawl with a panoramic view that stretches from the Lower East Side over the river and beyond. However, the rigid grid of the city, rendered in gritty tones of brown and red, rises starkly above the cool blue openness of a placid East River, a contrast in form and atmosphere that divides the painting into two equal parts and reinforces Ohman's concerns about the alienating effects of this urban environment. KMJ

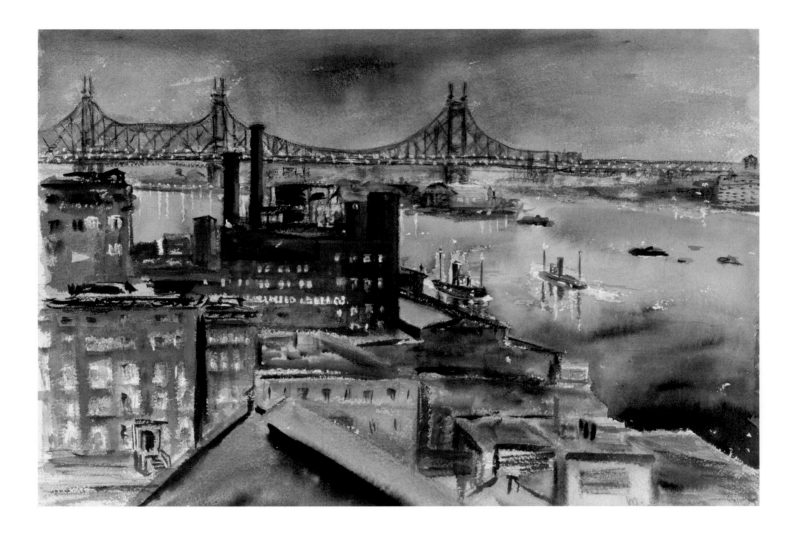

59
Marguerite Ohman
VIEW OF THE EAST RIVER AT NIGHT WITH QUEENSBOROUGH BRIDGE,
NEW YORK CITY, c.1940

Watercolor, graphite, and white gouache on paper laid on card mounted on board
19 ½ x 25 ½ inches
Collection of the New-York Historical Society, New York, New York
INV.14852

West Palm Beach only

ORIGINALLY KNOWN AS BLACKWELL'S ISLAND BRIDGE, the Queensborough was considered both a symbol of American engineering and technical innovation as well as a work of art. A double cantilever bridge, it is a symphony of interlacing iron grillwork, rhythmically composed into two sets of cantilevers with tilting struts topped by finial ornaments. From its entrance among the factories and warehouses of Queens, it spans the East River like an elegant swan, making a dramatic entrance on the Upper East Side. Ohman captures some of that majesty in her nocturnal view of the bridge from the Lower East Side. Although her approach to her subject is very direct and matter-of-fact, the glittering lights and glistening river transform the view into something mysterious and magical. KMJ

60
George Parker (1888-1957)
EAST RIVER, N.Y.C., 1939

Oil on canvas. 32 ¼ x 40 inches
Collection of the New-York Historical Society, New York, New York
Purchase, James B. Wilbur Fund, 1940.200

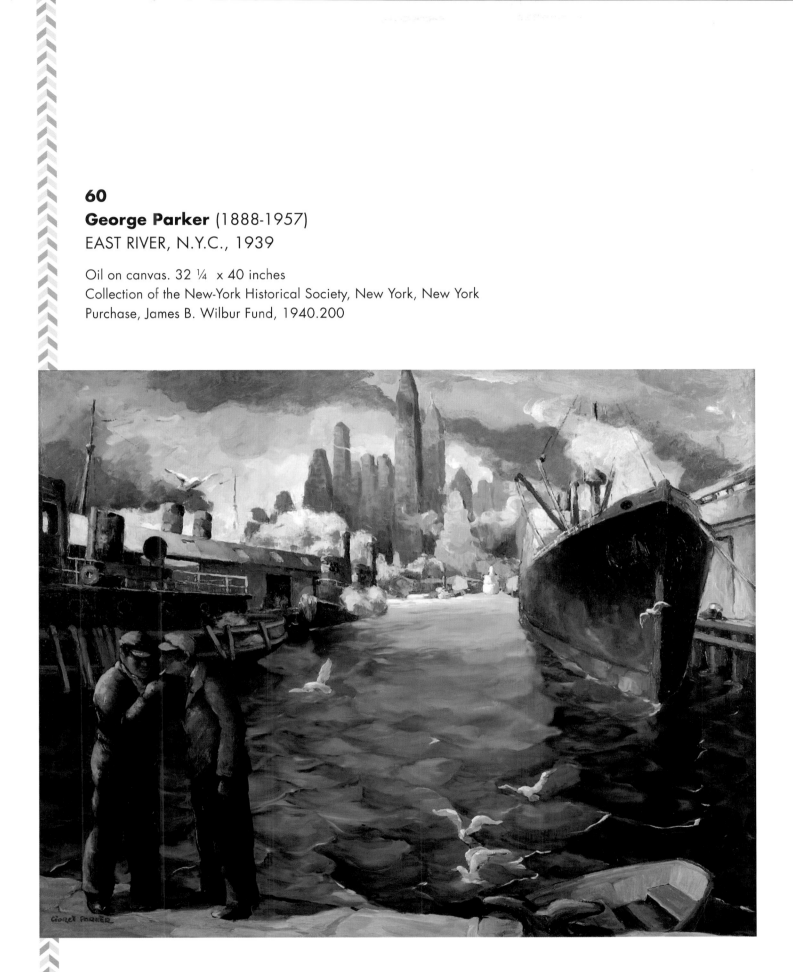

I N *EAST RIVER,* Parker provides an up-close view of the working men of the Brooklyn docks
who are taking a cigarette break. Compositionally, his work is similar to George Bellows' *Men
of the Docks* (Fig. 11), painted a generation earlier. Parker uses the same ground-level perspective
to emphasize the mass of ship hulls looming over the workers as well as using the long line of the
vessels to lead the eye back towards the dramatic skyline on the other side of the East River. By
1939 the worst of the Great Depression was ended but so had the peak years for Urban Scene
painting, which was already in decline. BFB

THE PAINTINGS

61
Van Dearing Perrine (1869-1955)
PALISADES, 1906

Oil on canvas, 41 x 68 inches
Susan Perrine King and Shawn King, Executors
Van Dearing Perrine Estate

WHEN PERRINE PAINTED *PALISADES*, he was actually living in a small shack that clung to this rocky outcrop. In his painting Perrine successfully captures the drama of the ledge of rocks that had been a favorite subject for Hudson River School artists throughout the 19th century. The awe-inspiring effect of the Palisades is one of the definitions of the "natural sublime," and Perrine's choice of the Palisades as his subject at the time most American artists were rushing to embrace a view of urban life and man-made grandeur is telling. It recognized the 20th-century link to the tradition of 19th-American landscape, albeit in a more modern, vigorous painting style. Perrine's composition, like that of earlier artists, emphasizes the reverential perspective, making the viewer a supplicant who looks up at nature's magnificence, a stance soon to be adapted by early 20th-century artists painting skyscrapers. BFB

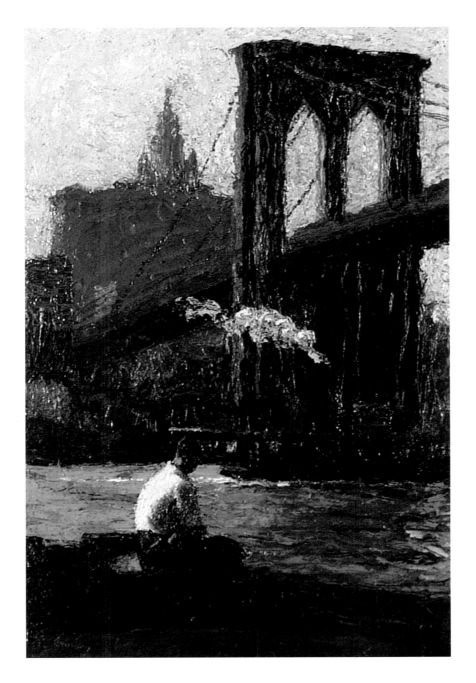

62
Robert K. Ryland (1873-1951)
THE BRIDGE PIER, 1931

Oil on board, 10 ¾ x 7 ½ inches
Collection of Remak Ramsay
Photography: Godel & Co. Fine Art, New York, New York

RYLAND WAS BORN IN MISSISSIPPI and attended Bethel College in Kentucky before studying at the Art Students League, the National Academy of Design, and the American Academy in Rome. In this small and moody sketch, painted when he was nearly sixty and a New Yorker, Ryland captures something of the dreaminess that can be generated by living in the city. We are reminded of Thomas Cole's *Allegory of Youth* from his series *The Voyage of Life*, also set along a river. Here Ryland makes the soaring gothic arches of the Brooklyn Bridge into a real-life stand for the "Taj Mahal-esque" castle of dreams once conjured by Cole. Ryland painted this work during the depths of the Great Depression, and it is perhaps sadly suitable to the time, showing a man sitting on a pier contemplating the East River. He does not reach out but looks in quiet contemplation at something beyond his grasp. BFB

63

Charles Rosen (1878-1950)

THE ROUNDHOUSE, KINGSTON, NEW YORK, 1927

Oil on canvas, 30 ⅛ x 40 ¼ inches
Collection of the James A. Michener Art Museum, Doylestown, Pennsylvania
Gift of the John P. Horton Estate

CHARLES ROSEN BEGAN HIS CAREER painting prismatic impressionist landscapes but by the 1920s his approach to the landscape began to show more modernist tendencies, with a particular interest in form, rather than subject. The *Roundhouse, Kingston, New York*, is a tightly constructed canvas dominated by the dynamic curves of buildings, tracks, and tower that follow the arc of the river at the uppermost edge of the painting before sweeping, vortex–like, into its center. The site was known as the Rondout, a yard servicing the Ulster and Delaware Railroad, and the body of water is Rondout Creek, one of the many Catskill tributaries flowing into the Hudson River. Rosen's tilted perspective creates a sense of disorientation, however, which causes the viewer to disassociate the buildings as a specific place and focus instead on the forms and their swirling movement. KMJ

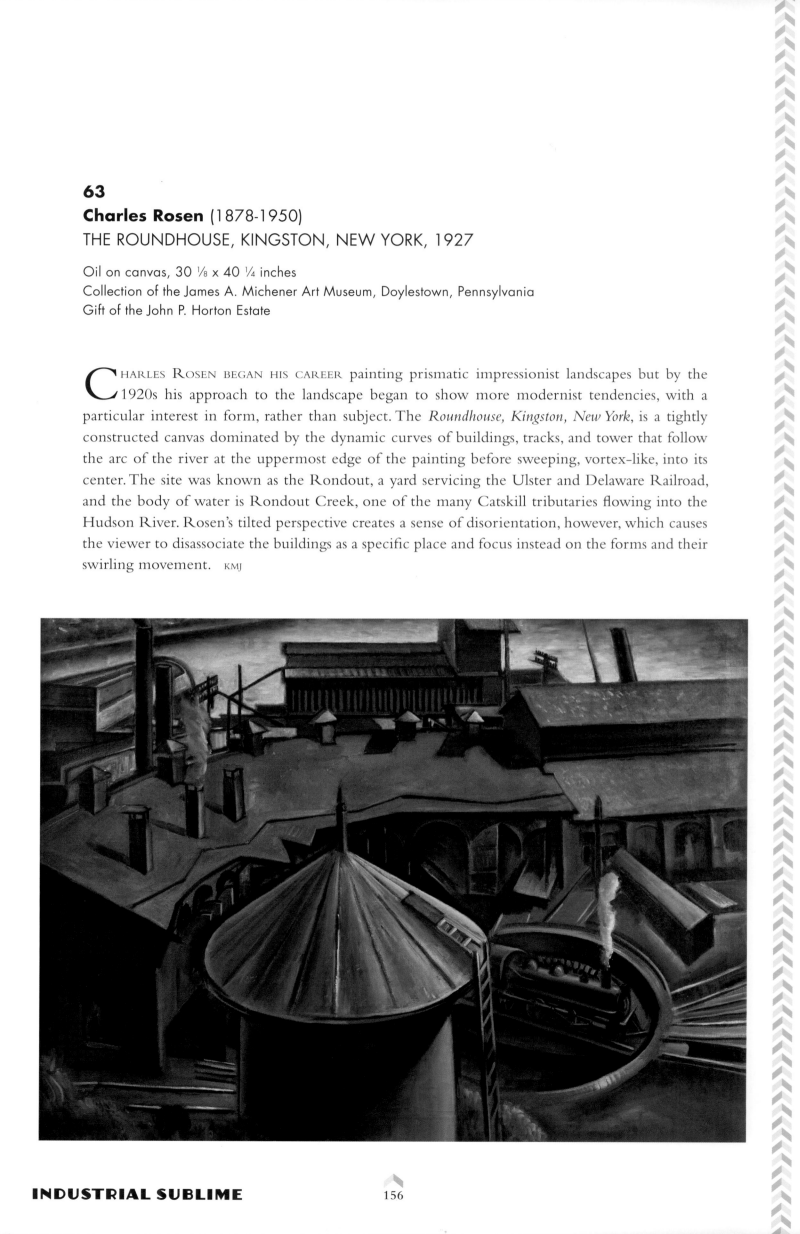

64
Everett Shinn (1876-1953)
BARGES ON THE EAST RIVER, 1898

Charcoal and wash on paper, 20 x 27 inches
Private Collection

S HINN, BORN TO QUAKER PARENTS in Woodtown, New Jersey, spent his early working years as
an illustrator for the *Philadelphia Press*. *Barges*, a wonderfully candid scene of daily city life that
Shinn completed the year after he moved to New York, demonstrates his growing ambition as an
artist and the developing maturity of his style. He was increasingly attracted to the working aspects
of the city and made it a subject of his painting, one that would coalesce in what would soon be
known as the Ashcan School. Here Shinn shows the importance of barges to the transportation
and economy of New York at the turn of the 20th century and he gives us, too, a glimpse of leisure
moments in the day for men working on river barges, the boats that became second homes for
them. Lines of laundry drying on deck, musical interludes, and recreational, if dubious, swims in
the polluted East River were part of the sailors' spirited life and Shinn's vision. BFB

65
John Sloan (1871-1951)
CLIFFS OF THE PALISADES, 1908

Oil on canvas, 9 x 11 inches
Collection of Thelma and Melvin Lenkin
© 2013 Delaware Art Museum / Artists Rights Society (ARS), New York

INTIMACY IN LANDSCAPE PAINTING is difficult to convey but Sloan achieves it in this small sketch of the Palisades, the cliffs that fringe the Hudson River waterfront. It is interesting to compare this sketch of seemingly contradictory Arcadian Realism to John Sloan's larger work *Hudson Sky* [Cat. 66], painted from a magisterial view — looking down the cliffs to the river. *Cliffs of the Palisades*, in contrast, is painted with a reverential view from the base of the Palisades — looking up. Sloan, though, angles his composition, so that the rocks do not appear threatening in their magnificence. BFB

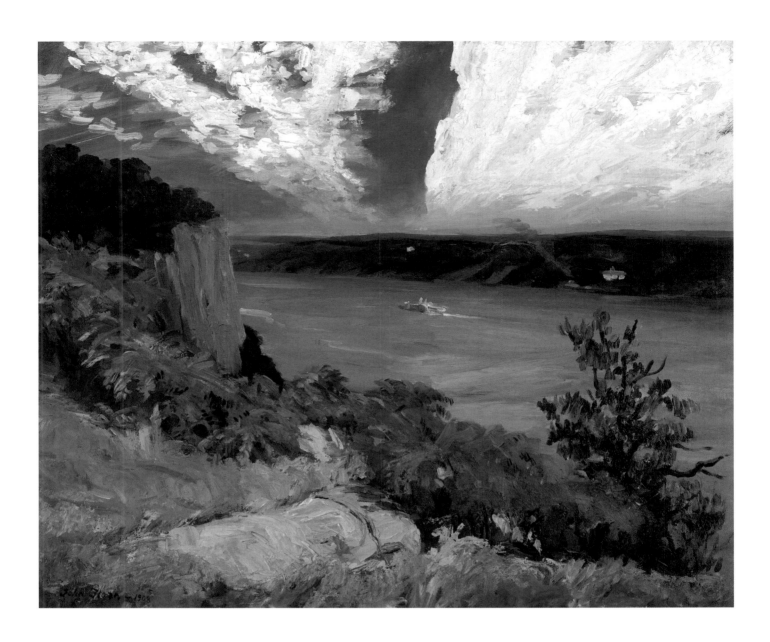

66

John Sloan

HUDSON SKY, 1908

Oil on canvas, 26 ⅛ x 32 ⅛ inches
Wichita Art Museum, Wichita, Kansas
The Roland P. Murdock Collection, M5.39
© 2013 Delaware Art Museum / Artists Rights Society (ARS), New York

*H*UDSON SKY WAS PAINTED the same year John Sloan, usually associated with the urban subjects embraced by the Ashcan School, showed his work in the landmark exhibition *The Eight*, which presented the social realist works of eight artists at the Macbeth Gallery on New York's Fifth Avenue. Gradually in his later work, he began to move from visions of city life, and this painting is a magnificent example of sublime landscape painting. The beauty of its brushwork links Sloan, a major figure in modern American art, with the traditions of the earlier Hudson River School. The desire to escape the city for the unpolluted land and water of the Hudson Valley was a long-held impulse that had existed since Thomas Cole's day and the purity of *Hudson Sky* makes a dramatic contrast with the polluted scene of Shinn's *Barges on the East River* [Cat. 64]. Sloan's painting represents a country just a few miles remove from the city but is a world apart from Manhattan's waterfront. BFB

THE PAINTINGS

67
Robert Spencer (1879-1931)
WEATHER, 1925

Oil on canvas, 30 x 36 inches
Collection of Gregory and Maureen Church

I F SOME ARTISTS CHOSE TO LOOK UP, silhouetting New York's dramatic skyline against a vibrant, sunlit sky, Robert Spencer's urban landscapes like *Weather* bring us back down to earth. Here, Spencer directs our attention away from the gleaming Art Deco skyscrapers and mammoth bridges of New York City to the more commonplace subject matter of the brick tenements, warehouses, and wave-worn docks that line the waterfront of the Hudson and East rivers. The more modest, undulating skyline becomes the backdrop to what is really the focus of Spencer's interest — vignettes of everyday urban life at the city's outermost edges. KMJ

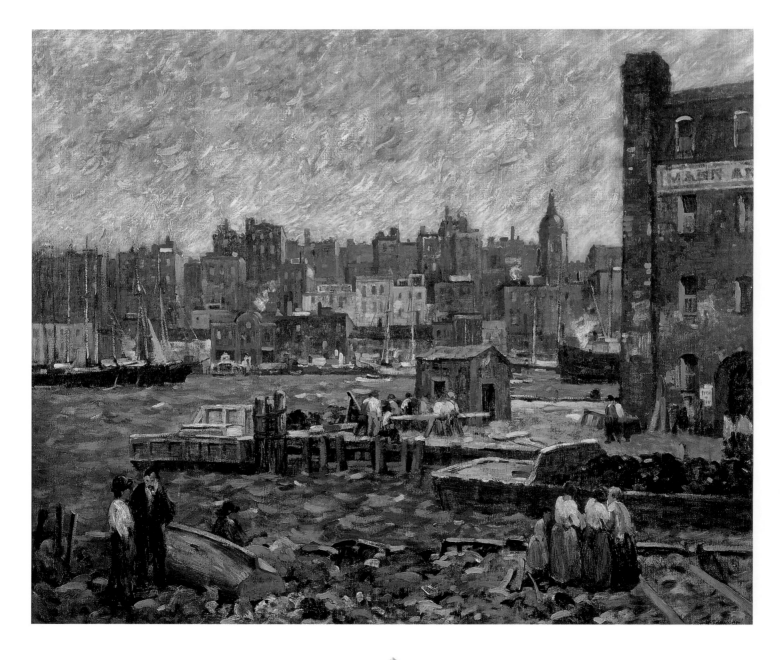

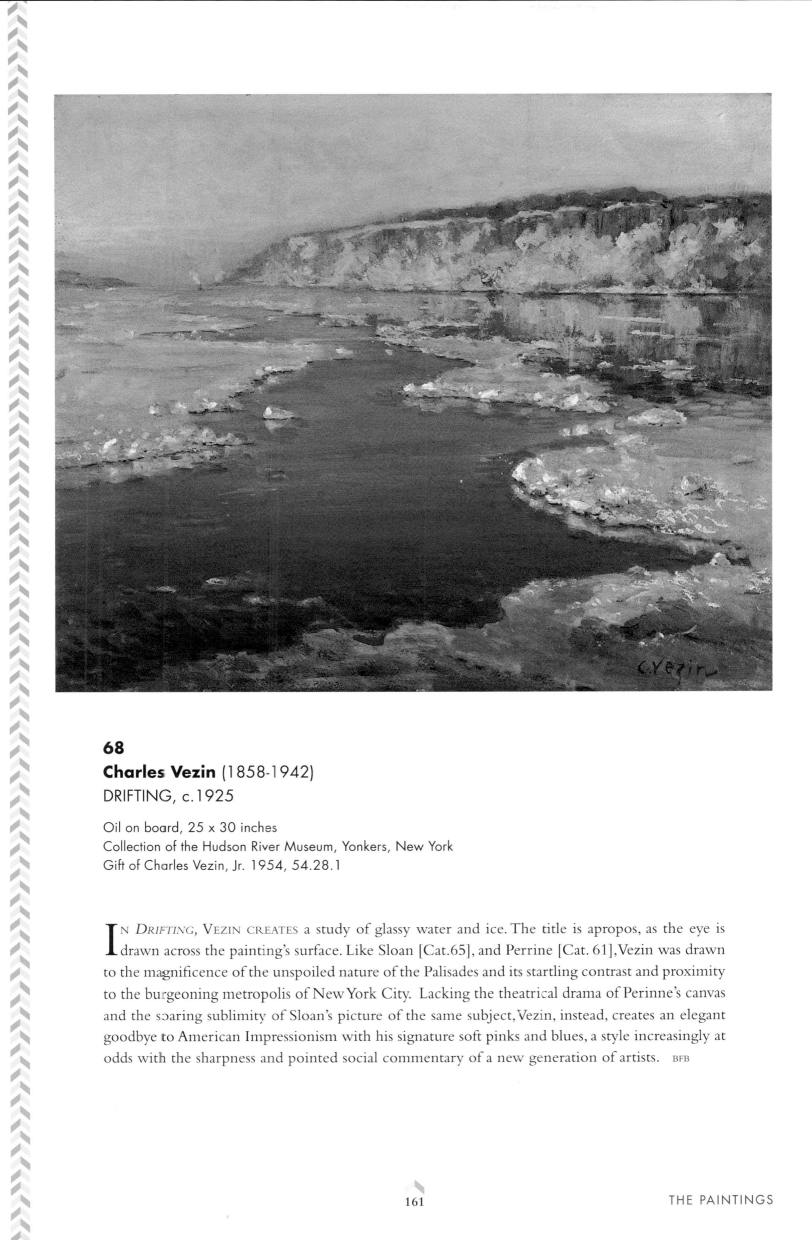

68
Charles Vezin (1858-1942)
DRIFTING, c.1925

Oil on board, 25 x 30 inches
Collection of the Hudson River Museum, Yonkers, New York
Gift of Charles Vezin, Jr. 1954, 54.28.1

I<small>N</small> *D<small>RIFTING</small>*, V<small>EZIN</small> <small>CREATES</small> a study of glassy water and ice. The title is apropos, as the eye is drawn across the painting's surface. Like Sloan [Cat.65], and Perrine [Cat. 61], Vezin was drawn to the magnificence of the unspoiled nature of the Palisades and its startling contrast and proximity to the burgeoning metropolis of New York City. Lacking the theatrical drama of Perinne's canvas and the soaring sublimity of Sloan's picture of the same subject, Vezin, instead, creates an elegant goodbye to American Impressionism with his signature soft pinks and blues, a style increasingly at odds with the sharpness and pointed social commentary of a new generation of artists. <small>BFB</small>

69

Everett Longley Warner (1877-1963)
BROOKLYN BRIDGE (STUDY FOR MANHATTAN CONTRASTS), n.d.
Oil on board, 6 ¼ x 9 ⅜ inches
Collection of Remak Ramsay

WARNER, BORN IN IOWA, was educated in Washington D.C., where he studied at the Corcoran School of Art. At the startlingly early age of 18, he became an art critic for the *Washington Star*. Warner also experienced artistic success early, and, in 1903, through sales of his art work he financed a trip to Paris to study at the Académie Julian. When he returned to New York, Warner drew his subjects from the cityscape, finding "the daily commercial activity, the smoke and steam, the softly colored eighteenth century buildings…and the modern buildings that thrust up behind the old streets" a source of inspiration. In a series of small sketches and larger canvases, he captured the beauty of the Brooklyn Bridge, which has beguiled so many artists. BFB

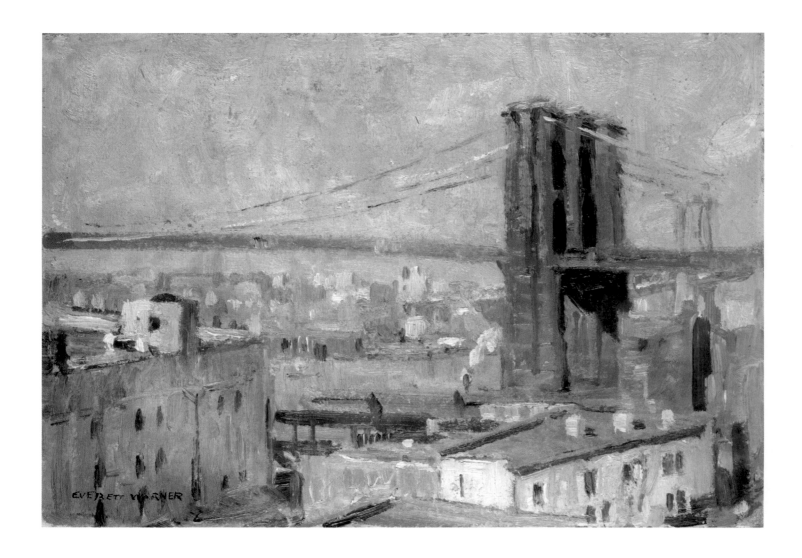

70
Everett Longley Warner
DAWN, EAST RIVER, n.d.
Oil on canvas board, 6 ¼ x 9 ⅜ inches
Collection cf Remak Ramsay

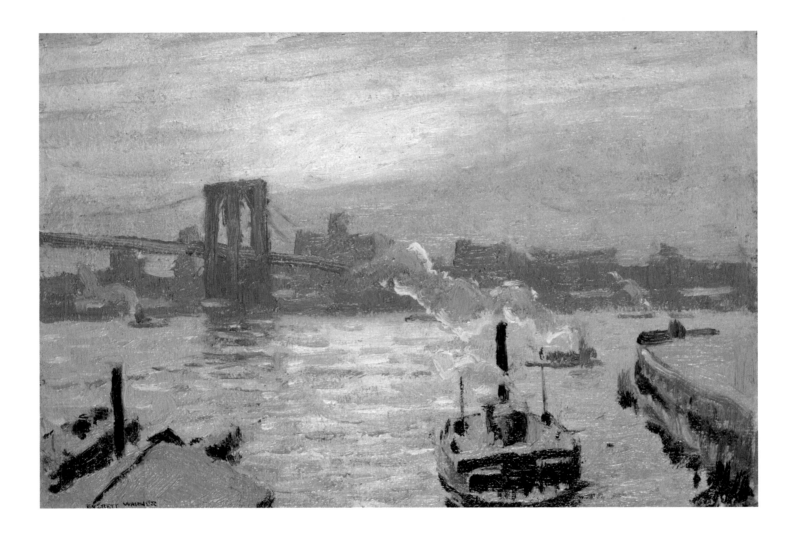

W ARNER SPENT IDYLLIC SUMMERS in the Old Lyme, Connecticut art colony, a center of American Impressionism, even after that style was no longer at the avant garde. Works like *Dawn, East River* demonstrate how successfully a style most often associated with white churches, rocky coasts, and scenic nature could be adapted to portraying modern New York. As the sun rises over the East River, Warner creates an iridescently sublime moment of optimism for the dawn that reveals the spiritual chasm between continually renewing hope and the mundane of everyday life. BFB

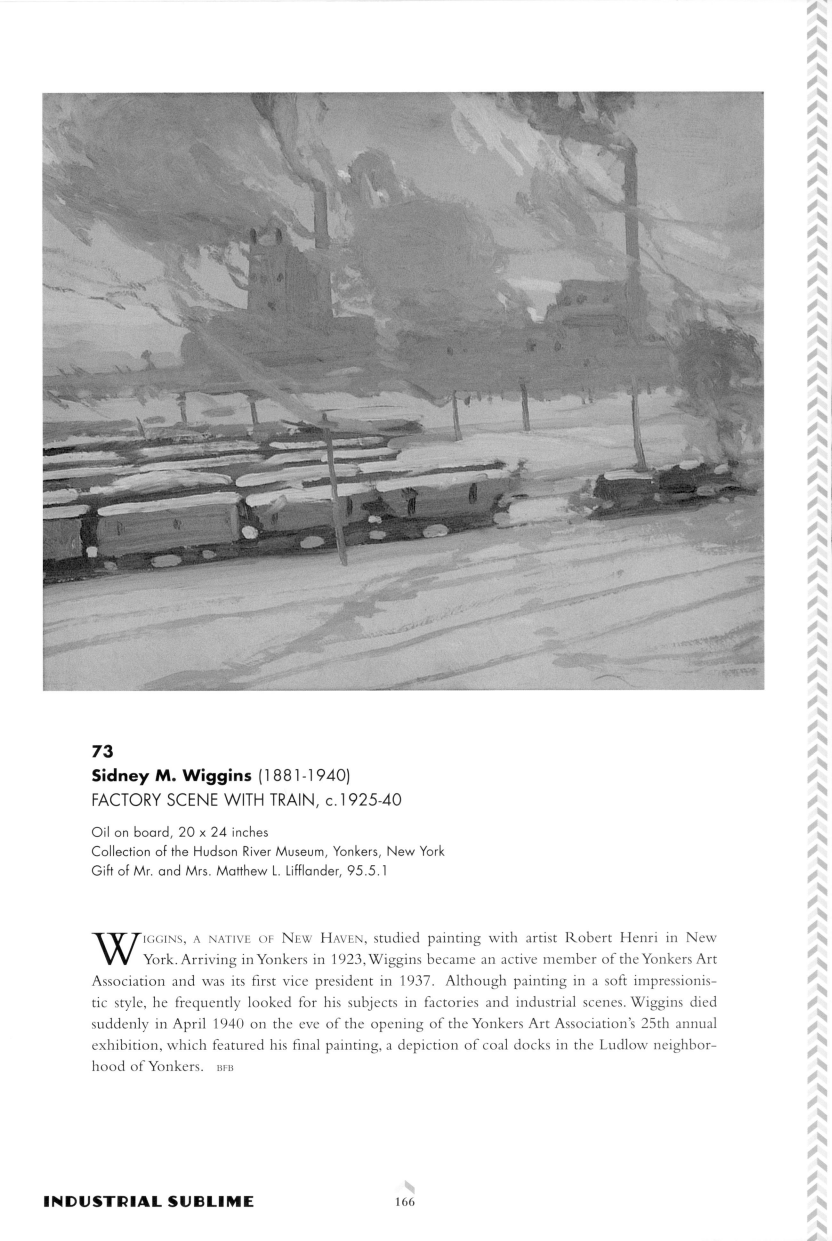

73
Sidney M. Wiggins (1881-1940)
FACTORY SCENE WITH TRAIN, c.1925-40

Oil on board, 20 x 24 inches
Collection of the Hudson River Museum, Yonkers, New York
Gift of Mr. and Mrs. Matthew L. Lifflander, 95.5.1

WIGGINS, A NATIVE OF NEW HAVEN, studied painting with artist Robert Henri in New York. Arriving in Yonkers in 1923, Wiggins became an active member of the Yonkers Art Association and was its first vice president in 1937. Although painting in a soft impressionistic style, he frequently looked for his subjects in factories and industrial scenes. Wiggins died suddenly in April 1940 on the eve of the opening of the Yonkers Art Association's 25th annual exhibition, which featured his final painting, a depiction of coal docks in the Ludlow neighborhood of Yonkers. BFB

ARTISTS IN THE EXHIBITION

Adler, Esther and Kathy Curry.
American Modern: Hopper to O'Keeffe
New York: Museum of Modern Art, 2013

Balken, Debra Bricker.
John Marin: Modernism at Midcentury
New Haven, Connecticut:
Yale University Press, 2011

Barrett, Ross.
"Speculations in Paint: Ernest Lawson
and the Urbanization of New York,"
Winterthur Portfolio 42 (spring 2008): 1–26

Barton, Phyllis.
Cecil Bell
McGrew Graphics, 1976

Berman, Avis, et. al.
William Glackens
New York: Skira Rizzoli, 2014

Brock, Charles, ed.
George Bellows
Exhibition Catalogue, National Gallery of Art,
Washington D.C., 2012

Brock, Charles.
Charles Sheeler: Across Media
National Gallery of Art,
Washington D.C., 2006

Cohen, Marilyn.
*Reginald Marsh's New York: Paintings,
Drawings, Prints and Photographs*
Dover, 1983

Cooper, Heather Campbell and
Joyce K. Schiller.
John Sloan's New York
Exhibition Catalogue, Delaware Art Museum,
Wilmington, Delaware, 2007

Doezema, Marianne.
George Bellows and Urban America
New Haven, Connecticut:
Yale University Press, 1992

Earle, Susan, ed.
Aaron Douglas: African American Modernist
New Haven, Connecticut:
Yale University Press, 2007

Gerdts, William H., Jorge Santis,
and William J. Glackens.
William Glackens
New York: Abbeville Press, 1996

Gerdts, William H. and Carol Lowrey.
Jonas Lie
New York: Spanierman Gallery, 2006

Haskell, Barbara.
*Swing Time: Reginald Marsh and
Thirties New York*
New York: Giles, 2012

Haskell, Barbara.
Ralston Crawford
New York: Whitney Museum
of American Art, 1985

Hemingway, Andrew.
*The Mysticism of Money: Precisionist Painting
and Machine Age America*
London: Periscope, 2013

Jensen, Kirsten M.
Folinsbee Considered
New York: Hudson Hills Press, 2013

Kennedy, Elizabeth, ed.
The Eight and American Modernisms
Chicago: Terra Foundation for American Art,
2009

Leeds, Valerie Ann.
Leon Kroll: Revisited
New York: Gerald Peters Gallery, 1998

Loder, Elizabeth, M.
Putnam Brinley 1879-1963
Yarmouth, Maine: The New Canaan
Historical Society, 1982

Lowrey, Carol.
Hayley Lever and the Modern Spirit
New York: Spanierman Gallery LLC, 2010

Lynes, Barbara Buhler.
Georgia O'Keeffe
New Haven, Connecticut:
Yale University Press, 1999

Lucic, Karen.
Charles Sheeler and the Cult of the Machine
Cambridge, Massachusetts:
Harvard University Press, 1991

Nemerov, Alexander.
To Make A World:
George Ault and 1940s America
New Haven, Connecticut:
Yale University Press, 2011

Peterson, Brian H. and Tom Wolf.
Form Radiating Life:
The Painting of Charles Rosen
Philadelphia: University of
Pennsylvania Press, 2006

Peterson, Brian H.
The Cities, the Towns, the Crowds:
The Paintings of Robert Spencer
Philadelphia: University of
Pennsylvania Press, 2004

Schiller, Joyce K, Heather Campbell Coyle,
Molly S. Hutton, and Susan Fillin-Yeh.
John Sloan's New York
Delaware Art Museum, 2007

Setford, David and John Wilmerding.
George Bellows: Love of Winter
Exhibition Catalogue, Norton Museum of
Art, West Palm Beach, Florida, 1997

Solon, Deborah Epstein and
William H. Gerdts.
East Coast/West Coast and Beyond: Colin
Campbell Cooper, American Impressionist
New York: Hudson Hills Press, 2006

Tedeschi, Martha, Kristi Dahm, Ruth Fine,
and Charles Pietrazewski.
John Marin's Watercolors: A Medium
for Modernism
Chicago, Illinois: Art Institute of Chicago, 2011

Turner, Elizabeth Hutton.
In the American Grain: Arthur Dove, Marsden
Hartley, John Marin, Georgia O'Keeffe, and
Alfred Stieglitz: The Stieglitz Circle at the
Phillips Collection
Counterpoint: Washington, D.C., 1995

Yokelson, Bonnie.
Alfred Stieglitz New York
New York: Skira, Rizzoli, 2010

CONSERVATION
AND NEW YORK'S RIVERS

Binnewies, Robert O.
Palisades: 100,000 Acres in 100 Years
New York: Fordham University Press and
Palisades Interstate Park Commission, 2001

Bone, Kevin.
The New York Waterfront: Evolution and Building
Culture of the Port and Harbor
New York: The Monacelli Press, 1997

Buttenwieser, Ann L.
Manhattan Water-Bound: Manhattan's Waterfront from
the Seventeenth Century to the Present, 2nd ed.
Syracuse, New York:
Syracuse University Press, 1999

Dunaway, Finis.
Natural Visions: The Power of Images in American
Environmental Reform
Chicago, Illinois:
University of Chicago Press, 2005

Kline, Benjamin.
First Along the River: A Brief History of the U.S.
Environmental Movement, 4th ed.
Lanham, Maryland: Rowman and
Littlefield, 2011

PAINTING NEW YORK CITY

Bland, Bartholomew F. and Vookles, Laura L.
The Panoramic River:
The Hudson and the Thames
Exhibition catalogue, Yonkers, New York:
Hudson River Museum, 2013

Bogart, Michele H., et. al.
Painting the Town: Cityscapes of New York
New Haven, Connecticut:
Yale University Press, 2000

Brooklyn Museum.
The Great East River Bridge 1883-1983
Brooklyn, New York: Brooklyn Museum,
distributed by Abrams, 1983

Conner, Celeste.
Democratic Visions: Art and Theory
of the Stieiglitz Circle
Riverside, California:
University of California Press, 2000

Conrad, Peter.
The Art of the City:
Views and Versions of New York
New York: Oxford University Press, 1984

Corn, Wanda.
The Great American Thing:
Modern Art and National Identity, 1915-1935
Berkeley, California:
University of California Press, 1999

Doezema, Marianne.
American Realism and the Industrial Age
Cleveland, Ohio: Cleveland Museum
of Art, 1980

Gerdts, William H.
Impressionist New York
New York: Abbeville Press, 1994

Haw, Richard.
Art of the Brooklyn Bridge: A Visual History
New York: Routledge, 2008

Haskell, Barbara.
The American Century:
Art and Culture, 1900-1950
New York: The Whitney Museum
of American Art, 2000

Stavitsy, Gail.
Precisionism in America, 1915-1941:
Reordering Reality
New York: Harry N. Abrams, 1951

Tottis, James W., et. al.
Life's Pleasures: The Ashcan Artists' Brush
with Leisure, 1895
New York: Merrell Publishers, 2007

Tsujimoto, Karen.
Images of America: Precisionist Painting
and Modern Photography
University of Washington Press, 1982

Weber, Bruce.
Paintings of New York 1800-1950
New York: Chameleon Books, 2005

Zurier, Rebecca, Robert W. Snyder,
and Virginia M. Mecklenburg.
Metropolitan Lives: The Ashcan Artists
and Their New York
Exhibition Catalogue, Washington, D.C.:
National Museum of American Art,
Smithsonian Institution, 1995

Metropolitan Museum.
American Paradise:
The World of the Hudson River School
New York: Metropolitan Museum of Art,
1987

Millhouse, Barbara Babcock.
American Wilderness:
The Story of the Hudson River School
Black Dome Press, 2007

Novak, Barbara.
Nature and Culture: American Landscape
and Painting, 1825-1875
New York: Oxford University Press, 2007

Nye, David E.
American Technological Sublime
Cambridge, Massachusetts: MIT Press, 1994

Wilton, Andrew and Tim Barringer.
American Sublime: Landscape Painting in the
United States, 1820-1880
Exhibition Catalogue, Princeton, New Jersey:
Princeton University Press, 2002

THE SUBLIME AND
THE HUDSON RIVER SCHOOL

Ferber, Linda.
The Hudson River School:
Nature and American Vision
New York: Skira Rizzoli, 2009

Maddox. Kenneth W.
In Search of the Picturesque: Nineteenth Century
Images of Industry Along the Hudson River Valley
New York: Edith C. Blum Art Institute,
Bard College, 1983

BARTHOLOMEW F. BLAND, Director of Curatorial Affairs at the Hudson River Museum, is the co-curator of *Industrial Sublime*. He has organized many exhibitions related to the art and history of New York City and the Hudson Valley, including *The Panoramic River: the Hudson and the Thames; Dutch New York: The Roots of Hudson Valley Culture; Westchester: The American Suburb*; and, *A Field Guide to Sprawl*, which traveled to Yale University. He has organized a wide range of interpretive projects for the Snug Harbor Cultural Center's Staten Island Museum, the Palazzo Strozzi in Florence, the Ronchini Gallery in London, and the Flagler Museum in Palm Beach, Florida.

WENDY GREENHOUSE is an independent scholar and consultant specializing in American art of the 19th and early 20th centuries. An authority on the history of art in Chicago, she has co-authored catalogues for exhibitions at the Chicago History Museum, Brauer Museum at Valparaiso University, Illinois State Museum, Terra Museum of American Art; and, other institutions. Greenhouse has also written extensively on the collections of the Union League Club of Chicago and the Terra Foundation for American Art. Former Curator of Paintings and Sculpture at the Chicago History Museum, she earned her Ph.D. in the history of art at Yale.

KIRSTEN M. JENSEN, a curator at the Hudson River Museum, co-curated *Industrial Sublime*. She served as Director of the John F. Folinsbee Catalogue Raisonné and holds a Ph.D. in the history of art from the City University of New York. Jensen has curated exhibitions for the Woodmere Art Museum; Cedar Grove, the Thomas Cole National Historic Site; and the Greenwich Historical Society. She was a Leon Levy Fellow at the Frick Collection, where she conducted research on curator Sara Tyson Hallowell and her influence on collecting in the Gilded Age.

KATHERINE E. MANTHORNE is a specialist in modern art of the Americas, and earned her Ph.D. from Columbia University. She is currently Professor of Art History at the Graduate Center, the City University of New York. Prior to that Manthorne was Director of the Research Center at the Smithsonian's American Art Museum, and Executive Editor of the journal *American Art*. She was recently selected Tyson Scholar at Crystal Bridges Museum of American Art. Long focused on artistic exchanges across the Americas, she shifted her attention to the role of women in the American art world in a biography of Eliza Pratt Greatorex.

ELLEN E. ROBERTS is Harold and Anne Berkley Smith Curator of American Art at the Norton Museum of Art, where her projects include an exhibition on American women modernists and a book on museum founder Ralph Norton. Before coming to the Norton in 2012, she was Assistant and then Associate Curator of American Art at the Art Institute of Chicago, where she contributed to numerous exhibitions and catalogues including *Edward Hopper, American Modernism at the Art Institute of Chicago* and *Art and Appetite: American Painting, Culture, and Cuisine*. She earned a Ph.D. in art history from Boston University.

A

Académie Julian 105, 112, 162, 164
Albrecht, Kurt XIV, 25-6, 94
American Sublime 171
Art Students League 99, 142-4, 155
Ault, George IV, IX, XIV, XIX, 26, 62,
 74, 76, 79, 85-7, 91, 96, 169

B

Beal, Reynolds XIV, 98
Bell, Cecil Crosely 17-18, 99
Bellows, George XIV, XIX, 21-2, 35,
 38, 42-3, 45, 47, 58-63, 65, 100,
 121, 133, 168-9
Bleumner, Oscar XIX, 96, 101
Brinley, Daniel Putnam XII, 24, 102
Brooklyn Heights IV, XIX, 74, 76, 79, 86, 96
Bruce, Edward 78-80, 83, 86, 91, 96, 103,
 171
Butler, Theodore Earl 104

C

Central Park 4, 52, 63, 150
Chase, William Merritt 34, 47, 61, 104, 106
Church, Maureen XVI, 160
City Beautiful 60
Cole, Thomas VII, 11-13, 18-19, 27, 97,
 155, 159
Coleman, Glenn XIX, 26, 37, 108-10
Cooper, Colin Campbell 111-12, 168-9
Crane, Frank 65
Crane, Hart 27
Crawford, Ralston XIX, 70, 87, 89, 91,
 113, 168
Criss, Francis XVI, 114
Cropsey, Jasper Francis 56-7

D

Douglas, Aaron XIV, XIX, 29, 62-3, 84,
 86-7, 115-16, 168
Driggs, Elsie 3

E

Erie Canal VII, XI

F

Folinsbee, John XIV, 74, 117-18, 132, 168

G

Gare Saint-Lazare 22-3
Garsoïan, Inna XIV, XIX, 4, 87-8, 119
George Washington Bridge 85-7, 107

H

Harlem 87, 115-16
Harlem Bridge 107
Harlem River Bridge 107
Hassam, Childe 38
Henri, Robert IX, XIV, 20-2, 27, 34-7,
 47, 100, 106, 110, 120-2, 124
High Bridge XIX, 15, 21, 130, 138
Hoboken waterfront IV, XIX, 81, 99, 128
Hopper, Edward 40, 95, 121
Hudson, Henry 26, 62, 84
Hudson River Museum I, IV, XI-I, 27,
 79, 95, 102, 107, 161, 166, 170, 173

J

Jefferson Market Court House 114

K

Kingston VIII, 22-3, 156
Kroll, Leon XIV, XIX, 23-4, 26, 43-4, 47,
 67, 125-6, 137, 168
Kuehne, Max XIV, XIX, 43, 124

L

Lawson, Ernest 130
Lever, Richard Hayley XIX, 14-15, 21-2,
 44, 47, 130-2, 169
Lewis, Martin XIV, 43, 133
Lie, Jonas XIX, 16, 25, 32, 38-9, 117, 134-6
Lozowick, Louis VIII, 80, 83, 91, 96, 137
Luks, George 22-3, 27, 100, 138